What SUCCESSFUL
Schools Do to
Involve Families

What SUCCESSFUL Schools Do to Involve Families

55 Partnership Strategies

Neal A. Glasgow ● Paula Jameson Whitney

A Joint Publication

CORWIN PRESS
A SAGE Company

NATIONAL ASSOCIATION
OF SECONDARY SCHOOL
PRINCIPALS
promoting excellence in middle and high school leadership

For information:

Corwin Press
A SAGE Company
2455 Teller Road
Thousand Oaks, California 91320
www.corwinpress.com

SAGE Ltd.
1 Oliver's Yard
55 City Road
London, EC1Y 1SP
United Kingdom

SAGE India Pvt. Ltd.
B 1/I 1 Mohan Cooperative
 Industrial Area
Mathura Road, New Delhi 110 044
India

SAGE Asia-Pacific
 Pte. Ltd.
33 Pekin Street #02-01
Far East Square
Singapore 048763

Printed in the United States of America

Library of Congress Cataloging-in-Publication Data

Glasgow, Neal A.
 What successful schools do to involve families : 55 partnership strategies / Neal A. Glasgow and Paula Jameson Whitney.
 p. cm.
 Includes bibliographical references and index.
 ISBN 978-1-4129-5603-1 (cloth) — ISBN 978-1-4129-5604-8 (pbk.)
 1. Home and school. 2. Education–Parent participation. I. Whitney, Paula Jameson. II. Title.

 LC225.G57 2009
 371.19′2–dc22

2008028634

This book is printed on acid-free paper.

09 10 11 12 13 10 9 8 7 6 5 4 3 2 1

Acquisitions Editor: Carol Chambers Collins
Editorial Assistant: Brett Ory
Production Editor: Appingo Publishing Services
Cover Designer: Michael Dubowe

Contents

Foreword

As my son worked his way through the public school system, I approached each new school year with some trepidation, always wondering whether I would be a welcome participant in his classroom. So I was intrigued when I saw the title of Neal Glasgow and Paula Jameson Whitney's new book, *What Successful Schools Do to Involve Families: 55 Partnership Strategies.* While family involvement has always been a topic of intense interest to most parents, I was curious to learn more about it from the teacher's perspective. I was rewarded with a treatment of the issue that I think both teachers and parents will find informed, instructive, and worthwhile.

In this book the authors present a new approach to collaborative partnerships that invites and encourages parents, siblings, grandparents, and other caregivers to be involved in the life of the student. Citing the increased involvement of parents and families as an important predictor of school and student performance, the authors open the discussion on how to develop a more inclusive environment. With specific advice on how to get every type of family group to feel connected and valued, they seek to create the home–school–community connection that truly brings the public back into public schools.

Based on the principle that everyone who touches a student's life is a potential teacher, the book looks at the role of teacher as facilitator in the learning process. Whether addressing homework issues, math and reading difficulties, or the challenges of teaching students from nontraditional families, the authors approach their subject matter with compassion and respect, encouraging teachers to form meaningful partnerships with parents and other caregivers.

Recognizing that schools have a responsibility to help *every* student— not just the privileged ones—succeed, the authors also address the complexities of the socioeconomic, ethnic, racial, and cultural differences that can act as barriers to the communication between school and families. Focusing on ways to break through those barriers with a combination of intellectual effort and heartfelt passion, Glasgow and Whitney provide

concrete and practical strategies to give teachers the knowledge and confidence to craft their own personal approach.

While their work underscores the intense challenges facing public school teachers in this increasingly diverse and fragmented student universe, the authors are far from being deterred by this. Instead they have delved into educational research to explore applications that have worked both within and outside the United States, offering practical and proven techniques, providing encouragement, warning of potential pitfalls, and giving both new and veteran teachers effective management tools.

The concise and straightforward format synthesizes a wealth of information covering both traditional topics, like open house and homework help, to more hot-button issues, like bullying and discipline. The research references provide the foundation for the practical and proven applications that link the research to real-world examples. This makes the book an especially useful resource by providing both teachers and parents with the opportunity to see how a collaborative approach, even in the most difficult and highly charged environments, can lead to new and innovative solutions.

As a parent, former PTA president, and current director of a nonprofit educational foundation, I have been involved with public schools for almost 20 years. Too often I have heard parents complain about not being a part of the process, about schools not listening to their feedback, and about nontraditional families who have little or no access to the classroom. It is inspiring to hear from experienced educators with such a positive, practical, and proactive approach to embracing parents and families as partners in learning.

As the poet William Butler Yeats once remarked: "Education is not the filling of a pail but the lighting of a fire." Glasgow and Whitney aim to light many fires by encouraging schools, families, and communities to work together to bring every student into the warm glow of learning.

Sheila E. Durkin
Executive Director
San Dieguito Academy Foundation

Preface

If a child can't learn the way we teach, maybe we should teach the way they learn.

—Ignacio Estrada

The greatest sign of success for a teacher . . . is to be able to say, "The children are now working as if I did not exist."

—Maria Montessori

What Is a Teacher?

Parents are a child's first teachers, but somehow parents lose some of that notion as the child grows, especially after the child leaves elementary school. Slowly, the parents turn over the teaching to the schools. How do we help parents to retain that identity and role of teacher and stay involved? Try to widen your paradigm for what a teacher is, where and when learning takes place, and how the community, parents, and other caregivers can be empowered as teachers. It is the goal of this book to help teachers and schools in the K–12 paradigm continue to keep parents, families, and communities in the educational mix.

All of us, from the day we are born, learn within and from a huge range of life experiences that are lived and experienced formally and informally, sometimes intended and sometimes coincidental. Buddhist philosophy says that a teacher appears when the student is ready. Children learn a language before they are 5 years old, and most of it is learned without the help of a formal teacher. This bit of wisdom within the philosophy suggests that there are teachers around us all the time. The goal, then, is to do everything possible to develop a ready and willing student. What circumstances and set of experiences produce a ready and willing student?

Sometimes children are teachable because of simple curiosity. Curiosity is a gift from birth, and ambition is the sibling of curiosity. Let's think about what passes as a decent education and how students and teachers perform their respective roles, measure their contributions, and collaborate in the outcome of learning.

The way we teach in America doesn't guarantee anything. There are wonderful people with minimal formal education or specialized training who do wonderful things, and there are others with multiple degrees from very good schools who do little in life. In the American system of learning, within an open society operating in a marketplace culture, learning opportunities and professional participation are open to all. The downside to this availability is that universally accepted standards in teaching, learning, and success in this system are not always predictable or easily defined. People rarely agree on what we should teach, when and how we should teach it, and exactly what will lead to success outside the classroom.

So under what circumstances does our educational system produce ready and willing students? Students usually come to the classroom seeking mastery over materials, processes, and content. Early in a student's school career, teaching to these goals is enough. However, we serve our students best once we introduce the deeper, more complex, and very personal engagement that produces the greatest motivation and achievement over longer periods of time. Knowledge and skill without soul are common and ordinary. With soul and passion, knowledge and skill can become extraordinary. Teachers teach and students study, but somewhere down the road we all become responsible for our own education, and the only way we can be sure our knowledge base and our mind-set are sufficient is to plan on being a student for the rest of our lives.

To do this, we all need to be able to see everyone as a potential mentor, surround ourselves with teachers, and become part of a community of curious learners. Rarely will the world come looking for us. Teachers can be powerful people in the lives of students. Whether we like it or not, how we teach and what we teach subliminally tell students what we think is important. Avoiding parents is not an option as we nurture lifelong learners. We need to consider parents and the community as important resources and potential teachers.

For a high school science research class a number of years ago, mentors were coming in to work with students on their projects. We had two mentors from a water chemistry and aquatic biology lab: a marine ecologist from a local university and a fish specialist from Trout Unlimited. We had other professionals from a variety of disciplines. Some of the mentors were parents of students in the high school, and others were community members who wanted to work with kids. The mentors came to the class every Friday for a full year, or the students left to work off-campus with their mentors. They worked on a variety of local science-related projects together. I was in teaching heaven! My job as a science teacher morphed into that of a manager of learning. This was the Buddhist philosophy at work. There are indeed teachers around us, all the time, and many of them were in my classroom! All I needed to do was meet the goal to do everything possible to develop ready and willing students and surround them with potential teachers. My job was to connect the students with the mentors and support the mentors as they developed the teaching skills they

needed to seal their relationships with the students. They were excited and willing but needed help.

What Do Parents Want?

Let's examine what parents want. In many school districts across the United States, parents can express a preference for their child's school-teacher. Given that all teachers have distinct strengths and weaknesses, the requests that parents make may provide insight into the things they value in education.

In their 2005 study, *What Do Parents Value in Education? An Empirical Investigation of Parents' Revealed Preferences for Teachers*, Brian Jacob and Lars Lefgren reported findings that are somewhat surprising. It seems that, on average, parents of elementary students strongly prefer teachers whom principals describe as the most popular with students—that is, those who are good at promoting student satisfaction. In contrast, parents place relatively less value on a teacher's ability to raise standardized mathematics or reading achievement scores. This suggests that "softer" teacher attributes may be quite important to parents. However, the average preference masks striking differences across family demographics.

Families with children in higher poverty and minority schools in the district strongly value student achievement. When they make requests, they are more likely to pick teachers who provide high "value" in terms of student achievement scores and teachers whom the principal rates highly in terms of factors such as organization, classroom management, and enhancing student achievement. However, these parents were essentially indifferent to the principal's report of a teacher's ability to promote student satisfaction. Interestingly, the results are exactly reversed for families in higher income schools. These parents are most likely to request teachers whom the principal describes as a good role model and/or good at promoting student satisfaction. They do not choose teachers who provide high value in terms of student achievement or who receive high scores in the organization, management, and content strength areas from their principal.

The authors (Jacob & Lefgren, 2005) suggested several potential explanations for this finding. First, they noted that education should be viewed as a consumer good as well as an investment and that it is possible that wealthier parents simply place a higher premium on the consumption value of schooling. Second, the authors noted that these findings are consistent with a declining marginal utility of achievement on the part of parents. In other words, wealthier parents may believe their children already have something of a head start in basic reading and math skills, so they value a strictly achievement-oriented teacher less highly than do more disadvantaged parents whose children may not have these basic skills. More generally, these results suggested that what parents want from

school is likely to depend on family circumstances as well as on parent preferences. Fair enough; so the next question for teachers is what do they want from their parents and community?

What Do Teachers Want From Parents?

The research (Jacob & Lefgren, 2005) suggested that parents have a clear idea regarding their preferences for teachers. What do teachers want from parents and the community, and how can they get it? The answers to these two questions depend on the teacher and how he or she has come to view parents and community.

If you buy in to a wider view of what constitutes a teacher and when and where you can find teachers, then avoiding parents is not an option as we nurture curious, lifelong learners. Community, families, and parents are important necessities. We need to consider parents and the community as important resources. Everyone in the student's life has the potential to be a teacher.

It is part of a teacher's job to connect the motivated and willing student with the appropriate formal and informal teacher, and the timing for this magic does not always place the students in the classroom. When students need to learn something and when they are willing to learn, parents, families, and the community can offer the greatest opportunities for this to happen. It's the school and classroom teacher's job to facilitate these relationships.

This book is about making this happen. It is about empowering parents, families, caregivers, and community members to become teachers and mentors. This book brings together the strategies that work for helping parents, families, and others become better at being teachers, both in the classroom and in the community. Again, teachers teach and students study; but somewhere down the road we all become responsible for our own education, and we all need to help students recognize learning opportunities both in and out of class.

It's important to teach your students that most of their learning will take place once they leave your classroom, over their lifetime of work and achievement. Prepare them for it, and help others in the student's life to help with the task. Hopefully the strategies in this book will help you as you work with parents, families, and other community members to fulfill the notion that a teacher will appear when the student is ready.

Source

Jacob, B. A., & Lefgren, L. (2005, July). *What do parents value in education? An empirical investigation of parents' revealed preferences for teachers.* KSG Faculty Research Working Paper Series RWP05-043 (also NBER Working Paper 11494).

Acknowledgments

Neal A. Glasgow would like to thank his coauthor, Paula Jameson Whitney, for her unique perspective into the K–8 realm and for her ability to see the book through the eyes of an administrator. He appreciates the high standards and expectations she brought to this writing project. He would also like to thank editor Carol Collins for fine-tuning the project and making it work for a wider range of educators. His wife, Dr. Peg Just, continues to be an inspiration, and she provides a model for what dedication to quality work looks like.

Paula Jameson Whitney would like to thank Neal Glasgow for his confidence and trust in her. His commitment to the marriage of educational research and to the writing of truly educator-friendly books makes him a role model for those who want to have a greater influence on the education profession. She would also like to thank the mentors who have influenced her and taught her how to thrive as an educational administrator: Brian Marshall, Karen Walker, Lois DeKock, Kathie Doberteen, and Cara Serban-Lawler.

Paula would also like to acknowledge and thank all the parents and teachers she has worked with in the La Mesa–Spring Valley School District. The teachers and parents who make up the Gifted and Talented Parent Advisory Council, School Site Councils, and District English Learner Councils and who live in the hallways and classrooms of the schools she worked at have taught her to "lead with her heart."

Finally, love and thanks go to her husband, Rick Whitney. Without his help and support, her dedication to children and the future of public education would not be possible.

Corwin Press thanks the following reviewers for their contribution to this book:

Beverly Ellen Schoonmaker Alfeld
Educational Consultant in Private Practice and Published Author
Crystal Lake, IL

About the Authors

 Neal A. Glasgow has been involved in education on many levels for many years. His experience includes serving as a secondary school science and art teacher, both in California and New York, as a university biotechnology teaching laboratory director and laboratory technician, and as an educational consultant and frequent speaker on many educational topics. He is the author or coauthor of ten books on educational topics: *What Successful Teachers Do: 101 Research-Based Strategies for New and Veteran Teachers* (second edition, 2008); *What Successful Literacy Teachers Do: 70 Research-Based Strategies for Teachers, Reading Coaches, and Instructional Planners* (2007); *What Successful Teachers Do in Diverse Classrooms: 71 Research-Based Strategies for New and Veteran Teachers* (2006); *What Successful Teachers Do in Inclusive Classrooms: 60 Research-Based Strategies That Help Special Learners* (2005); *What Successful Mentors Do: 81 Research-Based Strategies for New Teacher Induction, Training, and Support* (2004); *What Successful Teachers Do: 91 Research-Based Strategies for New and Veteran Teachers* (2003); *Tips for Science Teachers: Research-Based Strategies to Help Students Learn* (2001); *New Curriculum for New Times: A Guide to Student-Centered, Problem-Based Learning* (1997); *Doing Science: Innovative Curriculum Beyond the Textbook for the Life Sciences* (1997); and *Taking the Classroom to the Community: A Guidebook* (1996).

 Paula Jameson Whitney has been an educator for 21 years. During that time she has been a middle school teacher of language arts, ESL, and social science; middle school vice principal; elementary school principal; and central office director of learning support and categorical programs. Her Master's of Education is in English Language Development, and her expertise is in instructional practices for English learners and gifted and talented students and in leadership strategies for school improvement.

Introduction

A child educated only at school is an uneducated child.
—George Santayana

Children have to be educated, but they have also to be left to educate themselves.
—Abbé Dimnet, *Art of Thinking*, 1928

It's a simple cliché—*Two heads are better than one*—and its meaning has far-reaching consequences. It is a phrase meant to highlight the importance of partnerships and combining intellectual effort. The bottom line is that students will benefit if schools, teachers, parents, and communities are in consensus with one another and working as a team focused on the student.

The involvement of community, families, parents, and others in the life of a child has been part of education since the beginning of the public school paradigm. One of the earliest examples of this occurred in 1895, when Alice McLellan Birney began what evolved into today's PTA by expressing a deep concern for the miserable condition of some groups of urban children and families. Children were treated very differently in the nineteenth century than today. Through consistent hard work, sometimes after years of perseverance, the dreams became reality: kindergarten classes, child labor laws, a public health service, hot lunch programs, a juvenile justice system, and mandatory immunization were accepted as national norms. Between 1897 and 1919, 37 state-level congresses were chartered to help carry out the work of the cultural organization of children and families. Because Alice McLellan Birney needed more than the enthusiastic support of her family, she enlisted the help of her dedicated friend, Phoebe Apperson Hearst. Phoebe Hearst (mother of William Randolph Hearst), who had become a schoolteacher at age 16 and later married into the affluent Hearst family, became the perfect partner for Alice McLellan Birney and her concerns for the plight of children. Together they shared a vision that would "create an unprecedented movement" of dedication and determination to create a better place for countless children.

On February 17, 1897, in Washington, D.C., Alice McLellan Birney and Phoebe Apperson Hearst realized their dream. It was the beginning of the National Congress of Mothers. The National Congress of Mothers drafted a statement of purpose in 1897. The purposes included

- The education of parents for child development
- The cooperation of home and school
- The promotion of the kindergarten movement
- The securing of legislation for neglected and dependent children
- The education of young people for parenthood

In 1924, the National Congress of Mothers evolved into the National Congress of Mothers and Parent-Teacher Associations. In another development, by 1911, Selena Sloan Butler, an African-American teacher and wife of H. R. Butler, who was a prominent physician in Atlanta, Georgia, had founded the first Colored Parent-Teacher chapter, which later became the National Congress of Colored Parents, to address the special needs of students in the states where segregation was legally sanctioned. And finally, in 1924, the National Congress became the organization we know today as the Parent Teacher Association, or the PTA. Their 1924 handbook stated:

A parent-teacher association is an organization of parents, teachers and others interested, for the purpose of studying reciprocal problems of the child, the home, and the school, and the relation of each to the community and the state, in order that the whole national life may be strengthened by the making of better, healthier, happier, controlled and more intelligent citizens. (Ladd-Taylor, 1994, p 8)

Over the past 50 years, the notion and nature of parent/family involvement has changed from a narrowly defined concept into a wider set of ideas and goals. The traditional views have often included activities that are unidirectional (parents give to schools), with involvement that is exclusive or practiced only by a small group of "privileged" parents and with a narrow focus centering mainly on their children's achievement. Newer ideas and concepts focus on the development of mutual partnerships involving a range of families and community members and groups. Within this newer paradigm, people are recognizing a new range of community and family involvement. These changes imply that educators must prepare to reflect a more inclusive and comprehensive understanding of their communities and parent/family involvement. The call for an updated view on what community and families can do with the teaching and learning paradigm comes at a wonderful time. The news about parental attitudes toward schools is good.

A 2006 Phi Delta Kappa/Gallup Poll asked the public to assess its schools using the familiar A to F scale. The practice was started in 1974 with a question asking the respondents to grade the schools in local

communities. Parents were asked to grade the school their oldest child attended. Here are some of the highlights.

- Public ratings of the local schools are near the top of their 38-year range.
- The closer people get to schools in the community, the higher the grades their students receive.
- Policies at the state and federal levels are built on the assumption that local schools generally have high approval ratings and are likely to gain public support.
- Gaining public support for school improvement will be more likely if proposals are based on schools at the local level rather than at the national level.
- There has been no decline in public support for public schools. Approval ratings remain high and remarkably stable.

What does this mean to educators? Ask any politician about listening to their base. Their base is the group that got them elected, the group that provides them with power, and the group that will get them reelected. If they move too far from their base, then trouble occurs. Educators and schools are subject to many of the same forces. Local communities and parents make up a school's base. They pay taxes and make up the PTA, school foundations, and school boards. It should be no secret that the effectiveness of schools is highly influenced by parent and community involvement. Of the many professional responsibilities educators have, there are few more important than forming a productive relationship with the community and parents.

Where do parents get information on what is happening within schools, and how do teachers contribute? Malcolm Gladwell's book, *Blink: The Power of Thinking Without Thinking* (2005), looked at the notion that successful people can make accurate decisions about complex situations in the blink of an eye without conscious deliberations. It is the subconscious mind that is involved in first impression decisions and judgments, those powerful and spontaneous feelings we get while engaging someone or experiencing something new or for the first time. Every time a community member approaches your school or talks to a staff member or teacher, the opportunity for a "Blink Test" occurs. Every time parents and other adults see the school, come into the school, talk to a school staff or faculty member, or talk to a neighbor or friend about the school, they both consciously and subconsciously filter large amounts of information. They use this information to assess, evaluate, make judgments, and draw conclusions about schools, classrooms, and teachers.

Increased involvement of parents and families is often cited as one of the most important ways to improve schools. The goal of this book is to open up the parent involvement and school paradigm for analysis, discussion, assessment, and the synthesis of individual action plans to better

engage and involve the parents, caregivers, and community in supporting children. The phrases *parental involvement* and *family involvement* are used here for reasons of readability. The choice of the words *parent* or even *family* are not intended to exclude other adult caregivers from active participation in the education of children. In many cases, the words *family*, *foster parent*, or *a relative* could be substituted for *parent*. Children may live with relatives such as grandparents, aunts and uncles, and even older siblings. In many cultures, the responsibility for child rearing is extended to other family members. While certain types of participation are limited to parents and others with legal responsibility, there are many other types of participation that are open to the imagination of the school and the interested parties.

Traditionally, parent involvement in education has included home-based activities such as helping with homework and reading and promoting school attendance and school-based activities such as attending meetings or parent–teacher conferences, participating in school improvement projects, helping to raise money, or volunteering or coaching during the school day. It also includes adults working in many other capacities that directly and indirectly affect schools.

Although some parents may be unable to visit the classroom because of work commitments and time constraints, educators are discovering and inventing additional ways parents can help students and contribute to their schools. In the end, much of this involvement is dependent upon the school's desire to involve parents.

All this information delivers a strong message about the importance of local governance and local communities and especially parents and families. We know that the closer the public is to schools, the higher the public rates them. We also know that parental involvement improves school performance. Therefore, while working with students is still our first priority, working with community and family members should be close behind.

Much has been written, both general and specific information, about the effect parents, families, and communities have on schools and the effect schools have on them. The urgent need is to provide a high-quality education for students, and that calls for increased expertise on the part of classroom teachers and all others in the student or child's life. Teachers and schools can be the resource for most matters pertaining to linking parents, families, and communities in more productive, beneficial, and effective instructional relationships. This book explores, examines, synthesizes, and organizes the most relevant and current information related to this paradigm.

To synthesize this wealth of information on these relationships, a means of organization is needed. Strategies within the chapters are structured in a user-friendly format.

- *Strategy*: A simple and concise statement of a teaching tip or parent engagement suggestion.

- *What the Research Says*: A brief discussion of a journal article, multiple journal articles, or a book from peer-reviewed research literature that led to the tip. This section should simply give the reader some confidence in, and a deeper understanding of, the ideas, concepts, and principles being discussed as a teaching tip.
- *Classroom Applications*: A description of how this teaching and learning tip can be used and/or applied in an instructional or broader school setting.
- *Precautions and Possible Pitfalls*: Caveats intended to make implementation of the tip reasonably error-free. This section attempts to help teachers, principals, and other educators avoid or consider common difficulties before they occur.
- *Source(s)*: One or more sources are provided so that interested teachers can refer to the original research that contributed to the tip or strategy.

These strategies are organized into related chapters. Chapter 1 deals with some of the more traditional topics involving parents, such as open house and parent conferences. Chapter 2 provides strategies to give educators a fresh look at the homework paradigm through a number of strategies and current research. Chapter 3 looks at a full range of literacy topics and how they relate to the student's life outside the classroom, and Chapter 4 examines mathematics in much the same way. Chapter 5 examines special education as it relates to students and families. In contrast to a parental focus, Chapter 6 explores the roles of nonparental caregivers, such as extended family members. Chapter 7 strategies center on the art of home–school–classroom communications, while Chapter 8 tackles what the research tells us about the more challenging or at-risk students and family situations. Chapter 9 provides a number of strategies targeting families and students from nondominant cultures and how we can better relate to their individual needs. Chapter 10 provides strategies to better understand and manage the social or affective realm and how families relate to bullying, discipline problems, and classroom academic social behaviors. Finally, Chapter 11 offers several schoolwide strategies for principals and leadership teams to consider when dealing with parents and parent involvement as a school improvement initiative.

We hope all teachers, principals, and community members will benefit from the practical applications we have filtered through research findings and our own experiences and those of many colleagues, parents, families, and community members. We know that new teachers receive advice and support from colleges and universities, mentors, veteran colleagues, and induction programs. This book's intention is to bring teachers and principals advice and support from the educational research literature as well. It is likely that any teacher—first year or beyond—reading this book for the first time will find strategies that don't apply. As with any concept in

education and as time passes, teachers may tend to "not know what they don't know" and may need to refresh their perspective and experience. We ask that you come back and revisit the book from time to time. What may not be applicable the first time you read it may be useful at a later date. We also would like principals and teacher-leaders to read the tips and set them in the larger context of how these strategies can assist with overall school improvement. A principal might read one of these tips and know exactly which teacher and parent can benefit most or which student and parent are likely to be receptive.

Teaching and education in general have never been more challenging or exciting. Expectations for all stakeholders continue to rise. The more strategies educators have and can use to assist their students, parents, families, and communities on their educational journey, the better the outcome for all of us. We hope all educators find this book a practical and useful addition to their collection of teaching resources.

Sources

Gladwell, M. (2005). *Blink: The power of thinking without thinking.* New York: Little, Brown.

Ladd-Taylor, M. (1994). *Mother-Work: Women, child welfare, and the state, 1890–1930.* Champaign: University of Illinois Press.

1

Parents, Families, Teachers, and School Appreciating and Supporting Each Other

Quality is never an accident; it is always the result of high intention, sincere effort, intelligent direction and skillful execution; it represents the wise choice of many alternatives.

—Willa A. Foste

I am always doing what I cannot do yet, in order to learn how to do it.

—Vincent Van Gogh

 Strategy 1: Recognize the various assumptions and myths that surround parental involvement in schools.

What the Research Says

 Russell and Granville (2005), of George Street Research in Scotland, developed a report that details findings from qualitative research addressing the issue of parental involvement in the

education of their children. The need for the research derived from a growing recognition of the importance of the role of parents and home–school partnerships in improving levels of achievement and attainment in schools and the overall quality of the educational experience. The Scottish Executive Organization is committed to improving the involvement of parents in their children's education and in the work of the school itself. This research explores the level of involvement that parents currently have in different types of educational and school-related activities and aims to identify barriers to involvement so that strategies can be introduced to overcome these and ultimately improve parental involvement.

Note that the term *parent* is used throughout the report to refer to the wide range of individuals who are responsible for the care and upbringing of children and young people across the country. Occasionally, the report makes use of other terms, but this is where the view expressed is attributable to a particular type of caregiver only (for example, *foster caregiver* for asylum seekers and refugees). The specific objectives set for the research were as follows:

- To gather feedback and views from key parent stakeholder groups about their current involvement in their children's education
- To include the opinions of groups who, in the past, have been reluctant or unable to provide appropriate feedback
- To reflect the views of parent stakeholders from all parts of Scotland and include residents in cities, towns, and rural areas
- To identify actions and recommendations that will help to improve the quality of parental involvement

Classroom Applications

There is a range of parental expectations concerning the nature of the relationship they experience with the school and the range of roles and responsibilities they expect the school to offer, with some parents committed to a closer relationship with the school and teachers than others. Most parents accept that they are required to fulfill some fundamental responsibilities, and these are generally regarded as basic expectations that schools can reasonably have of any parent. Parents also have expectations about the type of relationship they should have with the school. However, for the most part, the greatest percentage of parents currently have relatively low levels of involvement, while perceiving that what they do is all that is needed.

Additionally, in two-parent households, it is often the case that one parent is more involved than the other. This again is considered to be adequate and is the most practical approach for many families, especially if

one parent is the breadwinner and the other is the homemaker or is seen as doing the majority of the parenting. There are some differences in expectations among parents from specifically targeted groups such as parents from minority ethnic backgrounds and various immigrant families.

One of biggest challenges facing us is to overcome the fixed assumptions held by the majority of parents. It is very hard for parents, who have a deeply ingrained mind-set about their responsibilities, to visualize themselves playing a more active role in schools. The goal, therefore, is to establish the key messages that are meaningful to parents that we can use in future communications in order to bring about change and establish new roles for caregivers.

The majority of parents perceive a fairly distinct boundary between the role of the home and that of the school. Parents expect the school and teachers to be the principal educators of their children while parents play a relatively minor but important supporting role.

This quote sums up many parental attitudes: "The teachers are there to teach the children . . . they are getting good wages and good holidays to do it and we pay our taxes . . . we are the parents who bathe, feed and clothe them, look after them and make sure they behave themselves" (Russell & Granville, 2005, p. 9). The average parent perceives a need for only a supportive involvement in their children's education with principal responsibility lying with the teaching staff.

The following types of activities represent the involvement of the majority of parents:

- Ensuring that children complete their homework and helping with it when they can
- Attending parents' night meetings at school
- Supporting their children when performing or playing sports
- Keeping track of their children's academic progress

This relatively limited range of activities, many of which are supportive rather than active, are nonetheless considered to be involvement. As such, *parental involvement* means different things to different people. Moreover, the majority of parents assume that what they are currently doing is adequate, reflecting the particular needs of their own children, and that there is no requirement for more or better involvement. Many parents feel that, "You can be involved without being near the school. We are involved with their activities. We're active parents in the home—you don't need to go near the school" (Russell & Granville, 2005, p. 9).

This is particularly the case if their child does not seem to have any problems and the school is fulfilling the parents' expectations. Another quote from the study supports this notion: "If you're happy with the report card, the teachers and that your child is getting what he or she

needs or expects and is doing well, why get involved? If the school is doing a good job you want to just stand back and let them get on with it" (Russell & Granville, 2005, p. 10).

In fact, some parents feel there is danger of doing too much and being overly involved. They recognize that some parents tend to dominate too much, trying to have too much control: "Too much interference from parents might rock the boat. Parents can't expect to control everything" (Russell & Granville, 2005, p. 10). Parents acknowledge that the principle reason to contact the school would be if their child was having a problem of some sort, such as bullying. When things go wrong is the only time that parents really want to know. There is still also the assumption that the school will contact parents if there is a serious problem or issue, and for the most part this does appear to happen.

The average parent also recognizes that they have a basic responsibility to offer some level of support to their child's learning. Indeed, parents are aware that their input at home has a positive impact on academic achievement as well as the emotional well-being of their child. In addition, parents recognize that they have some fundamental responsibilities to ensure that their child

- attends school in a fit state to learn,
- is punctual,
- is appropriately dressed and adequately equipped,
- behaves well, and
- respects the rights and interests of others in the school community.

Parental expectations about the level and type of involvement often reflect their own upbringing and experiences in schooling and the level of involvement of their own parents. A pattern of expectations is modeled through the generations. As mentioned earlier, those individuals whose own parents were not involved in school activities are less likely to perceive a need for their involvement in their own children's education. Parents who have had a negative experience at school are also less likely to be interested in getting involved or playing an active role in school events and activities.

It is also important to note that parental expectations of the school, and what the school can feasibly do, are affected by a perception that teachers have excessive workloads and face limitations in the additional time they can offer to engage parents in the learning process or foster links between the school and home. Some parents are, therefore, sympathetic to teachers and reluctant to make any suggestion that could put greater pressure on teachers' time.

Parents from different cultural backgrounds, such as minority ethnic communities and immigrants, seem to have differing views about the level of responsibility that the school should have. In some countries, the

boundaries between the school and the home are much starker, and the relationship between the home and the school is more formal. For example, a Nigerian parent once said that Nigerian schools have a clear set of educational responsibilities in which parents are not expected to get involved—to do so would be considered interfering.

In other countries, parents are expected to be far more involved compared to the United States. For example, parents from Lithuania and Russia emphasize the importance of parental presence and assistance in many different aspects of school life, and this is considered to be a parental duty. Their involvement helps parents to become integrated into the local community.

There are also differing ideas about the limits of the school's responsibilities. For example, some parents have issues with the school providing sex education or drug education for their children because they feel it is putting ideas into their heads. An Indian father emphasized that he would like this responsibility to be placed back in his hands.

Several parents from different cultural backgrounds in the Russell and Granville (2005) research also mentioned what they feel is a lax attitude to discipline in Scottish schools, compared to the schools in their own countries. They expected the school to play a stronger disciplinary role: "I think there is too much freedom for the kids . . . even if they go in ten minutes late they are just signed down but it doesn't matter. They don't bother. In our country if the child is late today, then the next day he will get a punishment" (Russell & Granville, 2005, p. 13).

Precautions and Possible Pitfalls

When reflecting on the role of parents in schools from an educator's perspective, it is also necessary to examine your own expectations for parents. Teachers also have clear ideas, comfort zones, and boundaries for the roles parents play in schools. If you are really concerned with changing the parental roles in schools, you will need to expand your own paradigm on what is possible. Many teachers just don't like dealing with parents, usually because they see parents as bringing more problems than solutions. This will need to change if more productive partnerships are to be facilitated.

It also should be mentioned again that each nondominant culture in our schools can have a unique or nonmainstream view of their parental roles in their children's schools. It is important for teachers not to stereotype these parents. Nonparticipation should not be mistaken for indifference. Prior knowledge is important here, and educators should do their cultural research before making any assumptions regarding parents and their roles within the schools. Misunderstanding is not a good way to begin a relationship.

Source

Russell, K., & Granville, S. (2005). *Parents' views on improving parental involvement in children's education.* Edinburgh, Scotland: George Street Research for Scottish Executives.

> ### Strategy 2: Resist the temptation to indulge in the "blame game" or the blaming of parents and students for low achievement.

What the Research Says

 This study (Thompson, Warren, & Carter, 2004) identified the characteristics of teachers at an urban fringe high school who were most likely to blame parents and/or students for the students' underachievement. Rather than targeting more typical reform efforts, this research looks at the actual classroom environment—particularly the impact of teacher attitudes and expectations on student achievement. In contrast to research on elementary teachers, there is little research about secondary teachers. The current study identified the teachers in an underperforming urban fringe high school in southern California who were most likely to blame students and their parents for underachievement. Data was collected through questionnaires from 121 teachers in 2002.

Results of this study of high school teachers corroborated previous research about high school teachers. Sixty-four percent of the teachers agreed with the statement "I believe that parents are largely to blame for students' low-achievement." Fifty-seven percent of the teachers agreed with the statement "When students fail to pass a test or assignment, they are largely to blame." Also, it was found that teachers who blamed students also were the most likely to blame parents. The results of this research were seen as a huge obstacle to home–school relationship reform.

Classroom Applications

One of the strengths of this study (Thompson et al., 2004) is it demonstrates that improving student achievement in underperforming schools is a challenging and complex task that must include the work of changing teachers' mind-sets, beliefs, attitudes, and expectations

about students and parents. When teachers become aware of the potential impact their attitudes have on student achievement, hopefully they will do what is necessary not to communicate these messages to their students. Teacher expectations have a large impact on achievement.

The results of the study suggest that there is a need for the individual teachers, administrators, professional developers, and reformers to shift from educators focusing solely on systemic change to considering the specific pedagogical environment of the classroom and teacher. Because teacher beliefs and expectations can become self-fulfilling prophecies, professional development would do well to focus on strengthening instructional practices and change the deficit mind-sets and negative beliefs that teachers harbor for specific students and student groups.

Attending inservices and workshops designed to increase teacher self-efficacy can be helpful. Researchers (Thompson et al., 2004) have found that teachers' expectations are correlated to their sense of teaching efficacy. Many teachers in the cited study stated they had not been adequately prepared to effectively teach most of their students, especially in urban settings. Teachers in underperforming schools are especially vulnerable to developing negative beliefs about students, parents, and the school community.

The goal is to adopt mind-sets to avoid the pitfall of the "blame game" and avoid the stereotyping, bias, and negative attitudes that are communicated subliminally to parents and students. Individual teachers can better help parents and students by being prepared to take responsibility for student achievement. That means teachers need to revisit and redefine how they view the students in their classes.

Precautions and Possible Pitfalls

Professional development remedies to this situation are rarely found in schools. Teachers need to begin to see their students and parents as educational opportunities rather than classroom burdens. Teachers need to begin to recognize the symptoms of the described phenomena and do what they can to avoid the "blame game" pitfall. The blame game usually accompanies and is symptomatic of teacher burnout.

Source

Thompson, G. L., Warren, S., & Carter, L. (2004). It's not my fault: Predicting high school teachers who blame parents and students for low achievement. *The High School Journal, 87*(3), 5–14.

> *Strategy 3: Develop an understanding of what parents want from an open house as a promotional school event.*

What the Research Says

Market forces, state and local politics, and the media are more and more a part of school and educational discourse these days. Higher accountability, open enrollment, choice, demand or competitive funding, and the diversity of school types and programs all contribute to marketization and marketing as a response to external forces and the need to compete for students. This study (Oplatka, 2007) focused on exploring the perception of the importance of promotional events in secondary schools. Specifically they looked at how Canadian parents, their children, and teachers were influenced by these events and what role these events had in the process of school choice and school life. The findings suggested that both families and teachers displayed contradictory perceptions of the concept of "open house." Teachers and families also differed in their understanding of the place of this event in school life and choice. Four effective aspects of this promotional event were subjectively identified from the respondents.

Classroom Applications

The major elements or assumptions underlying school-choice reform and program choice are that school improvement is going to happen due to the parents' ability to distinguish between good and bad schools or programs. With minimal indirect contact with schools, somehow parents are going to understand good and bad schools in terms of instruction, discipline, organization, and other qualities that schools exhibit. When you consider the limited snapshot parents and other school visitors receive, with very little insight into educational philosophy and pedagogy of curricular design, the parents' ability to manage and make valid comparisons can be questioned. So what information and strategies can you take from this research regarding open house activities? Here are some perceptions.

Most teachers in the study indicated that the open house concept has a strong influence on parental choice because school staff devoted so much effort to introducing the school and various departments. Although some felt that open house couldn't really transmit the school's true teaching and learning paradigm, most teachers assume this promotional event had some impact on parents and children in the scheme of a market-

oriented system. This is not surprising because it wouldn't make much sense for teachers to do this marketing-type work without believing in its effectiveness.

Conversely, when this study analyzed the parent and student perspectives toward the promotional activity of open house, the picture became more complex. The significance of open house in the school-choice process by parents and children, shared by many parents worldwide, seems to be that open house is a source of information, and many don't consider it to be of high impact on school-choice decisions. In the Oplatka (2007) study, many of the parents in the study pointed to the similarity between school open houses with respect to messages and organization. This contributed to the low impact open house had on their reasons for making choices.

There are other factors that influence choice and satisfaction, such as proximity to home, a student's background, peer pressure or the desire to be with friends, and/or the community's belief in whether an individual school will meet the student's long-term goals. However, in the most practical sense, it is suggested that school staff place more emphasis on the role of feelings and emotions in a school's promotional activities. Creating a friendly, personal, and intimate atmosphere during open house is likely to engender positive responses and attitudes among visitors that have a positive influence on choice.

Creating welcoming and friendly environments accompanied by reliable messages and information during open house promotes and stimulates a comforting and positive state of mind. It fills the visitor with a feeling of personal and supportive teaching and caring that are both signs and symbols of what parents consider good and nurturing schooling.

The participation of current students in presentations adds to the intimacy that creates an emotional attachment between the students and prospective students, which increases the positive feelings and trust in the school's ability to deliver a nurturing environment. The more desired outcomes are brought about by tours, evidence of caring teachers, and generally more human interaction rather than sitting through long speeches by administrators.

Precautions and Possible Pitfalls

Many educators feel that the parents' and children's school-choice process is more driven by emotion and symbolic factors rather than more rational considerations filled with educational jargon. However, it is also important to provide parents with clear information on the instructional processes and the teacher and school support that take place in the school and classrooms.

An unwanted side effect that can easily occur at open houses, especially at the elementary school level, is that in an attempt to market the

school, individual teachers can find themselves in competition with each other. Teachers do their best to present their classes and programs to their advantage, and parents wandering from class to class find themselves comparing teachers, ultimately wanting their child in a particular teacher's class. School administrators are wise to set some parameters to try to decrease individual "teacher shopping" while still allowing the parents to see the entire school in a positive light.

Unfortunately, when the school-choice selection is not a result of the accurate flow of information about schools but rather emotional or symbolic understandings, it is unlikely that school competition for students will lead to improvement and greater effectiveness in education.

Source

Oplatka, I. (2007). The place of the "open house" in the school-choice process. *Urban Education, 42*(2), 163–184.

Strategy 4: Learn what your teacher education program didn't tell you about parent conferences. Get help from knowledgeable colleagues, master teachers, or a college or university supervisor.

What the Research Says

A questionnaire was developed to determine preservice program requirements relative to information and skills for parent–teacher conferences. A total of 136 teacher education institutions were questioned, and 124 institutions responded. The percentages of those that frequently required preparation for parent–teacher conferencing were as follows:

- Elementary: 59%
- Early childhood education: 57%
- Special education: 44%
- K–12/All levels: 42%

Nineteen percent of the responding institutions provided and required a separate course for parent–teacher conferences. Seventy-five percent indicated that these skills are taught in a methods course context. Seventy percent included parent–teacher conferencing content and skills in field-based experiences.

Despite renewed emphasis on parental involvement, the investigation found that preservice programs did not consistently identify parent–teacher conferencing skills as a major instructional objective. Field-based experiences address the topic but appear hindered by school policies in actual conferences with preservice teachers.

Classroom Applications

If, as a new teacher, you do not feel prepared for parent–teacher conferencing, you are not alone. Many veteran teachers avoid and are not comfortable in these situations and, many times, view them as adversarial or confrontational. Experience is the best teacher. If a beginning teacher does not receive a background in and a basic understanding of parent–teacher communication techniques, he or she may need to look for other sources of information on effective strategies. Learning on the job by acquiring information from colleagues can be helpful. Teachers can also search academic literature, where there is an extensive knowledge base.

Parents come to the table with their own agenda, and the teacher is usually there to react to their concerns. Occasionally, a teacher can react positively to their concerns about the student. However, most of the time, teachers are in a position that requires them to mitigate and litigate the student–teacher or student–curriculum–pedagogy relationship. Occasionally, the teacher is called to defend his or her practices. Here is a list of suggestions that can help.

- Collect phone numbers (including work phone numbers) and addresses, and put the information on file cards. This lets students and parents know the teacher is willing to be proactive in communicating with home. If a student's last name is different from his or her parents, making sure the correct last name is used can be critically important in establishing rapport from the beginning of the conversation. Identify early which parent the students would like the teacher to communicate with. Young students, in Grades K–3, shouldn't make this choice. In most cases, the class size at this grade level is smaller, and the teacher can determine early on which parent is the one to call first.
- Let parents know how they can best reach the teacher, through telephone calls, e-mail, or other strategies. Teachers can send the information home by mail or announce it during open house. The smart teacher will create a returnable parent acknowledgment of receiving the information and reward the student.
- If appropriate, the teacher can make his or her calls during school hours with the student present. After the teacher has spoken to the parents, parents often want to talk to their son or daughter. This

works well with behavior problems. Students usually want to avoid these situations. Once a new teacher does this, the rest of his or her class will quickly get the message that parental relationships are important to the classroom teacher.

- Teachers should acknowledge potential trouble early and be proactive. The teacher can avoid getting calls by making calls home first. It's common for the first call to be made to someone in administration. Often a call at the first sign of trouble can clear up misunderstandings early and avoid further involvement by the administration.

- It is important to realize that the classroom experience the student takes home is filtered through the mind of that student. Students generally advocate for themselves first. Teachers need to itemize and break down the potential issues ahead of time, role-play the potential conversation, and prepare a response. Acknowledge the concerns parents bring and prepare to redefine them from your perspective. It is helpful to remember that the teacher and parents are on the same side, as collaborators in the students' education.

- As a "new teacher on the block," try to talk to counselors, administrators, or other teachers familiar with the student and parents before making calls or conferencing with parents. Sometimes even veteran teachers need help in dealing with certain parents. Teachers shouldn't put themselves in a position to be ambushed. If a teacher is really worried, it is perfectly OK to have a counselor or administrator familiar with the parents present and let the parents know they will be there.

- Sometimes it might be better for a teacher to let others familiar with the parents and students make the call. The teacher can then set up a conference if necessary. A teacher shouldn't see this as a sign of weakness; it can be the best strategy. A vote of confidence directed toward the teacher by a trusted counselor or administrator can get around the school community quickly and begin to build the new teacher's reputation as a caring and effective teacher and communicator. This can be a really necessary strategy for non-English-speaking parents.

- Once in a parent–teacher conference, the teacher should start the conference by listening carefully to what the parents have to say. Having itemized grades, lessons, handouts, student work, and so on will help. The teacher can then break down parental concerns and carefully address each one individually. Being organized and prepared with potential solutions to the problems a teacher expects to hear ahead of time can reap rewards in increased communication and rapport with parents.

- Letting supervisors know ahead of time about problems that could spill over into their laps allows teachers and supervisors to work

on strategies together. Giving the supervisor copies of relevant materials (classroom policies, copies of tests, etc.) in advance so they are brought up to speed can help make the new teacher's job easier.

Precautions and Possible Pitfalls

 Many times parent conferences turn out to be hugely successful. However, they can also turn sour. Occasionally, parents simply will not be there for the teacher or for their son or daughter. They may not have control over their relationship with their child, and sadly, phone calls home and parent conferences may be lost causes in some cases. However, they are still necessary in order to establish the fact that the teacher is willing to work with the parent for the good of the child. Counselors can often alert the teacher to situations where conferencing won't help. A teacher could end up listening to the parent's problems and never really resolve the issues with the student. In these cases, the teacher will need to follow through on the paperwork required by the school or district, such as sending home notifications. However, sometimes teachers may need to accept the fact they are on their own and need to come up with strategies that don't include the parents.

Sources

Henderson, M. V., Hunt, S. N., & Day, R. (1993). Parent-teacher conferencing skills and pre-service programs. *Education, 114*(1), 71.
Rabbitt, C. (1984). The parent/teacher conference: Trauma or teamwork. *Phi Delta Kappan, 59*, 471–472.

 Strategy 5: Develop strategies to involve those hard-to-reach parents, and take the time to meet parents where they are to form meaningful parent–school partnerships.

What the Research Says

Two Los Angeles subdistricts are making significant efforts to involve parents in the education of their children. Although language and cultural barriers make it difficult for parents to get involved, these schools have developed programs that "meet the parents

where they are" rather than excluding them (Jacobson, 2002). Notable methods focus on achieving school academic outcomes and include

- Interactive homework sessions in which teachers teach parents and students key concepts
- Math Nights and other Open Nights focusing on family learning
- Learning Walks, where parents visit classrooms during the school day
- Computer literacy and immigration classes for parents
- Mother–Daughter College Prep, where mothers learn how to prepare their daughters to be the first generation in their families to attend college
- Tea for Ten, where parents of successful students share their methods
- Cross-mentoring, where parents of struggling students mentor other students who are having trouble while another parent mentors their child

Classroom Applications

 Most parents want to have a positive relationship with their children, and many have a strong desire to help children succeed at school. However, many parents also feel uncomfortable with their abilities when it comes to offering academic support—particularly at the school level. By taking the time to understand the ethnic or racial culture and experience of the specific parents at their school, teachers can determine the best program to meet parents' abilities and needs. The first step should be to conduct an informal survey or assessment of the situation. Small, single-meeting activities will often yield more positive results than large parental events, until parents become more comfortable attending and interacting. Another strategy to consider is offering a parent–student homework support session focusing on a single academic subject or specific project. Some teachers may be comfortable establishing a Web site where parents can check grades and course assignments. These Web sites can also feature links to tutorials and other Web sites parents can use to become familiar with content concepts. For example, there are math Web sites that feature excellent tutorials for math content basics. Finding the right level of involvement for parents and teachers is an individual and ongoing process.

Precautions and Possible Pitfalls

Avoid making the mistake of evaluating a program or event on the basis of the number of parents who attend. People lead very

busy lives and are often unable to follow through with all the things they would like to. Communication practices can cause limited parent attendance at events. Phone calls are the most effective way to inform parents. Beware the backpack flyer; often the information doesn't end up in the hands of the parent, especially after the intermediate grades. In addition, some cultures view teachers as the ultimate authority and do not question what the school does. In these cases, lack of attendance should not be misinterpreted as lack of support. Any effort teachers make to involve a student's parents in their education will have a positive effect.

Source

Jacobson, L. (2002). Putting the "parent piece" in schools. *Education Week, 22*(5), 1–4.

 Strategy 6: Learn how some parents succeed in managing their children's education, and develop strategies to help parents help their children to succeed academically.

What the Research Says

Gutman and McLoyd (2000) used open-ended questioning techniques to examine variations in parents' management and organization of their students' education within the home, at school, and in the community. The goal was to define parent behaviors typical of successful students and contrast them with students experiencing behavior and academic problems. Questionnaires focused on how parents' encouragement of educational activities differed between high-achieving and low-achieving students, and research explored how these activities differed. This investigation also examined the frequency of parents' school involvement and the different reasons for involvement. Lastly, researchers explored the frequency of children's extracurricular and religious involvement inside and outside of school and how it was different for both groups. They also looked at why parents manage or fail to manage these activities.

Gutman and McLoyd (2000) found that parents of high achievers used more specific strategies to help their children with their schoolwork. They also had more supportive conversations with their children than parents of low achievers. In the community setting, parents of high achievers not only were more involved but also had different reasons for their involvement than parents of low achievers. Parents of high achievers explicitly engaged their children in more activities to support their achievement.

The sample included information from 22 elementary schools and 10 middle schools with 42% African-American students and with 84% of the total students involved in a reduced-fee or free lunch program. To select a subsample to identify high-achieving and low-achieving students, student grades were collected from school records, and groups were defined.

Classroom Applications

More parents of high achievers reported being involved in their children's school than parents of low achievers. The parents of high achievers were also involved in different ways, with more checks on progress as well as checks just to maintain contact. In contrast, parents of low achievers were involved with their students more for misbehavior or poor work. While both groups reported helping their children, parents of high achievers reported using more specific strategies to assist their children. This is where teachers can help. Communicate to parents how they can best help their students with content goals in specific assignments.

In this study it was common for parents of low achievers to discuss their personal barriers to the management of their child's activities and academic achievement rather than focus on their child. Teachers have to package any strategies they want to communicate to parents keeping this notion in mind.

According to Clark (1983), students often perceive their parents' involvement in school as evidence of continued parental expectations for school success. Students reported that their parents accepted some responsibility for student performance and success at school.

Teachers, schools, and communities can support low-income families with low-achieving students in many ways. Schools and teachers can help parents to help their students by organizing practical programs that give parents the necessary skills to prepare their children for specific classroom activities and lessons. For example, when assigning long-term projects, teachers might include suggested activities and assignments in a "parent" section and suggest sources of information or other resources, including lists of TV programs that could support the curriculum. Teacher Web sites, while not always available to all parents, also can help by providing class and school information.

Teachers can also promote positive interactions with parents through recognition of their involvement as a valuable resource for their children's achievement. To encourage parental involvement, teachers can stress positive developments over problem areas whenever possible. Take-home messages on paper or phone calls can help connect parents positively to school.

Teachers may want to offer suggestions for programs that don't rely on parental participation or permission for student involvement. Promoting the school's extracurricular programs and activities, not just to students

but also to parents, can increase student participation. The effort should be made to make these programs accessible to parents with hectic lives.

Another option is to develop a "home–school agreement" that can raise standards and contribute to school effectiveness by enhancing partnerships between parents and teachers. Home–school agreements can provide a framework for the development of such a partnership and set clear expectations for the nature of the partnership. The processes involved in introducing and reviewing the agreement will clarify what the school is trying to achieve, and the agreement will establish the role of the school, parents, and pupils in this vital partnership.

Provided that staff, pupils, and parents have been consulted effectively when drawing together the agreement, it should successfully build on existing working relationships between home and school. The partnership promoted by an agreement should result in

- Better home–school communication (for example, on issues such as pupil progress, information on what pupils will be taught, homework, and domestic concerns that may affect the pupils' ability to learn effectively)
- Parents and teachers working together on issues of concern (for example, aspirations, expectations, behavior, bullying, and drug education)
- Parents supporting and helping their children's learning at home more effectively
- The identification of issues that need to be addressed through the School Development Plan

The clarification of roles and responsibilities in a home–school agreement, supported by effective home–school policy and practice, should generate high expectations, parental encouragement and support, and strong home–school links. It is another layer of responsibility for the teacher, but once established, it is easy to modify and adjust as the years pass. Experience tells teachers what works best and what doesn't work.

Precautions and Possible Pitfalls

Some of the suggested strategies will make it easier for parents to become engaged in positive ways with their children's academic experience. However, there will be parents who still don't respond. Children of these parents need to be included to prevent them from feeling left out or somehow less worthy than other students. Too much touting of parental involvement can be hurtful for those students. Be careful to be sensitive to the needs of students whose parents may not be participating.

Sources

Clark, R. M. (1983). *Family life and school achievement: Why poor black children succeed or fail*. Chicago: University of Chicago Press.

Gutman, L. M., & McLoyd, V. C. (2000). Parents' management of their children's education within the home, at school, and in the community: An examination of African American families living in poverty. *The Urban Review, 32*(1), 1–24.

> **Strategy 7: Be aware that there is a correlation between a teacher's effort and class size and how these factors play a part in how and when parents support their children at home with schoolwork.**

What the Research Says

Bonesrønning's (2004) research explored whether parents provide more or less help to their children when classes are smaller or larger. The study found that parents provided their children with more help with homework when class sizes were small. The study also suggested that parents' effort was related to teacher effort (that is, as teachers increased their effort, so did parents). Parents of girls gave more help with homework than parents of boys and responded more to changes in class size. Parents tended to provide less help with their children's homework when class sizes increased, particularly when class sizes increased from a low number of pupils. The evidence for these conclusions was based on a mix of questionnaires for pupils and assessments of their learning.

Ninth-grade students (ages 14 to 15) from 123 schools in five counties with the largest variation in expenditure per student in Norway took part in the two-year study. The students were tested in mathematics and Norwegian language at the start and end of the school year; 2,815 students participated in the first test and 1,684 of the students participated in the last. The students also answered two questionnaires, one year apart, about their preferences, their time usage, their family background, and their teachers, but in particular about their parents' involvement in education-related activities. They were asked to indicate, on a four-point scale from *never* to *very high*, how often

- they asked their parents for help with homework,
- their parents controlled their homework,

- they discussed subject-related issues with their parents, and
- they spent leisure time with their parents.

Here are the links this study found between class size and parental help with homework.

- There was significant evidence that parents with children in small classes provided more assistance with homework than parents with children in large classes.
- Parents provided less help with homework when class sizes increased, and increasing class sizes from small classes affected the amount parents supported their children more than increasing classes from large sizes.
- The relationship between parental effort and class size was significant for girls, but there was no evidence that the parents of boys responded to class size changes, providing indirect evidence that the parents' responses to changes in class size were linked to their children's responses to class size changes.
- Girls received more parental support with homework than boys. The boys may have underrepresented the parental assistance they received, but similar gender differences were apparent in their performance, and the researcher felt that reflected underlying gender differences related to effort.
- Students with two parents and few siblings received more parental support than other students.
- Well-educated parents (identified by the number of books at home) gave high levels of support, but parental response to class size was not conditional upon their educational level.
- Parental support was compensatory. Students who performed poorly on the first mathematics test received more assistance and monitoring than well-performing students.
- If teacher monitoring of homework was well below the sample average, parents responded to class size increases by increasing their own efforts, but when teacher monitoring was average or above, parents responded to increased class size by decreasing their efforts, indicating that teachers may be able to manipulate the relationship between class size and parental effort.

Classroom Applications

 This study could help practitioners reflect on the involvement of parents in their children's education and how they could influence parental support. It also frames the question about when and under

what circumstances teachers should exert the most effort in enlisting parental assistance. In completing this research, the authors began to ask the following questions about implications for practitioners:

- Would professional development help teachers in your school find and share ways of motivating students in large classes to do their homework and obtain their parents' support, such as designing interactive homework assignments that involve students in demonstrating or discussing homework with a family member?
- Could your school support teachers of large classes to set and mark homework when there is likely to be an increased volume of marking to do as a consequence of teaching large classes?
- Would it be helpful for your school to offer workshops or discussion groups to give practical tips to parents about how they could help their children with their homework? You might focus, for example, on study skills such as organization, time management, and active study strategies.
- Would teachers and parents find it helpful to reflect on how both private and public time can be harnessed to support homework positively for parents of large families?

Intuition suggests that if children, their parents, and their teachers exert more effort, the academic performance of the children improves. There are questions about which source of effort affects academic performance most. This includes gender and age issues. The research did not test any of these solutions to the phenomena of less parental effort with children in large classes. In many schools in the United States, the class size gets larger as the students get older. In California, there is a significant difference between class size in Grade 3 (20 students) and Grades 4 and up (32–35 students). Upper-level teachers have far more student contacts and student needs and, by necessity, have far more paperwork than lower-grade teachers. It would be a boon to upper-grade teachers if it were possible to solicit more help from parents by working with colleagues, administrators, and parents to increase the amount of help students receive on homework.

Working harder to support learning and parental involvement in large classes seems like the logical solution to class size problems. Determining exactly how to do that is the challenge for teachers. Hopefully this discussion will help teachers begin to solve some of the consequences of larger class sizes.

Precautions and Possible Pitfalls

This is not necessarily about having to do more work. This is about taking your knowledge about the phenomena and working smarter. Once you upgrade your responses to larger class sizes, the techniques that you develop will serve you the next year and the following years. Teachers should not become discouraged—just more precise in how their instructional techniques and parental involvement strategies are applied.

Source

Bonesrønning, H. (2004, February). The determinants of parental effort in education production: Do parents respond to changes in class size? *Economics of Education Review, 23*(1), 1–9.

2

Teachers, Students,
Families, and Homework

Sex education may be a good idea in the schools, but I don't believe the kids should be given homework.

—Bill Cosby

I like a teacher who gives you something to take home to think about besides homework.

—Lily Tomlin as "Edith Ann"

 Strategy 8: Engage in fresh dialogue with all stakeholders about homework trends as they relate to teachers, parents, students, and others to make homework a more important, vital, and valid part of your academic standards.

What the Research Says

 Gill and Schlossman (2004) examined homework's place in U.S. schooling over the last century. Their work is a review article that looked at homework trends within the overall

homework paradigm. Their three main conclusions were: First, homework always has a contested notion that has aroused passion both pro and con. Second, despite press reports to the contrary, most parents consistently supported homework over the last 100 years. Third, homework practice is slow to change. However, increases in homework after the *Sputnik* era suggest it is not unmovable. Finally, the researchers state that the academic excellence program of the last 20 years has succeeded in raising the homework expectations for only the youngest students.

Classroom Applications

Today, stakeholders involved in the discussion on homework debate many of the same issues: too much or too little, too easy (busy work) or too hard, a motivating factor to student achievement or a student's alienation, a sign of good teaching or incompetence, a character developer or a factor in the loss of self-esteem, too demanding of parents or not demanding enough, a key to global economic competition or senseless, mindless inertia. To these issues, add the role of the parent and the uneven homework environment and resources in the homes of your students. Once leaving your classroom, your students encounter many things that you as a teacher can't control. At this point a short historical homework perspective can help provide a context for your own thinking.

Homework was not often seen as a problem in the nineteenth century (Gill & Schlossman, 1996). It was mainly limited to high school students. Students averaged two to three hours a night and on weekends. Attendance laws extended to those ages 14 and below. Only a small part of the population chose to attend high school. Educators collectively felt that those who were willing to attend school must be willing to study. Homework in the elementary grades (Grades 1–4) was rare. In grammar school (Grades 5–8), pedagogy stressed drill, recitation, and memorization and thus required students to sustain preparation time at home. This style of learning and amount of homework was often burdensome for families.

The progressive education movement of the late nineteenth and early twentieth centuries prompted a new discourse on homework. The greatest concern was focused on homework in Grades 4–8 as homework assignments in the earlier grades were rare. The focus was on the practices of drill/memorization and recitation. A number of public groups saw this type of learning as a threat to the physical and mental health of preteens. In the most intense era of progressive education, the 1920s to the 1940s, homework continued to enter the public discourse and receive considerable attention. It would not receive the same attention again until the publication of *A Nation at Risk* (National Commission on Excellence in Education, 1983). A few communities dropped homework altogether, and others restricted homework between the late elementary and junior high years. The early

grades were still spared. Again homework was deemed a health hazard. Arguments centered on the notion that homework threatened health by limiting the amount of outdoor playtime seen as important for development. This was especially true for elementary and junior high students. To continue the argument, critics lamented the loss of other afterschool activities such as music lessons and other nonschool learning activities.

Others argued further that homework even failed to improve learning or meet its own academic expectations, especially in the pre-high school demographic. With very few exceptions, critics concluded that homework provided no value until high school. According to Gill and Schlossman (1996), parents appeared to have accepted and supported homework no matter what the media and experts told them otherwise. Parents did not typically enthusiastically support large amounts of homework, but they did want their children to spend some time daily at home with school assignments.

According to Gill and Schlossman (1996), parents of children in Grades 1–8 approved of homework by a 78% to 22% margin. They expected at least 15 minutes of homework to begin in early first grade and expand to one hour in the late elementary school years. Parents believed homework fostered good character traits, kept children home at night, and helped parents maintain involvement in their children's school and education. A 1948 Purdue Opinion Poll, at the end of the progressive education period, found only 8% of high school students did more than two hours of homework at night with the average coming in at less than one hour per day. Based on these numbers, we can predict that even less was done in the early grades.

In the 1950s and 1960s, the progressive education movement was gradually replaced with the academic excellence movement that stressed high standards and basic subject matter instruction. Emphasis and attention to homework became an important part of the Cold War strategy that made education central in meeting the threat of the Soviet Union and military superiority. This became especially true after the launch of *Sputnik* in 1957. Homework discourse became rehabilitated and reformed. Many believed that Russian children were smarter and were working harder in school. The negative reaction to too much homework earlier in the century was replaced with the notion that not enough homework was being done. Favorable views began to emerge from academic studies in the 1950s and 1960s.

Research and politics began to lead to a reemergence and rehabilitation of homework as a routine element of teaching and learning. As higher and tougher standards emerged, the limits on how much homework teachers could assign were reduced and the norms of the earlier homework paradigm changed. The academic excellence movement had replaced the progressive movement, and the ratcheting up of homework norms replaced the negative views of the 1940s. The chief arguments of the reforms were

that homework was compatible with the principles of academic excellence and progressive education. Schools could not aspire to higher standards of learning and teaching by going backward pedagogically. The Purdue Opinion Polls during the 1950s and 1960s (Blumenfeld, Franklin, & Remmers, 1962; Remmers, Horton, & Scarborough, 1952) showed that students began to do more homework and that the proportion of students doing more homework increased. The cultural and political forces associated with the Cold War had their effect. Before then, many parents did not see low homework rates as a problem, but because they had always supported homework more than the professional academics, parents generally approved of the increases in homework in the post-*Sputnik* era.

The period between 1968 and 1972 fostered declining educational standards (Gill & Schlossman, 1996). Homework discourse was replaced as a hot button issue with bigger classroom concerns. There was an overall decline in student attendance, respect for teachers, and education in general. These declining standards started a new academic excellence movement that led to the "back to basics" movement. *A Nation at Risk* sounded the call for this new excellence movement in 1983. *A Nation at Risk* brought homework back into the national debate by calling for far more homework, selling it both as a character-building exercise and as promoting international competitiveness. A nationwide poll in 2000 (Public Agenda, 2000) found that only 10% of parents believed their children had too much homework.

Over the last 100 years of the pedagogical strategy called homework, it is clear that the notion of homework has a passionate history. Opponents have exaggerated its harms and limits, and its supporters have exaggerated its benefits. And, despite media coverage to the contrary, evidence suggests that most parents consistently support homework. Generally, homework strategies and practice are slower to change than public and expert opinion. The *Sputnik*-era academic excellence movement, however, did produce a rapid change. Movements to increase homework in the middle schools and high schools, areas thought to the most beneficial, have been neither substantial nor sustained. Gill and Schlossman (1996, 2004) believe that teenagers do very little homework and that most 17-year-olds do no more than 13-year-olds. They state that the last 20 years of the academic excellence movement have managed to raise homework expectations only in the youngest children. They go on to suggest a fresh look by teachers, parents, students, and scholars about how to make homework a more valid, vital, and important part of setting high academic standards for all students.

There is still the chicken and egg question that comes when you say that while students who do more homework may get better grades, there is little research to connect homework with improved student performance. Whether we can answer this question or not, right now, schools are under extraordinary pressure because many political and business leaders view our educational system as crucial in giving students the skills that will allow

them to be more effective participants in the job market. They view the job market as increasingly internationalized and ever more competitive.

Unfortunately, many are unwilling or unable to examine the way business practices, international organizations, and trade treaties have shaped the very terms of this competition. Thus, the pressures on schools and teachers often have been passed on to students and parents. Students are tested more, and teachers are under the gun. To meet these intensified requirements, more homework often is seen as one of the key solutions.

But in addition to this concern growing out of political economy, the issue needs to be viewed from a broader cultural perspective. One could say that homework is a part of larger cultural wars. In their workplaces, workers are constantly encouraged to "do their homework," and in school, children are told that homework is "part of their job."

These cultural practices are a response to cultural anxieties. Americans increasingly have a kind of love–hate relationship with work. Work is viewed as one of the central meanings of life, but at the same time, it now takes so much of many adults' lives that there is little room for anything else. And at least on some level, doubts have crept in as to the limits of work itself. Although the debate about homework involves genuine pedagogical issues, one cannot fully understand this issue or the heat surrounding it without some attention to this cultural civil war over whether work is to retain its all-encompassing place in our culture.

For teachers, it is key that they understand that what parents do at home has a critical influence on their children's success in school. Beyond working with students on your homework instructional goals, it is key for parents to be involved in the discussion. And at times, teachers need to help parents learn how to become involved. Finally, after more than 100 years of homework, the research shows that parents will support thoughtful and valid homework as an instructional tool. The trick is to know what that looks like.

Precautions and Possible Pitfalls

History suggests that parents are firmly behind schools in expecting homework to be part of the learning experience. It's really up to the teachers to make it valuable to the students and to communicate its value to parents. It is also important for teachers to empower parents to provide a home environment that helps facilitate homework success. Remember that once students leave your classroom, the academic playing field is not level for all students. Some homes have the resources, and others don't.

Gill and Schlossman (2004) feel that homework has increased for the very youngest, and most parents of kindergartners through second graders, many of whom are dealing with homework for the first time since they were in school, will tell you that they feel this increase in expectations. Since most

of this homework cannot be done independently, as young children are capable of very little independent practice, teachers should be aware of the perception of parents that the homework is for them, not the kids. Teachers of kindergarten through second grade should have good communication with parents about homework, and parents should be able to readily recognize the value of a particular assignment.

Finally, homework should be designed to facilitate improved student performance within other aspects of academic success, not just improve grades by turning it in. You really need to balance instructional goals and how big of a role homework plays in evaluation and grading versus other forms of assessment.

Sources

Blumenfeld, W. S., Franklin, R. D., & Remmers, H. H. (1962). *Teenagers' attitudes toward study habits, vocational plans, religious beliefs, and luck* (#67). Purdue Opinion Panel.

Gill, B. P., & Schlossman, S. L. (1996). A sin against childhood: Progressive education and the crusade to abolish homework. *American Journal of Education, 105*, 27–66.

Gill, B. P., & Schlossman, S. L. (2004). Villain or savior? The American discourse on homework, 1850–2003. *Theory Into Practice, 43*(3), 174–181.

National Commission on Excellence in Education. (1983). *A nation at risk: The imperative for educational reform*. Washington, DC: U.S. Government Printing Office. (ERIC Document Reproduction Service No. ED226006)

Public Agenda. (2000). *Survey finds little sign of backlash against academic standards or standardized tests*. New York: Author.

Remmers, H. H., Horton, R. E., & Scarborough, B. B. (1952). *Youth views purposes, practices, and procedures in education* (#31). Purdue Opinion Panel.

> ☑ *Strategy 9: Parents need to know that homework provides students with time and experience to develop positive beliefs about achievement and with strategies for coping with setbacks and difficulties.*

What the Research Says

 Bempechat (2004) argues that, as a pedagogical practice, homework plays a critical, long-term role in the development of students' achievement motivation. The article reviews current research on achievement motivation and examines the ways parents and

teachers encourage or inhibit the development of adaptive beliefs about learning. In addition, the article integrates and engages the literature on homework and achievement motivation and shows that homework's motivational benefits, while not obvious to some, have been in evidence for some time. Finally, Bempechat argues that homework is a vital means by which students can learn to be self-directed, mature learners once leaving school.

Classroom Applications

 If you believe in homework as a learning tool and have a written message to parents about homework, you need to include Bempechat's less tangible benefits of doing homework within your policies that you use to communicate with parents.

Many arguments against homework point to the fact that research has produced inconsistent findings and that homework's impact on achievement, especially in the lower grades, is unclear. They argue that if there is no connection between achievement and homework, why engage in a practice that can produce conflict between parents and children and interfere with a child's development in other, more family-oriented nonschool activity? Why burden working parents and low-income parents with few resources for helping their children?

Bempechat (2004) answers these concerns and states that teachers need to develop and maintain appropriate standards of performance for their students via well-planned and well-developed homework assignments. She argues further that under the guidance of adults who challenge the intellectual growth of students, homework provides students with the training they need to develop achievement beliefs and behaviors beyond just the supporting or reinforcing of the current curriculum. Finally, she adds that all children, affluent and low-income, need to be pushed with high expectations rather than be pitied as they struggle to become mature learners.

Teachers sometimes have students that earn good grades by doing homework assignments while earning low grades on class tests. In contrast, some students do well on tests and rarely do homework assignments, and their grades reflect this. Ultimately, if you believe in Bempechat's argument, you will need to help parents believe it as well.

Parental help and respect for your homework policies will only come if what you assign has observable value in the parents' eyes. The more relevance and value parents see in your homework assignments, the more support you will receive. Consider including in your syllabus or other communication with parents the following caregiver suggestions regarding homework.

- Reward time spent and progress; use lots of praise and share your child's work with others.

- Help your child develop a homework schedule that works for both of you.
- Provide a suitable place for study and, if possible, make it quiet and away from distractions.
- Avoid making homework a punishment.
- Talk to your child every day about homework assignments, go over the work, see if it is complete, ask questions about it, and authentically engage in helping your child, but don't do the homework yourself.
- Find out how much and what type of homework is being assigned in each class, what standards have been set for assessment and evaluation, and the due dates. Find out what your child is to do when they don't understand something, and help them manage the workload.
- Have high expectations for your child's learning and behavior, both at home and at school.
- Be a role model in getting work done before play.
- Establish routines in the home and limit afterschool jobs and activities.
- Encourage your child to share information about the school and respond with empathy.
- Read to younger children or have them read to you every night. Encourage older children to read by reading yourself and by having interesting and appropriate material available at home.
- Contact your child's teacher to learn specific strategies to help with homework.

Parents need to know that at-home learning activities such as reading or reading aloud with frequent family discussions are activities that, according to research, improve student achievement. Research also has shown that sustained reading at home, in its various forms, works better than small-group instruction with a reading specialist. Literacy crosses all discipline boundaries and benefits learning in everyone's classroom.

Precautions and Possible Pitfalls

No real pitfalls here. This just bolsters your argument for including homework as a learning tool within your instructional strategies. But realize that some parents will not always share your values, and they will transfer their beliefs to their child. This may set up a clash of values between you and the parents. The best you can do is to back off to reduce the stress and conflict that the child might be feeling.

Source

Bempechat, J. (2004). The motivational benefits of homework: A social-cognitive perpective. *Theory Into Practice, 43*(3), 189–196.

Strategy 10: Take a fresh look at how the concept of homework can present unexpected problems for students and families.

What the Research Says

A book by Etta Kralovec and John Buell (2000) presents a unique view of the homework concept and questions the value of the practice itself. Few studies have been conducted on the subject, and while the book offers perspectives from both sides of the debate, it is clear that the homework concept needs to be examined more closely. For example, the authors cite homework as a great discriminator because children, once leaving school, encounter a range of parental support, challenging home environments, afterschool jobs and sports, and a mix of resources that are available to some and not to others. Clearly, opportunities are not equal. Tired parents are held captive by the demands of their children's school, unable to develop their own priorities for family life.

Kralovec and Buell (2000) provide examples of communities that have tried to formalize homework policy as they tried to balance the demands of homework with extracurricular activities and the need for family time. They also point out the aspects of inequity inherent in the fact that many students lack the resources at home to compete on equal footing with those peers who have computers, Internet access, highly educated parents, and unlimited funds and other resources for homework requirements. They also point out that homework persists despite the lack of any solid evidence that it achieves its much-touted gains. Homework is one of our most entrenched institutional practices, yet one of the least investigated.

The big questions that Kralovec and Buell (2000) explore are: With single-parent households becoming more common or with both parents working, is it reasonable to accept the homework concept, as it is now practiced, as useful and valid considering the trade-offs families need to make? How does homework contribute to family dynamics in negative or positive ways? Does it unnecessarily stifle other important opportunities or create an uneven or unequal playing field for some students?

Classroom Applications

Consider the inequalities that may exist in the range of students in your classes regarding their ability to complete homework assignments. Certain students may be excluded from the opportunities for support and other resources. Consider the following questions when developing a philosophy or policy:

- What is homework?
- How much homework is too much?
- What are or what should be the purposes of homework?
- Can different assignments be given to different students in the same class?
- Do all your students have equal opportunity to successfully complete the homework?
- Who is responsible for homework, the students or the parents?
- Do all your students have the same capacity to self-regulate?
- How are other school activities or family-based responsibilities factored in?
- What is the best and most equitable way to deal with overachievers?
- Is the homework load balanced between teachers?

Further consideration should be given to the following points and tips:

- Integrate the homework activities and expectations into your curriculum planning. Ensure that the tasks are an integral element of your coursework, and build feedback from the homework into a following lesson.
- Explain to parents and caregivers why you need their assistance. Parents and families need to understand why their involvement is helpful, as some believe schools expect pupils to complete homework entirely independently. A range of approaches may be required to explain, to as many parents and caregivers as possible, what you are proposing. This might include contact by telephone, personalized letters, specific meetings (consider venues other than the school), using the support of other agencies and community contacts, and so on.
- Stress that education is a shared responsibility between home and school. Homework can provide an ideal vehicle for establishing such a working partnership. Explain to parents that what happens out of school has a significant impact on children's performance in school—the assistance of parents or caregivers is essential to ensure that pupils perform to the best of their ability.

- Reassure parents that no specialist knowledge is required. Assure them that what is important is simply the time they give to their children and the discussion involved—pupils take the role of the teacher and explain what's expected. This is an important learning exercise for the pupil.
- It need not be the parents who help. Any trusted person (brother, sister, grandparent, neighbor, etc.) may be the source of support. It can also be a different person each time.
- Place equal value on the contribution of all parents. Often, positive support comes from homes where previous contact may have been limited. Don't underestimate the contribution of any family.
- Encourage the use of the language of the home. Homework tasks can be discussed or undertaken in any language. This should be encouraged.
- Be realistic about how frequently you can call on the support of parents or caregivers. It is essential not to place too many demands on the goodwill of the home—it can easily be lost. Give consideration to how frequently these homework tasks should be set. Consult colleagues about the demands they place upon parents.
- Value the responses from the home. It is important to ensure that the completion of these tasks is valued. If practical, display homework in a prominent place, in or out of school.
- Evaluate the homework activities with the pupils and their families. This can be done with questionnaires, homework diaries, your record sheet, or even the pupils' exercise books. Problems and successes need to be reviewed. A meeting can also be arranged to listen to the views of the parents and consolidate working practices.
- Sustain the commitment of families. End-of-term thank-you letters to families can give homework activities a high profile. Also acknowledging the homework responses through assemblies, school newsletters, and displays can help.
- Share the outcome of your practice with colleagues. It is important that all colleagues are fully aware of homework activities and the benefits that ensue.
- Consider a training day focusing on homework. A ten-minute overview of homework philosophy and expectations on a packed Back-to-School Night agenda isn't sufficient, especially for the parents of young children just entering the school system. A parent training day (or evening) may provide a valuable opportunity to broaden the base of support for your homework links with parents.

Finally, the National Education Association (NEA) has a Web site (http://www.nea.org/parents/homework.html) you can recommend to parents that offers some very good information.

Precautions and Possible Pitfalls

 Homework is still a contested paradigm, and teachers need to have their own philosophy and be ready to engage in conversation with parents and administrators. Traditionally, homework has been seen as a solution to educational problems rather than the cause. It takes a little bit of time to acclimate to the homework paradigm and to look at it with new eyes. Be careful of the politics involved in any discourse regarding the homework concept.

Source

Kralovec, E., & Buell, J. (2000). *The end of homework.* Boston: Beacon Press.

Strategy 11: Reflect on struggling students' homework difficulties when working with elementary school learners and their parents.

What the Research Says

Margolis (2005) identifies several causes of struggling learners' homework difficulties and explains how teachers can help struggling learners in elementary school succeed with homework and help parents who want to help their child with homework. He explains how elementary teachers can use listening and problem solving to secure parents' cooperation and jointly solve complex homework problems. Margolis is a professor and coordinator of special education at Queens College of the City University of New York and draws upon past research and academic literature to support his suggested strategies and techniques with elementary school children.

Classroom Applications

Doing homework can be intolerable to children who feel academically incompetent, frustrated, demoralized, and incapable of doing assigned work. After having spent a miserable day at school, their teachers and parents now insist they go home and spend an additional two or three hours being miserable. That many of these children try to evade their academic responsibilities is understandable. There is little incentive to children to do their assignments diligently when they believe they will receive poor grades on their homework no matter how hard they try.

According to Margolis (2005), the academic literature supports this view. The problem for many students is that homework is given to a whole class and that struggling students are asked to read and write beyond their reading levels or writing abilities. For them, work is perceived as being too complex or abstract, and without scaffolding, they reach their frustration level quickly. Their perception of the homework and a history of past frustration interfere with starting, organizing, and mastering the basic study skills needed to tackle work that may seem routine to others in their class. Homework requires voluntary, selective, sustained attention, self-monitoring, and assessment, and these qualities are missing in many students.

Keys (Margolis, 2005) to overcoming these problems include:

- Teach homework study and organizational skills along with your homework content goals. Construct your assignments in an open-ended way geared toward helping the struggling and average students be successful, not just challenging the most successful students. Individuals need to be able to be successful within their own ability levels.
- Stress challenging but familiar homework, and focus on successful completion as a goal without demanding excessive, laborious work and effort. Have a question-and-answer period talking about the homework before students leave class.
- Assume that many of your students will not have parental help but will be working independently. This may involve instructing or modeling for learners on how to do the homework and having them explain it or begin it in class. Practicing in class will help students feel some success before they get home.
- Make sure the students know that their work will matter to you, know how long it should take, and know how and when it will be collected and evaluated. In some classes grades are based more on in-class assessments. Make sure homework success is really valued and rewarded.
- Make homework motivating, interesting, relevant, and worthwhile. Place it in context with what's going on in class. Consider giving students a choice of homework assignments or focus in tune with their interests. Ask students about the kind of homework they prefer. The cliché answer will be none at all, but work past that point with them.
- Link homework with short-term goals and reinforcements; many struggling learners can't identify with long-term goals.
- Help struggling learners accurately record the assignments or give them copies of the assignments or needed materials. This helps them organize information and models management skills.
- Be available before and/or after school so that students have out-of-class access to you and other resources.

- Make your pattern of homework routine, not sporadic.
- Be patient and expect gradual improvements in completion and quality rates. Students need to believe that you are serious and that your system is real and not going away anytime soon.
- Let parents know your homework policy with ongoing contacts, newsletters, informal notes, e-mails, and telephone calls. Define the roles of all stakeholders, your expectations, and how homework will impact work in class. Have plans for the role of the parent or caregiver in your homework assignments.
- Inform parents on their child's homework progress. These contacts will influence the parents' willingness to support your policies and cooperate. You must respond to the parents' availability and language spoken and your perception of their own educational achievement. Avoid "teacher talk" or unnecessary educational jargon that they are not likely to recognize.
- Ask parents at the beginning of the year or during open house how they want to deal with homework (sign and review finished work, homework information sent home, etc.).
- Make a checklist of how parents can support successful homework completion. Teach parents how to help in a reasonable, productive manner without confrontation or without doing the majority of the work themselves.
- Realize that educational opportunities are not equal once students leave your class. Opportunities in one home may not exist in another. Equal opportunity may not be really equal. What if the parents can't be or aren't there to help?
- Parents appreciate being asked to stop the homework if their child is frustrated or has already spent an unreasonable amount of time on the assignment.
- Listen with empathy to parent concerns, and don't dominate conversations. Some parents feel uncomfortable or intimidated by school, especially parents from other cultures or those who speak other languages.

By designing, preparing, and matching homework to the struggling learner's independent academic abilities, by engaging parents, and by linking homework to specific goals, you can go a long way toward connecting students to a pattern of homework success. By shaping and managing the home environment with information, feedback, optimism, and/or positive attributions, you can create the belief that success can be a reality. Teachers can improve the likelihood that struggling students can master the homework paradigm.

Precautions and Possible Pitfalls

There is no doubt that all this takes time, effort, and patience. Teachers will not always be successful with parents and students. This is especially true with older students who have a history of resisting the efforts of the most persistent teachers. Be careful to not turn your efforts into just another bad experience for students with low self-esteem.

Sources

Greene, L. J. (2002). *Roadblocks to learning.* New York: Warner Books.

Margolis, H. (2005). Resolving struggling learners' homework difficulties: Working with elementary school learners and parents. *Preventing School Failure, 50*(1), 5–12.

3

Teachers, Students, Families, and Literacy

I find television very educating. Every time somebody turns on the set, I go into the other room and read a book.

—Groucho Marx

Outside of a dog, reading is a man's best friend. Inside a dog, it's too dark to read.

—Groucho Marx

Literacy is at the heart of sustainable development.

—Kofi Annan

Strategy 12: Literacy programs work best by involving the whole family.

What the Research Says

 Gail Weinstein (1998) synthesized research related to literacy and family involvement and suggested that parents' practices influence the school achievement of their children when it comes to reading and writing. Weinstein indicated that literacy programs in schools can be strengthened when they involve at least two generations of a family and that these relationships affect literacy use and development. She pointed out that studies of language use among Mexican

Americans (Delgado-Gaitan, 1987), Navajos (McLaughlin, 1992), and Cambodians (Hornberger, 1996), for example, show how language and literacy use reflect the cultural patterns of values and beliefs and may or may not be shared by schoolteachers and others. As immigrant children develop their English language ability, they can positively affect their parents' literacy development. So the goals of a family program would be to improve children's achievement by promoting parental involvement.

Classroom Applications

 This is a unique opportunity for teachers to bring the community into the classroom, encouraging the parents to visit their literacy lessons and participate in discussions and language-development activities. A major objective of a family literacy program is to improve reading skills (Weinstein, 1998), and this can be achieved when the teacher provides a variety of reading activities such as teaching parents to imitate behaviors of parents in the homes of successful readers, such as reading aloud to children and asking them specific questions. The children can also reverse this process by reading aloud to their parents when they return home from school. This becomes a two-way instruction program with the parents sometimes teaching their children and the children sometimes teaching their parents. In this way, generations can reach out to each other.

One example of such activities in action is getting the different generations of one family together in the classroom to discuss their family, backgrounds, beliefs, and values and how these compare to what they see in their community. The teacher can help prepare for this by gathering information about the family's cultural background from magazines and books. For example, if the children are from a country in South America, the teacher can access photos of the family's country of origin from *National Geographic* and other sources and videos about life in that country and then get the elders to describe the photos and explain the videos to the children in the class. In this way, both generations get practice in a range of literacy skills while passing knowledge from one generation to another. The class can produce a booklet on the culture in focus and/or develop a Web page on various aspects of that family's life, such as a family tree. This project-based work can link the classroom to the wider community and better involve parents and their children in developing literacy skills, although the focus is not on language learning.

Precautions and Possible Pitfalls

The main problem in setting up intergenerational literacy programs is "selling" their worth to both generations. The parents need to be informed about the benefits, especially the language

and literacy benefits, of participating in such a nonlinguistic project. The children need to be informed about the benefits of the two-way language instruction program that lie behind such a method. When the teacher informs both sides about the benefits of this two-way intergenerational method, the family project can progress smoothly.

Sources

Delgado-Gaitan, C. (1987). Mexican adult literacy: New directions for immigrants. In S. Goldman & H. Trueba (Eds.), *Becoming literate in English as a second language* (pp. 9–32). Norwood, NJ: Ablex.

Hornberger, N. (1996). Mother-tongue literacy in the Cambodian community of Philadelphia. *International Journal of the Sociology of Language, 119*, 69–86.

McLaughlin, D. (1992). *When literacy empowers: Navajo language in print.* Albuquerque: University of New Mexico Press.

Weinstein, G. (1998). *Family and intergenerational literacy in multilingual communities. ERIC Q&A.* Washington, DC: National Center for ESL Literacy Education.

Strategy 13: Find the out-of-classroom forces that shape reading habits and reading choices of young people to better develop their personal reading interests.

What the Research Says

Hopper (2005) considered the findings from data collected during one week in May 2002 on the reading choices of 707 school children between 11 and 15 years old. The information was collected in 30 schools in southwest England. The article reflected on adolescent reading choices, influences on those choices, and the importance of profiling all reading experiences beyond books, including "new" literacies such as the Internet, magazines, newspapers, comic books, and other areas not typically considered traditional literacy activities. Evidence from the study supported past research in that there has been no significant decline in student literacy habits.

Classroom Applications

There is an intellectual gap between what teachers provide as reading material and what young people choose to read, both in class and for private reading. This can most likely be attributed to a "generation

gap." Teachers need to distinguish between promoting curricular reading and fostering the students' personal reading interests. The goal here should be to make connections to the development of a reading habit that will empower young people as learners and future citizens beyond the classroom curriculum. Being aware of how young people and parents choose their reading material will help teachers begin this journey toward offering them a wide range of attractive choices for personal reading.

Giving students access to a range of appropriate books and other literacy activities requires an understanding of what triggers students' choices. Hopper (2005) rated clear categories of factors affecting choice that emerged from the study. Listed in descending order of importance, these categories can provide insight teachers can use to foster students' personal reading choices.

- Prior knowledge of the book or author
- The appearance of the book
- Recommendation
- Television or film
- Genre

Students often exchange information with others in their lives, creating "prior knowledge" before deciding on a book to read. Prior knowledge connects with recommendations students might get from others. Young readers also read books as part of a series with which they might already be familiar. This was a common response, as was reading multiple books from the same author. Genre choices, such as fantasy, were popular, and specific interest in nonfiction subject matter was also mentioned, especially by boys. It can be important for teachers to know about current trends and to have detailed knowledge of available books that students mention and books in the same or related genre or by the same authors.

The appearance of a book on a shelf also played a role in a student's decision to read. The color, pictures, or font could be significant factors in choice. Publishers know this and create covers with images that affect the targeted demographic. The *Harry Potter* series is a great example of this. In addition, the same book might have different covers for different markets. Television and film can also play a role, although a lesser one. The media hype certain books; the *Harry Potter* series as well as the *Lord of the Rings* books get lots of media play. Oprah's Book Club influences choice, and sales jump for any book she recommends. Genre is easy to connect to choice. Kids often become fans of a specific genre, such as science fiction or sports. These two genres are safe choices, especially for boys.

Regarding other forms of reading materials or nonbook sources (93% in Hopper's [2005] study cited reading nonbook texts during the study week), girls spend more time reading magazines. You can see this in what students carry around with them at school. Girls show more interest in love, sex, celebrity, fashion, and health magazines, and boys show interest

in technical, computer, and sports magazines. In the Hopper (2005) research, magazines proved to be an important reading choice for teens. Following magazines, newspapers were a significant nonbook reading source, and teens tended to read what was brought into their own households. Although not as popular as magazines or newspapers, the Internet was also cited as a source of nonbook reading.

Not surprisingly, teachers play a small role in influencing choice except for required class readers. This could be attributed to teachers' general lack of knowledge regarding what teenagers want to read.

So what do you do with this information? Use it to gain insight for stocking your own libraries or creating reading lists to share with your students. You can also use it to integrate more popular reading choices into your curriculum. You can use it to provide gender-specific choices to appeal to both boys and girls and to hard-to-reach groups of nonreaders.

Precautions and Possible Pitfalls

Developing an ongoing awareness of the reading preferences of teenagers takes time, and the job is never done. It's almost like predicting the type of music they are going to like. Many book lists online can help, and most are updated regularly. Do an Internet book list search and pick the lists that seem to be the most valid and useful, offer the greatest insight, and are the most current. There are also many agencies, clubs, and organizations that give book awards, and these are good sources of literary information. There is no one right way to develop this knowledge, but once you begin to tap into it, you will be better able to inspire teens and expand the range of what literacy can be for them in a school setting.

Regardless of whether the list developed by Hopper (2005) can be extrapolated to younger students, elementary teachers are well advised to keep up with the interests of their young charges. The world is ever changing, and although dinosaurs will always be fascinating to second-grade boys, there are many more topics and types of reading materials now than ever before. Interests of youngsters can be uncovered at the beginning of the year by asking parents at Back-to-School Night to fill out a survey. This early opportunity will allow the teacher to establish a quick connection with the parents, learn about the child, and begin the process of forming the class library and other literacy opportunities.

Source

Hopper, R. (2005). What are teenagers reading? Adolescent fiction reading habits and reading choices. *Literacy, 39*(3), 113–128.

Strategy 14: Rather than imposing a school literacy curriculum on parents, consider listening to the parents' voices about a "shared" curriculum.

What the Research Says

Pahl and Kelly (2005) explored the concept of family literacy by drawing on the fieldwork done in family literacy classrooms in the United Kingdom. They observed that parents and teachers often saw home and school as separate spheres, and children operated in both spaces. Their research defined a third space between home and school. The study centered on younger children and examined various parent–child–literacy interactions in family literacy classrooms. In this work, a family literacy classroom is described as a place where educators attempt to join home and school by focusing on shared literacy activities with parents and children, usually practiced on school sites, drawing on home-based activities. Family literacy classrooms are seen as a place between home and school, where both home and school literacy realms are recognized and validated. They serve as a third space where particular types of texts and discourses are produced. Usually this is seen as literacy activities from home being linked to school curriculum.

Various practices were examined in this context, exploring how these family literacy classrooms can act as places where children's texts can move from home to school and back again.

Classroom Applications

This application offers ideas and not a specific program or practice. In the large framework of parental involvement in schools, the idea of creating a class where parents and their students can interact is unique. The idea can trigger brainstorming on how the concept might work in a variety of settings and focus on a number of purposes. Pahl and Kelly (2005) explored a number of these classrooms where parents and students come together with teachers.

Most of the participants in these classrooms were students and their families who came from bilingual, bicultural households. All the programs examined targeted early elementary or preschool students. Most had multilingual identities that were upheld, validated, and recognized in these programs. In most settings, these are the parents who participate in school programs the least. This is what makes the idea of a family literacy

classroom most appealing. Parents were encouraged to draw on multiple language and cultural perspectives to produce various artifacts within the activities and curriculum of the class. Beyond the more traditional curriculum, the idea of a class where parents and students come together to spend time together talking, sharing, creating, playing, reading, writing, listening, and laughing is appealing. Pahl and Kelly (2005) noticed but did not quantify that many of the children's skills, knowledge, understanding, and confidence grew and that the parents' self-esteem grew as confidence in speaking in groups and risk-taking improved. Parents were better able to ask for information and share ideas and felt better able to approach the school. Standards in reading, writing, spelling, and grammar also improved.

How can you use these examples and information? As every school setting is different, any opportunity this concept provides has to be considered individually and crafted by motivated educators. One idea might be to set up a book club where students and their parents read a book together and then attend a session with the classroom teacher one day a week to analyze the characters, plot, and outcomes of the story. This could be very motivating for both students and parents. This type of activity would be well suited to Grades 3–5, when students switch from *learning to read* to *reading to learn* by deepening their ability to comprehend text through analysis and inference. A grade-level team, focusing on the essential standards in literacy that children in that grade are required to master, could work collaboratively on "third space" programs, as could teachers in departments in middle and high schools.

Many schools have a problem involving bilingual, bicultural families, and this idea offers possible solutions. This problem is especially prevalent in the older grades. The opportunities a family literacy class can provide are limited only by your imagination. They may also require a paradigm shift in educators regarding what family involvement in schools can look like.

Precautions and Possible Pitfalls

Parents work or don't always want to be involved in schools in the above-described manner. The lack of parent participation in your program can create an uneven playing field for some students, both academically and emotionally. You will need to consider children of both participants and nonparticipants. What can you do to compensate students of nonparticipants? In the above example, if not all parents could participate, possibly other parent volunteers or cross-age tutors could partner with children so that every child has someone with whom to share their learning. There are no easy answers, but you will need to consider the issues involved.

Source

Pahl, K., & Kelly, S. (2005). Family literacy as a third space between home and school: Some case studies of practice. *Literacy, 39,* 91–96.

 Strategy 15: Become an advocate for improved home literacy environments (HLEs) for all students, especially for preschool and K–3 students.

What the Research Says

 Burgess (2002) used a research approach to further define what is obvious to most educators: Shared reading experiences in home environments relate to the development of phonological sensitivity and oral language skills in young children. Informal literacy acquisition is thought to start at an early age, long before the child enters the formal classroom. The time children spend with parents early in their development is seen by most as key to their preparation for school-based, more formalized instruction.

The results of Burgess's (2002) study indicated that shared reading experiences (parents teaching children to read words or reading to their children) relate to language outcomes in oral language composition, expressive and receptive vocabulary, and phonological sensitivity. This study looked at the literacy environments of 115 4- and 5-year-olds from middle-income homes through parent surveys that recorded shared reading patterns over time. Children completed two standardized tests of oral language and four tests of phonological sensitivity.

This was one of the first studies to demonstrate a relationship between phonological sensitivity and shared reading. Deficits in phonological sensitivity, according to Burgess (2002) and Wagner, Torgesen, and Rashotte (1994), are the most significant factor for most children having difficulties learning to read. Burgess stated that the earlier children learn to read, the greater number of shared reading experiences they have.

Classroom Applications

 If you are involved with preschool children or K–3 students, the research described here is for you. With the growing demand for parental participation, there is an increasing and widespread call for

parents to read more to their children. Changing the home literacy environments is not easy. While the research does define the connections between home literacy environments and school literacy achievement, it doesn't define the specific activities that have been shown to improve reading-related skills. However, by facilitating literacy activities at home, you can't go too far wrong.

Because not all households are rich in resources, you may want to consider lending libraries or some other means to get books into the hands of parents. You may also want to consider copying reading material to send home (remember to research any laws on educational use).

Precautions and Possible Pitfalls

Most of the research on emergent literacy has been conducted with children from print-rich homes who identify with the dominant, school-oriented culture, where parent–child interactions provide experiences similar to classroom interactions. Through these experiences, children are motivated to learn about literacy events, functions, artifacts, forms (e.g., sound and letter names), and conventions before they learn more formally to read and write.

There is another side to this. There are reasons why parents may not want to read to and with their children. Maybe the parents are not comfortable reading aloud, or maybe they do not have access to reading and/ or other literacy materials such as the Internet. Bilingual or bicultural students may have parents who are not English speakers. While the research doesn't describe these situations directly, some believe that literacy skills in one language contribute to literacy skills in other languages.

Finally, at school the educational resources are usually equally available to all students. Once students leave school, however, that is not the case. Some households offer greater opportunities for their children. Involving parents can produce an inequality among students, and educators need to be sensitive to children with home situations that are not optimal.

Sources

Burgess, S. (2002, March). *Shared reading correlates of early reading skills*. Reading Online, International Reading Association, Inc. Retrieved September 9, 2008, from http://www.readingonline.org

Wagner, R. K., Torgesen, J. K., & Rashotte, C. A. (1994). Development of reading-related phonological processing abilities: New evidence of bi-directional causality from a latent variable longitudinal study. *Developmental Psychology, 30,* 73–87.

Strategy 16: Reflect on the complex issues surrounding school literature selection for bilingual and bicultural students.

What the Research Says

Jones's study (2004) focused on the questions of which strategies are the most appropriate in determining how literature is selected and how reading preferences for bicultural and bilingual students are identified. It also reflected on the potential negative consequences when bicultural and bilingual students are not provided with literature that reflects their personal situation. The prime focus of the study is on data about students' reading choices, which are used to determine whether bilingual and bicultural students of inner-city Derby, Wales, can find their own identities within the literature they read. Is their identity split between their two cultures? Should bilingualism and biculturalism be seen as separate entities? Indian immigrants comprised the study group. Jones looked at minority publishing in Wales to explore the range of literature available. The goal was to identify positive steps teachers and schools could take in providing literature for bicultural and bilingual students that better connected to these students' backgrounds and intellectual needs.

Classroom Applications

When most students watch movies or read books, their own life experiences contribute to their enjoyment of the film or book. The more they share or identify with the characters or the situations presented, the more they like the book or movie. Conversely, the less affinity they have with the situations and characters, the harder time they have feeling empathy and enthusiasm. This is not always the case, but it helps if characters are dealing with situations the readers are familiar with in interesting and unique ways. Many people like to fantasize, placing themselves in the stories and wondering what they would do.

Students living in a bilingual or bicultural environment may have a tough time finding books or movies that deal with their life experiences. Where are the heroes they need to help shape their identity and give them role models? Where are the books with gay and lesbian or bilingual and bicultural heroes? Chances are that most school libraries and classrooms select books more in tune with the experiences of the staff and faculty or the majority culture at the school. Also, much of the curriculum today is mandated or selected based on potential tests down the road. Material that

fits the needs of local minority populations is often hard to find and screen for appropriateness. School demographics are individual and localized. Today's schools are heterogeneous and it can be difficult to standardize inclusive films, videos, and literature for all schools. This doesn't mean there is no need to address these concerns. Each site must make the effort to dig for the materials to meet the needs of its own student populations.

Precautions and Possible Pitfalls

Be aware that taking responsibility for more appropriate materials for these populations may not be popular. Funding the needs of minority groups can be a very political activity. School budgets are always tight. Most minority groups and their parents don't have the "political presence" to exert much power over those who control the funding. It will take individual teachers or staff advocates promoting these types of concerns to make a difference. Very often these caring individuals will also need to do the searching and research to help select the materials and argue for the funding.

Source

Jones, S. (2004). Shaping identities: The reading of young bilinguals. *Literacy, 38*(1), 40–50.

Strategy 17: Develop proactive strategies to help nonreading parents support their children in becoming successful readers and writers.

What the Research Says

While not research in the pure sense, Cooter (2006) explored the historical factors that contribute to intergenerational illiteracy. This sociological phenomenon is defined as a situation in which illiterate parents inadvertently create home conditions that limit and hinder their children's acquisition of writing and reading skills. Intergenerational illiteracy often is found in high-poverty urban and in rural settings. It is not uncommon to find three generations of families with low literacy skills. Characteristics include homes with a lack of strong language examples, little child–parent interaction, and a lack of print materials in the home. Teenage parents also have similar difficulties helping their

children gain language and literacy skills. Research (Hoff-Ginsberg, 1991) shows us that children living near, at, or below the poverty level are more susceptible to intergenerational illiteracy but that it's a predicament beyond the family's control due to their social conditions.

Cooter (2006) went on to say that contrary to what some think, intergenerational illiteracy is not a matter of choice but a predicament. She felt that teachers can help struggling mothers succeed in helping their children become strong readers.

Classroom Applications

Teachers can help illiterate parents find ways to help their children with the skills they do possess to become successful home literacy advocates. A parent's educational level, literacy abilities, and language proficiency don't completely limit a parent's ability to support his or her children. There are a number of ways teachers can assist illiterate parents that don't depend on their own level of literacy, and teachers should focus on what these parents can do with children regarding reading instruction.

For example, one of the most powerful learning devices is called *dialogic reading*. Dialogic reading is sometimes thought of as picture book reading. However, dialogic reading is different. In this case a child directs and leads the conversation around the pictures, and the parent listens to the child's discourse, asks questions, redefines and extends the conversation, and still remains at all times a follower of the book's dialogue and interpretation. These types of interactions improve the lengths of a child's sentences, increasing the complexity of vocabulary. Parents can easily partner with their children in dialogic reading, and teachers can easily help parents learn these techniques.

Another strategy is to increase the parent's "mean length or utterance" or, more simply, increase the average number of words they use spoken together. When parents use longer sequences of words or word chains, children tend to imitate or mimic and also create longer sentences. Parents who utilize complete sentences are more likely to have children who respond in longer word chains (Peterson, Carta, & Greenwood, 2005). And parents who read or talk through books that are both narrative and manipulative (touch, pull, or handle) can increase the complexity of discourse (Kaderavek & Justice, 2005).

Just setting aside time to talk to their children can help. Having children tell their own personal narratives of the day's activities increases vocabulary. Parents should be encouraged to respond and expand the conversations using complex vocabulary and sentence structures when speaking with their children. Two-way conversations can offer major benefits toward literacy and language development.

The following are some of the suggestions derived from the research cited in Cooter (2006).

- Build on what a parent can do—talk.
- Let parents know that just by talking and listening, they can help their children become better readers and writers.
- Urge parents to tell family stories, songs, and family rituals.

Precautions and Possible Pitfalls

 This is a sensitive area for some parents, and the targeted parents may feel teachers are delving into areas where the parents don't want to go. Gather as much information as possible about the parents from colleagues and the children themselves before contacting the parents. Find out if the parents have ever been contacted before settling on a strategy.

Consider sending home information in a newsletter about how non-reading parents can help their children so as to not target specific parents and cause them embarrassment.

Sources

Cooter, K. (2006). When mama can't read: Counteracting intergenerational illiteracy. *The Reading Teacher, 59*(7), 698–702.

Hoff-Ginsberg, E. (1991). Mother–child conversation in different social classes and communicative settings. *Child Development, 62,* 782–787.

Kaderavek, J. N., & Justice, L. M. (2005). The effect of book genre in repeated readings of mothers and their children with language impairment: A pilot investigation. *Child Language Teaching and Therapy, 21*(1), 75–92.

Peterson, P., Carta, J., & Greenwood, C. (2005). Teaching milieu language skills to parents in multiple risk families. *Journal of Early Intervention, 27,* 94–109.

4

Teachers, Students, Families, and Mathematics

Do not worry about your difficulties in mathematics. I can assure you that mine are still greater.

—Albert Einstein

The kids in our classroom are infinitely more significant than the subject matter we teach.

—Meladee McCarty

 Strategy 18: Take steps to communicate with parents about mathematical concepts, skills, and problem solving, and share assessment tools and home activities geared toward helping parents target weaknesses and assist their children.

What the Research Says

 Mistretta's (2004) findings from a survey of a sample population of 790 parents of elementary and middle school students were used to answer two research questions. First, to what

extent and in what areas do children have difficulty learning mathematics as perceived by their parents, and does this vary across grade level groups (Grades 1–4 and Grades 5–8)? Second, to what extent do parents seek assistance in helping their children learn mathematics, and does this vary across grade level groups (Grades 1–4 and Grades 5–8)?

Mistretta (2004) determined that both groups of parents desire assistance to help them help their children with mathematics. Survey responses revealed that parents want background in mathematics standards, methods of teaching, assessment procedures, and applications. Above all, parents want practical ways to help their children develop a range of mathematics literacy concepts.

However, Mistretta (2004) found significant differences between the two parent sample groups. Grade 1–4 parents agreed with the notion that teachers should help support parents more than the Grade 5–8 parents. Both groups seek assistance in building their child's motivation toward and confidence in mathematics, helping with homework, and using manipulatives in addition to instructional technology.

Classroom Applications

 Create a department or school parent involvement program in mathematics. Whenever possible, don't do this alone. There is no one right way to do this, and it can vary based on input from all stakeholders. Consider teachers specializing in creating a parent plan for each mathematics discipline. Parents need to know there is a link between home and school that can enhance a school's curricular objectives, promote heightened interest, improve attitudes, and support the building of parent and student confidence. In this research (Mistretta, 2004), the results of the study were to be used to develop parent involvement tailored to the needs of the parents in the sample population. This program was going to be implemented in ten schools, with its effects on parents to be monitored over a three-year period. Once established, a parent plan can be adopted as an expectation for any new teacher coming to the school.

There are Web sites that specialize in offering math concept tutorials. Math.com offers many tutorials in a range of math disciplines that could serve to help parents help their children in middle and high school math. There are other Web sites, but teachers should evaluate them to see whether they match their needs.

Precautions and Possible Pitfalls

There are three possible problems. First, it takes development time to complete, implement, and adjust and fine-tune a parent program. It will take administrator buy-in to provide the time

necessary. Second, it will also take someone with a clear knowledge of the parent demographic to help tailor the program to the community. Clearly, it would help to have parents involved in the creation and development of this program. Third, the school will need to implement the program with the help of counselors and during orientation programs the school offers.

From a classroom teacher perspective, participation by parents may be uneven as some support the program and others don't. Consider and have a plan in place for students who continue to not get the help they need. It is unfair to penalize students who come from a less supportive home environment.

Source

Mistretta, R. M. (2004). Parental issues and perspectives involving mathematics education in elementary and middle school settings. *Action in Teacher Education, 32*(2), 69–76.

 Strategy 19: Help parents realize that their expectations and perceptions of confidence in their student's mathematic ability and their child's ability to take risks and enroll in higher-level math courses are predictors for math performance.

What the Research Says

 Do mothers' and fathers' attitudes toward their children's academic performance influence children's perceptions of their academic competence? Two types of parental attitudes—parents' level of satisfaction with their children's performance in school and the importance parents place on children's academic success—were the focus of this study. The data (McGrath & Repetti, 2000) from 248 children, 219 mothers, and 146 fathers were consistent with the belief that parents' attitudes play a central role in shaping children's self-perceptions. Mothers' satisfaction was positively associated with both sons' and daughters' perceptions of academic competence, independent of children's actual grades in school. Fathers' satisfaction correlated with sons' self-perceptions, but not when mothers' satisfaction was also included in the model. Both mothers and fathers reported being more satisfied with their daughters' grades than with their sons' grades, despite the fact that there were no actual differences between girls' and boys' academic performance. Finally, the importance fathers (but not mothers) placed on children's

academic success was positively associated with girls' self-perceptions. Acherman-Chor, Aladro, and Gupta (2004) and Holt and Campbell (2004) also call attention to the importance of parental attitudes in math success and the ability and confidence to feel supported in taking academic risks by taking more difficult classes.

Classroom Applications

 Math is a somewhat unique discipline in this regard. All a parent needs to do is tell his or her child that they were not very good at math or that they never use math in their adult context. They can instantly devalue math or explain why their son or daughter has problems learning math. This provides them with an instant excuse for their performance. The application is simple. Let parents know their attitude about the math discipline carries weight with their children. Administrators should make sure the entire staff is aware of this effect and counsel all of them to talk to parents about this research at Back-to-School Night and/or put the research information on the school Web site or in the principal's newsletter.

A teacher's teaching style, such as their use of cooperative rather than competitive learning and their overall expectations for females in math and science, also plays a pivotal role in girls' relationships with the disciplines. It is important that all those in the student's life validate the importance of math in their lives. Sell the importance of math.

Precautions and Possible Pitfalls

There are not any precautions or pitfalls here. The earlier a teacher is able to affect the parent's attitude, the better. Sometimes the damage is done in the younger years, and it is hard to undo.

Sources

Acherman-Chor, D., Aladro, G., & Gupta, S. D. (2004). Looking at both sides of the equation: Do student background variables explain math performance? *Journal of Hispanic Higher Education, 2*(2), 129–145.

Holt, J. K., & Campbell, C. (2004, May 31). The influence of school policy and practice on mathematics achievement during transitional periods. *Education Policy Analysis Archives, 12*(23). Retrieved June 13, 2007, from http://epaa.asu.edu/epaa/v12n23/

McGrath, E. P., & Repetti, R. L. (2000). Mothers' and fathers' attitudes toward their children's academic performance and children's perceptions of their academic competence. *Youth and Adolescence, 29*(6), 713–723.

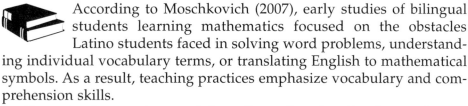

Strategy 20: Encourage English language learners and their parents not to emphasize low-level language and vocabulary skills over opportunities to actively and repeatedly communicate and engage in discourse about mathematical ideas, even if it is in their native language.

What the Research Says

According to Moschkovich (2007), early studies of bilingual students learning mathematics focused on the obstacles Latino students faced in solving word problems, understanding individual vocabulary terms, or translating English to mathematical symbols. As a result, teaching practices emphasize vocabulary and comprehension skills.

By contrast, current research in mathematics education focuses less on vocabulary and more on classroom discussions. Researchers have begun to consider mathematical discussions in bilingual classrooms and where students are learning English. "These studies are a first step in understanding the relationship between language and learning mathematics," said Moschkovich. She went on to emphasize that more attention needs to be paid to the specific ways in which bilingual students participate in mathematical conversations, particularly as classroom activities shift from silent, individual tasks to more verbal and social ones, she said.

The Gutiérrez (2002) research examined the instruction technique of three high school mathematics teachers whose classes with large numbers advanced Latina/o students (largely English-dominant) through the curriculum. The data are drawn from interviews with the teachers, from school and classroom observations over a 13-month period, and from student interviews. An analysis of teachers' work with Latina/o students suggests that some of the strategies used by elementary and middle school teachers and teachers of English language learners are also successful with high school Latina/o students who are primarily English-dominant.

Classroom Applications

The standards document from the National Council of Teachers of Mathematics (NCTM), *Principles and Standards for School Mathematics* (NCTM, 2000), offers six principles: equity, curriculum, teaching, learning, assessment, and technology. The principles that apply directly to English language learners include equity (high expectations and strong scaffolding and support for all students), teaching (offering challenging

curriculum and support for all students to learn mathematics well), and learning (engaging in the acquisition of new concepts and knowledge from instructional experience and prior knowledge to acquire mathematics knowledge with authentic understanding and comprehension). Two suggestions from the *Principles and Standards for School Mathematics* seem to address the concerns of the English language learners. First, depth over breadth is emphasized. Curricula should be offered that allows students to explore mathematics more deeply rather than more rapidly. Superficial treatment of a broad range of topics will not serve the students as well as developing deeper insights within the most important concepts. The second major principle relates to how strategies are developed to allow students to learn in heterogeneous groups.

These strategies include having students work in groups, allowing students to work in their primary language when necessary, supplementing textbook materials, and building on students' previous knowledge. Instructional methods need to be applied stressing differentiated support for a range of students within group structures. Finally, mind-sets and instruction divisive structures that exclude certain groups from a challenging and comprehensive classroom experience need to be identified and eliminated.

Many believe that non-native speakers of English are not under any major disadvantages in the mathematics classroom as mathematics is a language in itself and can be learned by people who do not speak the language of the instruction. However, the language of mathematics poses many obstacles and difficulties for English learners. Think of the concept of a word problem. Math is not language-neutral. *Coefficient, quotient, exponent, column,* and *table* all are words that are very technical and necessary to understand math concepts. Syntax and semantic problems occur because of the complexity of the language of math, and students are required to make inferences from everyday language. Textbooks often are written in an unnatural language style and must be read slowly and multiple times to gain understanding. Eye movement may range from left to right and up and down many times on the same page. Text processing must become part of the instruction and not be taken for granted.

Specially Designed Academic Instruction in English (SDAIE) principles apply to the mathematics class also. The goal is the production of comprehensibility. The strategies that most apply are:

- Provide instruction both orally and in written form for new concepts and classroom instruction, especially vocabulary. Engage students in hands-on/minds-on activities where concepts can be discussed in a concrete context.
- Verbalize the instructional strategies used to solve problems.
- Recycle and revisit vocabulary to reinforce understanding and acquisition. Relate new terms to prior knowledge or to the students' own lives.

- Use specialized content language with appropriate actions, concrete objects, and a valid recognizable context if possible. Providing an appropriate context for new vocabulary, syntactic structure, and mathematics discourse patterns is just good teaching technique. We rarely learn things unless we need the knowledge for something relevant to our lives.

- Many English language learners are unfamiliar with the basic tools associated with mathematics (rulers, protractors, calculators, computer software, etc.). Demonstrate their use and put the students to work using them in a real-life context. Create authentic reasons to use the tools.

- Check for comprehension often. Develop comprehension questions to engage all levels of language acquisition to make sure learning is taking place. Don't forget to incorporate writing, which helps to clarify the students' thinking and develop their communication skills.

- Finally, use cooperative learning strategies and, if necessary, discuss the concepts in everyday language. Don't limit the discussion to English only.

Regarding the use of a student's native language, students need to know when it is useful and appropriate to use their native language. SDAIE teachers should go through the following process to help students understand why it is important to speak English in the classroom.

- Place students in groups. Ask them to create a list of reasons why it is important to speak English in the classroom. A presenter in each group should explain to the class his or her group's list.

- Have students create a list of reasons that native language might need to be spoken at times. Share with the class.

- Have students create a list of ways that using native language in class is abused. Share with the class.

- Have students create a list of statements that can be used to ask others politely in class to use English. Example: "Please use English so that all of us can understand."

- Finally, develop guidelines for when and why the use of native language might be appropriate, especially in a mathematics class. Create a class statement that encourages the use of English during class. Select several polite statements that students can use to encourage the use of English. Put this information on a large poster that can be placed somewhere visible to all the students in the class. When or if the use of native language in class becomes a problem, make reference to the poster.

To conclude, all of these strategies should be considered when constructing homework assignments. Parents should be encouraged to support their

children in their native language if necessary. Many cultures take pride in their mathematical abilities and shouldn't be discouraged from helping their children. Remember the initial strategy: Encourage English language learners and their parents not to emphasize low-level language and vocabulary skills over opportunities to actively and repeatedly communicate and engage in discourse about mathematical ideas, even if it is in their native language.

Precautions and Possible Pitfalls

In any class you will likely have a range of English language learners and a range of math ability levels. It would be a mistake not to utilize various levels of Specially Designed Academic Instruction in English (SDAIE) principles in the bilingual math class. Also alert parents about the efforts and strategies you are using to help their children. Families will feel more comfortable approaching you for help when they know the strategies you are using to help their children.

Sources

Gutiérrez, R. (2002). Beyond essentialism: The complexity of language in teaching mathematics to Latina/o students. *American Educational Research Journal, 39*(4), 1047–1088.

Moschkovich, J. (2007). Bilingual mathematics learners: How views of language, bilingual learners, and mathematical communication impact instruction. In N. Nassir and P. Cobb (Eds.), *Diversity, equity, and access to mathematical ideas* (pp. 121–144). New York: Teachers College Press.

National Council of Teachers of Mathematics (NCTM). (2000). *Principles and standards for school mathematics*. Reston, VA: Author.

Strategy 21: Realize that parents suffer from math anxiety too.

What the Research Says

Math anxiety is described as feelings of tension and anxiety that interfere with the manipulation of mathematical problems in a wide variety of ordinary life and academic situations. Studies indicate that math anxiety is found in elementary students (Jackson & Leffingwell, 1999; Steele & Arth, 1998) and in high school students (Jackson & Leffingwell, 1999).

Math anxiety can result from environmental factors such as myths, teachers, and parents (Steele & Arth, 1998). Intellectual factors that affect

math anxiety include learning styles, persistence, self-doubt, and dyslexia. Personality factors such as low self-esteem, shyness, and intimidation can also affect math-anxious students (Fotoples, 2000).

A summary of the data in the cited research revealed that math anxiety is alive and well—and it's not just kids feeling the pressure. It is estimated that more than half of the parents (54%) report that they, too, experience some stress over their child's math homework.

Busy family schedules, increasing amounts of homework, and new teaching styles are taking their toll on parents in every corner of the country. According to a survey conducted by Russell Research, nearly three-fourths (72%) of parents surveyed reported that their child has math homework on most school nights. Seven out of ten parents (71%) say that because the approach to teaching math has changed since their school days, it's taking them more time to help their child complete his or her math homework.

Classroom Applications

It has been a long time since most parents sat in a math class, and the subject is taught very differently now. Parents who are willing to help find themselves spending quite a bit of time reviewing the textbooks and doing their own homework to help their kids with their questions.

Getting help when the student and parent need it is one of the most important strategies according to professional tutors. Most parents would probably agree that getting help with homework when they need it would ease their anxiety.

According to and compiled from the cited research, math anxiety's psychological symptoms include feeling nervous before a math class, panicking, going blank during a test, or feeling helpless while doing homework. The physiological symptoms include sweaty palms, racing heartbeat, or an upset stomach. The symptoms are essentially the same as stage fright or the "butterflies in the stomach" athletes experience before a game. However, the critical difference between stage fright and math anxiety is that math represents the gateway to almost all forms of higher education and many career opportunities. Math anxiety, feelings of dread and fear and avoiding math, can sap the brain's limited amount of working capacity, a resource needed to compute difficult math problems. While easy math tasks such as addition require only a small fraction of a person's working memory, harder computations require much more. Worrying about math takes up a large chunk of a person's working memory stores as well, spelling disaster for the anxious student who is taking a high-stakes test.

The following suggestions were adapted from The CollegeBoard.com's Web site, "Battling Math Anxiety." Teachers should read them and design

their own list of tips and hints for parents to help students with math anxiety problems. Each teacher will need to adapt them to his or her own instructional style and patterns of assigning homework.

Confidence + Preparation = Success

Math gets more challenging when you hit high school, so it's more important than ever to sharpen your skills. Plus, the demand for math is continually increasing in the real world. Here are some tips for approaching this subject.

Don't Sell Yourself Short. Perhaps one of the most important ways that you can do better is simply by having a positive attitude. Don't sell yourself short by saying things like, "I just don't have a brain for math." Set high expectations and rise to the occasion.

Ask a Lot of Questions. There's nothing embarrassing about wanting to get some clarification. It may not even be a matter of you not getting something. It may be a matter of the teacher not explaining it fully.

Don't Fall Behind. You're building on a base of skills and concepts. If you miss something early on, it gets harder to catch up later. Plus, to take more rigorous courses (courses that are viewed favorably by colleges) in math or science, you need to complete one or more prerequisite courses (such as Algebra I).

Problems Can Be Solved in Different Ways. While some problems in math may have only one solution, there may be many ways to get the right answer. Learning math is not only finding the correct answer, it's also a process of solving problems and applying what you have learned to new problems.

Practice. Usually it's not until you apply concepts to real problems that you "get it."

Build Your Confidence. When you do your homework, start with easier problems or problems you know you can do. That will give you confidence to approach more difficult problems.

Show Your Work. It's tempting to skip steps, but it's better to get into the habit of showing all of your work. That way, it's easier to correct mistakes. Plus, you may get partial credit.

Don't Ignore Your Wrong Answers. While accuracy is always important, a wrong answer can tell you to look further and see if you really understood the question.

Write Neatly. Think the days of penmanship are over? Not so fast. It's important that you organize problems and write numbers and variables clearly, so you don't confuse yourself (or your teacher).

Learn How to Use a Calculator Effectively. It's OK to use calculators and computers to solve math problems. In fact, students are often required to use them to do homework and take tests. The SAT, for example, permits the use of a calculator.

Use Flash Cards. Symbols, equations, and concepts can get overwhelming. Use flash cards to organize information or test yourself. This is helpful for all students Grades 1–12.

Don't Be Afraid to Ask for Help. Falling behind or getting frustrated can lead to a feeling of "why bother." Don't let it. Ask for help.

Get a Tutor. Find a family member or friend who is available to help, or look for a volunteer or private tutor. Ask your teacher or guidance counselor for advice or a recommendation.

Study With Friends or Classmates. Working through problems with others is sometimes more enjoyable than flying solo.

Remember, from statistics in sports to the sale price of sneakers, from figuring the calories in food to the amount of gas needed to visit colleges, math is connected to your daily life.

Precautions and Possible Pitfalls

 You many not solve all the math anxiety problems that are out there, but considering the problems in your home communication is a start.

Sources

Ashcraft, M. H., & Kirk, E. P. (2001). The relationships among working memory, math anxiety, and performance. *Journal of Experimental Psychology: Learning, Memory, and Cognition, 15,* 898–919.

Cates, G., & Rhymer, K. N. (2003). Examining the relationship between mathematics anxiety and mathematics performance: An instructional hierarchy perspective. *Journal of Behavioral Education, 12*(1), 23–34.

CollegeBoard.com. (n.d.). *Boost your skills.* Retrieved August 1, 2007, from http://www.collegeboard.com/student/plan/boost-your-skills

Fotoples, R. (2000). Overcoming math anxiety. *Kappa Delta Pi Record, 35*(4), 149–151.

Jackson, C., & Leffingwell, R. (1999). The role of instructors in creating math anxiety in students from kindergarten through college. *Mathematics Teacher, 92*(7), 583–587. (ERIC Document Reproduction Service No. ED431628)

Steele, E., & Arth, A. (1998). Lowering anxiety in the math curriculum. *Education Digest, 63*(7), 18–24.

5

Teachers, Schools, Families, and the Special Education Student

Give the pupils something to do, not something to learn; and the doing is of such a nature as to demand thinking; learning naturally results.
—John Dewey

Expecting all children the same age to learn from the same materials is like expecting all children the same age to wear the same size clothing.
—Madeline Hunter

> **Strategy 22: Consider how parents might be reacting to their child with a learning disability and how that might affect the student in class.**

What the Research Says

 Ferguson and Asch (1989) reviewed the research on family reactions to having a child with a disability. From this review and investigation, the researchers developed a conceptual framework to locate the major research orientations that developed over the last century. Ferguson (2002) found two new strands that have emerged in more recent research, and his review explored how these

approaches promise more useful interpretive frames for efforts to improve linkages between families and schools.

As with many social phenomena, a family's interpretation of the meaning of disability cannot help but reflect, to some degree, the larger context of social attitudes and historical realities within which personal interpretation emerges. Ferguson and Asch (1989) tried to reflect the interpretations of families within the research orientations of the time. They stated that this shared research activity between researchers and parents is a "meaning-making" event that ties us to our current time and place. They characterized their work as a snapshot of what interpretations seem to fit best right now and a review of how current interpretations have evolved over time.

The challenge was to catalog and sequence the evidence of parental damage and to argue for the efficacy of particular therapeutic interventions. The basic two questions they looked at were (1) What is the nature of parental reaction to having a child with a disability? and (2) What is the source of the reaction?

Ferguson (2002) dealt with how the answers to these questions are changed over time. Today, there is no longer an emphasis on how poor and probably disabled parents breed poor and inevitably disabled children. Professionals have shifted their attention to how children with disabilities inevitably damage the families into which they are born. Whether they preferred to use primarily attitudinal (guilt, denial, displaced anger, grief) categories or behavioral ones (role disruption, marital cohesiveness, social withdrawal), most researchers assumed a connection that was both intrinsic and harmful. They went on to describe and characterize a range of repeated responses typical of families. The main parental categories that describe the parents' state of mind were developed by Ferguson and Asch (1989) and are as follows:

- Psychodynamic Approach: The Neurotic Parent
- Functional Approach: The Dysfunctional Parent
- Interactionist: The Powerless Parent
- The Adaptive Family
- The Supportive Family Applications

Each of these categories brings a different set of circumstances and characteristics for teachers to deal with in helping their students. The research centered on analyzing the specific categories.

Classroom Applications

 First, keep in mind that the term *family* can describe and categorize a wide range of living conditions for a student, and relationships to family may have changed over time for a child. Consider how an

identified disability has "damaged" the parents and family and how the family and the student have responded or reacted to the damage. Much of the time, a disability is seen as a message telling the parents what the student can't do or accomplish or what he of she can't become in his or her life. Also, many times, it's the child's teachers who bring the messages. This can put teachers in a less-than-favorable role.

Teachers are part of a team of adults concerned about the individual students in their classes. Regardless of where one comes down on the cultural and societal context of families and children with disabilities, there is an immense variety of beliefs and practices that have undeniably powerful influence on how a specific family interprets a specific disability. Teachers will often be pulled into the mix, and it is a good idea to have some understanding of the potential structure of the family situation and how they might choose to react.

According to Ferguson and Asch (1989), parents may present or prefer to use primarily attitudinal (guilt, denial, displaced anger, grief) categories or behavioral ones (role disruption, marital cohesiveness, social withdrawal) as a reaction to the specific disability. They might be apathetic or involved, angry, or accepting. They might express displeasure with the support providers over a supposed lack of supports, as displaced anger originally directed toward their child. Teachers may want to examine their own performance inadequacies before categorizing the parental responses as unjustifiable anger toward the system.

On the positive side, Ferguson and Asch (1989) found there is increasing recognition that many families cope effectively and positively with the additional demands experienced in parenting a child with a disability. They found that families of children with learning disabilities exhibit variability comparable to the general population with respect to important outcomes.

Some suggestions for general education teachers are as follows:

- Read IEPs and know how the information in it manifests itself in your classes. There is nothing less professional than not being familiar with students' issues or their performance in class. Stay on top of it.
- Be prepared to deal with parents who exhibit many of the characteristics described here. Check with special education teachers or counselors who may have been dealing with the parents before contact.
- Discuss strategies for parental contacts with counselors and special education teachers. If you are a teacher of a first- or second-grade child, it is likely you will be part of the initial assessment and IEP process, so it is important to talk with the psychologist and case manager and relay what you know about the family and child prior to the meeting.

- Be prepared to focus on what is best for the child. Avoid discussing curricular or instructional needs and constraints. Parents want to know how you are going to help their child be successful.
- Remember to avoid telling parents what their child can't do. Keep hope alive with positive comments and strategies well thought out before meeting the parents.
- Listen carefully, as parents may provide information that will help you.

Precautions and Possible Pitfalls

 Parents are not concerned with anything but their children and how the school and teachers can help them. In conversations with them, always keep their child's needs as the focus and your teacher needs and school's limitations on the back burner.

Sources

Ferguson, P. M. (2002). A place in the family: An historical interpretation of research on parental reactions to having a child with a disability. *Journal of Special Education, 36*(3), 124–131.

Ferguson, P. M., & Asch, A. (1989). Lessons from life: Personal and parental perspectives on school, childhood, and disability. In D. P. Biklen, D. L. Ferguson, & A. Ford (Eds.), *Schooling and disability: Eighty-eighth yearbook of the National Society for the Study of Education* (Part II, pp. 108–140). Chicago: National Society for the Study of Education.

 Strategy 23: Consider the parents' level or stage regarding their child with a disability before recommending specific services and accommodations.

What the Research Says

 In their article on parent communication, Ulrich and Bauer (2003) argued that positive communication with parents may be improved by adopting a new model of perception.

Rather than cycling parents through the stages of grief, they asked teachers to consider the following stages, which are traversed by a transformational experience:

1. The Ostrich phase—often confused with denial, this may be a state of lack of information.
2. Special Designation—the parent accepts that the child has a disability and is now willing to actively (sometimes aggressively) seek help for the child.
3. Normalization—the parent seeks to find normal, peer-appropriate activities for the child.
4. Self-Actualization—recognition that the child needs support, and dreams are replaced with realities as the child learns to self-advocate.

Ulrich and Bauer (2003) encouraged teachers to use the stages and determine the parent's current level to help the communication process. One day a parent might request a one-on-one aide (level 2) and then contradict that statement by asking for the child to be placed in the general education classroom (level 3). Rather than be frustrated by this turnaround, teachers would be wise to understand that a transformational moment has occurred, allowing the parent to move to the next level.

Classroom Applications

It is important that teachers and parents communicate effectively prior to making decisions that affect students. An important part of this process is recognizing where each party is coming from and truly understanding his or her vision for the student. Teachers can facilitate this communication by asking questions that link to the levels identified by Ulrich and Bauer (2003). By questioning parents about the types of services and listening to their responses, teachers can explore what level a parent is at. For instance, asking if a child knows about his or her disability can often indicate parent level. Although the teacher may be ready to assist the student with self-advocacy skills, parents may still need the reassurance that there is a safety net, in the form of teacher follow-up, available for the student.

Precautions and Possible Pitfalls

The greatest danger in parent communication is assuming that the teacher knows better than the parent. Teachers should

always take the time to ask and offer choices to ensure that they are on the right track and shouldn't forget to include the student if he or she is able to speak about his or her preferences. Teachers might ask, "I know you would like weekly updates on Mary's progress. Would you feel more comfortable e-mailing her teachers? Otherwise, we have a form she can have teachers sign as she attends class to document her progress." In addition, although identifying stages may help a teacher gain insight, parents are individuals and should be treated on an individual basis.

Source

Ulrich, M. E., & Bauer, A. M. (2003). Levels of awareness. *Teaching Exceptional Children, 35*(6), 20–25.

> *Strategy 24: Help parents understand the nature of ADHD so they can better help you and their child manage the rigor of the classroom and academic workload.*

What the Research Says

 According to the National Institute of Mental Health (2006), attention-deficit/hyperactivity disorder (ADHD) is a condition that becomes apparent in some children in the preschool and early school years. It is hard for these children to control their behavior and/or pay attention. It is estimated that between 3% and 5% of children in the United States, or approximately 2 million children, have ADHD. This means that in a classroom of 25 to 30 children, it is likely that at least one will have ADHD.

Classroom Applications

There is much for parents to know about students with ADHD. This is a very common disorder and often a challenge for mainstream teachers. The goal is to be informative and helpful, gaining the support of parents in your efforts to help their children manage or modify their behavior to better master academic learning. Keep in mind that the lack of solid information can cause misunderstanding, as it is common for

parents to feel somewhat responsible for a child with a problem such as ADHD. The faster you can help them work through this, the faster they will begin to provide support and help. Teachers can help facilitate this by providing accurate information to help dispel myths associated with ADHD.

The following information is adapted from the National Institute of Mental Health (NIMH, 2006) and is only the beginning. Much more information about ADHD can be found at the NIMH Web site, http://www.nimh.nih.gov/publicat/adhd.cfm#intro. There are no copyright restrictions regarding this information or the information on their Web site, and it can be used by teachers and schools freely.

What Causes ADHD?

One of the first questions a parent will have is, "Why?" or, "What went wrong?" or "Did I do something to cause this?" A teacher can help parents begin to understand the facts behind the myths by knowing the latest information.

There is little compelling evidence at this time that ADHD can arise purely from social factors or child-rearing methods. Most substantiated causes appear to fall in the realm of neurobiology and genetics. This is not to say that environmental factors may not influence the severity of the disorder, and especially the degree of impairment and suffering the child may experience, but that such factors do not seem to give rise to the condition by themselves.

The parents' focus should be on looking forward and finding the best possible way to help their child. Scientists are studying causes in an effort to identify better ways to treat, and perhaps someday to prevent, ADHD. They are finding more and more evidence that ADHD does not stem from the home environment, but from biological causes. Knowing this can remove a huge burden of guilt from parents who might blame themselves for their child's behavior.

Over the last few decades, scientists have come up with possible theories about what causes ADHD. Some of these theories have led to dead ends, some to exciting new avenues of investigation.

Environmental Agents

Studies have shown a possible correlation between the use of cigarettes and alcohol during pregnancy and risk for ADHD in the offspring of that pregnancy. As a precaution, it is best during pregnancy to refrain from both cigarette and alcohol use.

Another environmental agent that may be associated with a higher risk of ADHD is high levels of lead in the bodies of young preschool children. Since lead is no longer allowed in paint and is usually found only in older

buildings, exposure to toxic levels is not as prevalent as it once was. Children who live in old buildings in which lead still exists in the plumbing or in lead paint that has been painted over may be at risk.

Brain Injury

One early theory was that attention disorders were caused by brain injury. Some children who have suffered accidents leading to brain injury may show some signs of behavior similar to that of ADHD, but only a small percentage of children with ADHD have been found to suffer a traumatic brain injury.

Food Additives and Sugar

It has been suggested that attention disorders are caused by refined sugar or food additives or that symptoms of ADHD are exacerbated by sugar or food additives. In 1982 the National Institutes of Health held a scientific consensus conference to discuss this issue. It was found (Consensus Development Panel, 1982) that diet restrictions helped about 5% of children with ADHD, mostly young children who had food allergies. Another study (Wolraich, Milich, Stumbo, & Schultz, 1985) on the effect of sugar on children, using sugar one day and a sugar substitute on alternate days, without parents, staff, or children knowing which substance was being used, showed no significant effects of the sugar on behavior or learning.

In another study (Hoover & Milich, 1994), children whose mothers felt they were sugar-sensitive were given aspartame as a substitute for sugar. Half the mothers were told their children were given sugar, half that their children were given aspartame. The mothers who thought their children had received sugar rated them as more hyperactive than the other children and were more critical of their behavior.

Genetics

Attention disorders often run in families (Faraone & Biederman, 1998), so there are likely to be genetic influences. Studies indicate that 25% of close relatives in the families of ADHD children also have ADHD, whereas the rate is about 5% in the general population. Many studies of twins now show that a strong genetic influence exists in the disorder.

Researchers continue to study the genetic contribution to ADHD and to identify the genes that cause a person to be susceptible to ADHD. Since its inception in 1999, the Attention-Deficit/Hyperactivity Disorder Molecular Genetics Network has served as a way for researchers to share findings regarding possible genetic influences on ADHD.

Recent Studies on the Causes of ADHD

Some knowledge of the structure of the brain is helpful in understanding the research scientists are doing in searching for a physical basis for attention-deficit/hyperactivity disorder. One part of the brain that scientists have focused on in their search is the frontal lobes of the cerebrum. The frontal lobes allow us to solve problems, plan ahead, understand the behavior of others, and restrain our impulses. The two frontal lobes, the right and the left, communicate with each other through the corpora callosa, nerve fibers that connect the right and left frontal lobes.

The basal ganglia are the interconnected gray masses deep in the cerebral hemisphere that serve as the connection between the cerebrum and the cerebellum and, with the cerebellum, are responsible for motor coordination. The cerebellum is divided into three parts. The middle part is called the cerebellar vermis.

All of these parts of the brain have been studied through the use of various methods for seeing into or imaging the brain. These methods include functional magnetic resonance imaging (fMRI), positron-emission tomography (PET), and single photon emission computed tomography (SPECT). The main or central psychological deficits in those with ADHD have been linked through these studies. By 2002, the researchers in the NIMH Child Psychiatry Branch had studied 152 boys and girls with ADHD, along with 139 age- and gender-matched controls without ADHD. The children were scanned at least twice, some as many as four times over a decade. As a group, the ADHD children showed 3% to 4% smaller brain volumes in all regions—the frontal lobes, temporal gray matter, caudate nucleus, and cerebellum.

This study (Castellanos et al., 2002) also showed that the ADHD children who were on medication had a white matter volume that did not differ from that of the controls. Those never-medicated patients had an abnormally small volume of white matter. The white matter consists of fibers that establish long-distance connections between brain regions. It normally thickens as a child grows older and the brain matures.

Although this long-term study used MRI to scan the children's brains, the researchers stressed that MRI remains a research tool and cannot be used to diagnose ADHD in any given child. This is true for other neurological methods of evaluating the brain, such as PET and SPECT.

Precautions and Possible Pitfalls

 General education or mainstream teachers should work closely with special education teachers regarding any student with an IEP that includes an ADHD diagnosis. Remember, teachers and

principals are not health professionals and cannot make a diagnosis of ADHD. Parents will oftentimes mistake your information on ADHD for a diagnosis, so be cautious in your communication. Nevertheless, if you do suspect a student of exhibiting ADHD symptoms, please don't hesitate to refer them to specialists at your site.

Sources

Biederman, J., Faraone, S. V., Keenan, K., Knee, D., Tsuang, M. F. (1990). Family-genetic and psychosocial risk factors in DSM-III attention deficit disorder. *Journal of the American Academy of Child and Adolescent Psychiatry, 29*(4), 526–533.

Castellanos, F. X., Lee, P. P., Sharp, W., Jeffries, N. O., Greenstein, D. K., Clasen, L. S., et al. (2002). Developmental trajectories of brain volume abnormalities in children and adolescents with attention-deficit/hyperactivity disorder. *Journal of the American Medical Association, 288*(14), 1740–1748.

Consensus Development Panel. (1982). Defined diets and childhood hyperactivity. *National Institutes of Health Consensus Development Conference Summary, 4*(3), 161–165.

Faraone, S. V., & Biederman, J. (1998). Neurobiology of attention-deficit hyperactivity disorder. *Biological Psychiatry, 44*, 951–958.

Hoover, D. W., & Milich, R. (1994). Effects of sugar ingestion expectancies on mother–child interaction. *Journal of Abnormal Child Psychology, 22*, 501–515.

National Institute of Mental Health. (2006). *Attention deficit hyperactivity disorder.* Retrieved September 10, 2008, from http://www.nimh.nih.gov/publicat/adhd.cfm#intro

Wolraich, M., Milich, R., Stumbo, P., & Schultz, F. (1985). The effects of sucrose ingestion on the behavior of hyperactive boys. *Pediatrics, 106*, 657–682.

Strategy 25: Teachers need to help parents help students with Individual Educational Plans (IEPs) and define the parental role in the process.

What the Research Says

Hammond, Casteneda, and Ortega (2006) simply stated that many parents are confused by IEP goals, accommodations and modifications, and educational jargon in general. Further, they felt that teachers misunderstand how confused parents can become with the IEP process, especially with their role in implementing and aiding the process of accommodations and modifications at home. They simply don't

know how to help their children at home. The researchers felt that teachers can be more proactive in helping parents.

Classroom Applications

 When a student has been identified for special needs, parents and family members design a plan to help the student develop skills in the identified areas. Teachers, both special education and mainstream, realize it is important that children with special needs get practice at learning the skills in school. Sometimes parents get confused about what it means to have a modification and what it means to have an accommodation. Usually, a *modification* means a change in what is being taught to or expected from the student. Making an assignment easier so the student is not doing the same level of work as other students is an example of a modification. An *accommodation* is a change that helps a student overcome or work around his or her disability and reduce the barriers to learning.

Many educators are challenged with the task of creating ways to empower and involve parents in practicing the goals, modifications, and accommodations that are listed in the IEP. While many teachers do make suggestions for home carryover programs for parents, much of the time parents find them hard to implement and do. Parents can become frustrated or confused at what the IEP says.

Consider developing an activity-based intervention (ABI). What is an ABI? It is a model that utilizes natural settings to aid learning and teaching. To begin, plan out times and ways to practice needed skills during the flow and context of naturally occurring daily activities. Homes, stores, and parks provide naturally occurring contexts for basic counting and other math skills, and most communities are filled with signs and other reading material found in stores and offices to put literacy skills in authentic contexts. The key as teachers is to help parents recognize home and community learning and teaching opportunities when they see them and to link goals, modifications, and accommodations with these home and community learning opportunities. Teachers can analyze everyday natural home and community activities and look for ways to utilize them to empower parents with instructional tips.

Precautions and Possible Pitfalls

Some teachers will look at ABI as additional prep or more work. However, once a teacher starts thinking and developing the home and community as instructional settings, it is only a matter

of establishing a list of learning opportunities and adding to the list as other opportunities appear. Once a list is created, a teacher just needs to match the student with the most appropriate activities for their condition and situation. Teachers can work in teams to brainstorm ideas and share them with each other. The empowerment that parents feel is tremendous, and parents are taught to serve as a wonderful resource for the teacher and school.

Sources

Cooper, P. (1996). Are Individual Education Plans a waste of paper? *British Journal of Special Education, 23*(3), 115–119.

Hammond, H., Casteneda, R., & Ortega, R. (2006). Taking a child's IEP home. *EP Magazine.* Retrieved July 31, 2007, from http://www.eparent.com

6

Looking at the Roles of Nonparental Caregivers in the Student's Life

Call it a clan, call it a network, call it a tribe, call it a family. Whatever you call it, whoever you are, you need one.

—Jane Howard

If kids come to us [educators/teachers] from strong, healthy functioning families, it makes our job easier. If they do not come to us from strong, healthy, functioning families, it makes our job more important.

—Barbara Colorose

 Strategy 26: Develop more specialized strategies for involvement when grandparents or other caregivers are primarily responsible for raising school-age children.

What the Research Says

 The role grandparents play in student development is an increasingly recognized phenomenon in the United States as well as other developed nations. For example, nearly 6% of

83

children reside in homes where grandparents are the head of household (U.S. Census Bureau, 2001), and there has been a steep increase in grandparents serving as surrogate parents to their grandchildren (Fuller-Thomson & Minkler, 2000). According to the latest census figures, 6.7 million children in the United States are being raised by grandparents and other relatives. That's roughly 1 in 12 children, or about 10 times the number of children in the U.S. foster care system. Also, about a quarter of grandparents raising grandchildren live below the poverty line. The increase is attributed to a number of dire conditions affecting parents and children of grandparents, such as death, divorce, child abuse, drug use, and incarceration (Edwards & Daire, 2006). Often, grandparents are the most willing of any family member to take grandchildren into their home (Edwards, 1998).

Edwards and Daire (2006) found that many grandparents who raise their grandchildren endure and suffer from psychosocial difficulties and physical distress. In their research utilizing a large sample of low-income families, they found that children raised by relatives exhibited lower academic scores when compared to their matched peers. They also exhibited more grade failure, learning disabilities, and feelings of loss, rejection, and attachment disorder.

They also found (Edwards & Daire, 2006) that grandparents had less energy to assist grandchildren with schoolwork and social-emotional development. Grandparents can also lack the expertise, time, and patience to help their grandchildren succeed academically. Some may feel anger, ambivalence, and resentment regarding their role or reentry into a parenting mode.

Aside from all the problems discussed in the research, researchers found that, for children, living with someone who loves them and is willing to raise them and having the opportunity to maintain the family connection and history are definite advantages that help keep them out of the foster care system.

Classroom Applications

 While the research cited looked at grandparents exclusively, the major concepts outlined here could apply to other caregivers and family arrangements. Here are some reasons grandparents or other caregivers step into the parenting roles.

- Substance abuse
- Death of a parent
- Child abuse and/or neglect
- Abandonment
- Teenage pregnancy
- HIV/AIDS
- Unemployment

- Incarceration
- Divorce
- Mental health problems
- Family violence
- Poverty

Keep in mind that school may be a much different place from the schools that older adults remember. Schools might consider scheduling extra time for nonmainstream caregiver–teacher conferences, letting them know how to reach the teacher not only when there is a problem but at any time, and encouraging grandparents or others to volunteer at school to gain a sense of current school practices.

Schools can contribute significantly to helping grandparents and others cope with the stresses of parenting a second time around. Use family-friendly strategies to encourage surrogate parents to take an active role in their children's education. These strategies include using inclusive language on home–school communications. Schools might want to stress to teachers the importance of understanding how the child views his or her primary caregiver. When the teacher is sending home important notices, the teacher needs to know whether it is the grandfather, the grandmother, or another caregiver who will need to read, sign, and return the forms. The child and his or her classmates need to hear the teacher's accurate acknowledgment of this important relationship. Be aware that oftentimes, the child will call the grandparent "mom" or "dad." It's conceivable that the classroom teacher won't realize the primary caregiver is the grandparent, as age isn't as much of a factor in this century as in the last. It is important that the principal, counselor, or school office manager (who usually does the enrolling at an elementary school) shares this information with the teacher.

Consider sharing with grandparents these two Internet sites: http://www.grandparentsasparents.org/ and http://www.aarp.org/families/grandparents/raising_grandchild/. These sites provide information and links for grandparents raising grandchildren.

Precautions and Possible Pitfalls

As a basis for understanding and helping, school personnel may need to learn to recognize and accept strong feelings experienced by each member of the caregiver–parent–child triad. Grandparents (even those who find great satisfaction in raising their grandchildren) often feel disappointment mixed with anger, blame, guilt, and serious concern about family finances. Parents usually have ambivalent feelings of gratitude and resentment as they grieve the loss of their child, even if they recognize that the decision to remove the child from their care is in the child's best interest. Often, resentment deepens as estrangement widens.

Children raised by grandparents or others may express feelings of abandonment, even though they are grateful to their grandparents for taking care of them (Saltzman & Pakan, 1996). Grandparent/caregiver, school personnel, and child interactions with noncustodial parents can be supportive or damaging to all the parties involved.

Sources

Edwards, O. W. (1998). Helping grandchildren raised by grandparents: Expanding psychology in the schools. *Psychology in the Schools, 35,* 173–181.

Edwards, O. W., & Daire, A. P. (2006). School-age children raised by their grandparents: Problems and solutions. *Journal of Instructional Psychology, 33,* 113–119.

Fuller-Thomson, E., & Minkler, M. (2000). America's grandparent caregivers: Who are they? In B. Hayslip Jr. & R. Goldberg-Glen (Eds.), *Grandparents raising grandchildren: Theoretical, empirical, and clinical perspectives* (pp. 3–21). New York: Springer.

Saltzman, G., & Pakan, P. (1996, Winter). Feelings . . . in the grandparent raising grandchildren triad (or relationship). *Parenting Grandchildren: A Voice For Grandparents, 2*(1), 4–6.

U.S. Census Bureau. (2001). *Census 2000 supplementary survey: Profile of selected social characteristics.* Washington, DC: Author.

Strategy 27: Be aware that in many cases, siblings replace parents as information sources when parents are not able to assist students with the college or university curriculum and application pathways.

What the Research Says

Ceja (2006) explored the college choice process of first-generation Chicana students by examining the information sources available to these students within their home environments. Specifically, the study looked at the ability of parents to assist their daughters as they prepared and planned for college. Further, the researcher also looked at the importance of having a college-going tradition via older siblings and the positive influence this can have on the ability of first-generation Chicanas to negotiate the college choice process.

This study examined the collective and individual educational experiences of 20 Chicana seniors enrolled in one urban high school in the Los Angeles area. All participants were first-generation, college-bound

Chicanas from low socioeconomic backgrounds. In this study, the term *Chicana* was defined as a female of Mexican descent living in the United States, regardless of immigration status.

The findings of this study suggest that in many cases, siblings with postsecondary educational experiences replaced parents as information sources when parents were not able or available to assist in the college choice and application process.

Classroom Applications

This discussion is based on the cited research (Ceja, 2006) involving Hispanic females. It is safe to say that families from other nondominant cultures can experience similar situations and issues. The majority of the parent participants in this study did not have the opportunity to experience the college choice process themselves, and most students noted that their parents were completely unfamiliar with the different aspects of the college choice process. In some cases, familiarity with the college choice process was greater among students from families with some college-going tradition by way of older siblings.

The ability of older brothers and sisters to assume the role of protective and informative agents is important for any siblings who are not able to gain this information from their parents. In many cases, these older siblings open the door of opportunity for their younger siblings.

The important role of siblings in this study shows the value of involving and utilizing all family members in the college or university choice and application process. Among the Chicanas in this study who did not have older siblings with college experience, planning for their postsecondary experience proved to be a greater challenge. The difficulties and pressures of being the first to go to college, coupled with the lack of parental knowledge and guidance, surely makes the college choice process more difficult. To add to the pressures, many children often feel the obligation to inform and familiarize their parents about the different aspects of the college or university process.

The findings of this study suggest that school personnel working with this demographic need to develop a highly proactive approach to their outreach programs. This needs to be done both formally and informally to involve other family members in assisting these students in decision-making processes regarding college and university attendance.

Schools' pre-college programs can develop protocols to reach out to other family members who could become part of the decision-making process. Teachers and counselors can begin to ask these students about which members of their family might have experiences they could learn and draw from and then utilize them.

Precautions and Possible Pitfalls

 Many teachers and other educators limit their interaction with families to the student and the parents or guardian. This view is often driven by school legal policy or generally acceptable common practices. It is easy to see that involving siblings or others, beyond the parents, can lead to policy questions. It's clear that each individual school and educator will need to begin discussions on if or how siblings and other family members fit into the school's paradigm on college and university preparation. However, it's clear from the study that there is no one-size-fits-all solution to getting minority students into schools of higher education.

Source

Ceja, M. (2006). Understanding the role of parents and siblings as information sources in the college choice process of Chicana students. *Journal of College Student Development*, 47(1), 87–104.

 Strategy 28: Develop a comprehensive picture of the many benefits of a broad definition of parent, family, and/or community involvement in all stages of the educational process.

What the Research Says

The idea behind this research was to document patterns of family activity that contributed to long-term student success through the student's secondary school experience into colleges and universities and on into the workforce. Data for this study was drawn from the National Educational Longitudinal Study (NELS, 2002), an extensive longitudinal study, which has been constructed to follow a cohort of students from eighth grade through high school, college, and into the workforce. The first wave of data was collected in 1988, and the same group was surveyed again in 1990, 1992, 1994, and 2000.

Several of the parent involvement factors when students were measured in eighth grade had significant and lasting effects on the instructional achievement after middle school, in high school, and in postsecondary achievement. The two primary outcomes tested were academic achievement in high school (measured by standardized test scores) and postsecondary attainment (measured by a six-point scale ranging from *some postsecondary attainment but no degree attained* to *PhD or a professional degree*

obtained). Some of the parent factors influencing academic achievement both in high school and beyond involved parental expectations that included the following:

- The further in school parents believed their adolescents would go, the higher the adolescents' academic achievement. They tended to rise to the expectations.
- The further in school parents believed their adolescents would go and the clearer the adolescents' perception of such expectations, the higher their own academic expectations and the higher their academic achievement.
- The further in school parents believed their adolescents would go, the more time they spent on homework and the higher their academic achievement.

Similar to findings from other research (Catsambis, 2001), setting high standards and expectations constitutes a powerful way parents can support continuously the educational attainments of their sons or daughters in high school and beyond.

Classroom Applications

It is so very important that parents understand the power and positive force they have and can be to shape their son or daughter's long-term success from an early age. Parents need to know that an adolescent student's desire for autonomy should not be seen as a barrier to family involvement. A student's desire for autonomy serves as a moderator of preferences for certain types of involvement over other types. It is not a barrier to all types of involvement. Generally, high school students believe they can perform better in the classroom if they know their family is mentally there at school with them and that they care if they're successful. This type of involvement is very different from homework completion, which is sometimes hard for high school parents.

What can you do? Make your expectations of student achievement clear as soon as they start school. The expectations you generate in elementary school will assist through the middle and high school years, but the effect of expectations is powerful for adolescents.

Some parents might be surprised to learn that research shows they have a strong influence on their teenagers. Simply letting them know is an important first step. Among other things, schools can encourage parents to (1) keep open lines of communication with their teens by maintaining family time to discuss things and share common activities; (2) enforce consistent rules that help adolescents learn the relationship of independence and responsibility; and (3) show that education is important by encouraging homework and reading, knowing the student's teachers, and supporting

postsecondary education planning. In addition to these general recommendations, it is important for schools to provide specific information and suggestions that are aligned with the broader curriculum framework and expand learning from the classroom to the home and beyond.

In order to further foster better communication between home and school, teachers should encourage parents to be aware of school policies and the curriculum. Letting parents know about the best ways to communicate with their teen's teachers will also promote communication as it lifts some of the confusion that the structural complexity of secondary schools creates. In addition to printed communications, there are many forms of communication through which such information can be communicated or reinforced: parent mentoring programs (especially during times of transition to middle school and then to high school), family resource centers, the school Web site, brown bag meetings, or parent–teacher meetings. Teachers should also recognize that school-initiated communication for specific students tends to take place when adolescents misbehave or face academic problems. It is critical to expand child-specific communication to include positive news. Such a strategy will foster a positive climate and make parents more involved and responsive to future school outreach. Making the first parent contact positive is one of the best tactics a teacher or principal can use to foster the relationships and parental expectations that research has shown are so crucial to student success.

Precautions and Possible Pitfalls

As with many of these strategies, there can be parents from different cultures who view schools differently than you do. Their goals for their children may be different. In some cases, goals and expectations differ for girls and boys. A caring teacher might be very disappointed to find that the parents' goals may not include college or graduate school.

Sources

Catsambis, S. (2001). Expanding knowledge of parental involvement in children's secondary education: Connections with high school seniors' academic success. *Social Psychology of Education, 5*, 149–177.

National Education Longitudinal Study of 1988. (2002). *Base-year to fourth follow-up data files.* Washington, DC: U.S. Department of Education, National Center for Education Statistics.

Patrikakou, E. V. (2004). Adolescence: Are parents relevant to students' high school achievement and post-secondary attainment? Retrieved September 11, 2008, from http://www.addfamilysupport360.org/3_10/DDRDocuments/FamilyInvolvementinEducation.pdf

7

Communicating With Families and Bridging the Gap Between School and Home

At home we have always regarded the dining table as the prime seat of learning. We planned it so it was impossible to see or hear a TV from the table, and it has paid dividends in the volume of ideas that have been shared over the evening meal.

—Noel Whittaker

Your best teacher is your last mistake.

—Ralph Nader

 Strategy 29: You can influence secondary school family outreach and involvement in a positive way by knowing what types of outreach parents would be most likely to respond to and appreciate.

What the Research Says

 Which types of outreach are parents more likely to want to engage in? This study (Simon, 2004) was developed from evidence drawn from a data sample within the National Education

91

Longitudinal Study (NELS, 2002), a survey conducted by the National Centre for Educational Statistics. The original sample of 24,599 students from 1,052 schools completed surveys in 1988 when they were in the eighth grade. These students were followed over time through high school and into postsecondary schooling or careers. Information was obtained on a range of research questions, including how different characteristics and practices of schools, families, and communities contributed to student success. The researcher analyzed data from a subset of 11,348 parents who completed a second follow-up survey in 1992.

Analysis of the data led the researcher to conclude that the extent of parental involvement in their children's education was related to the frequency of approaches made by the schools to parents, regardless of teenagers' socioeconomic status, gender, family structure, race/ethnicity, and achievement—as perceived by the parents themselves.

However, specific forms of school outreach were found to be related to specific forms of parental involvement. The study classified approaches that schools made to parents into activities relating to

- parenting, including helping their children prepare for life after school by planning and discussing future education or employment opportunities with them;
- volunteering, including attendance at school social activities with their children; and
- learning at home, including parents' knowledge of their children's academic progress and working with their children on homework or coursework tasks.

The evidence showed that the more contacts there were in these specific areas, the more parents were likely to respond.

Classroom Applications

 Parents reported that they responded in specific ways, saying that increased contacts with school about certain topics led them to respond as follows:

- Postsecondary education and employment activities correlated positively with improved parent attendance at workshops and meetings about this topic, leading to more discussions between parents and their children about postsecondary planning and course selection and to greater parental involvement with homework activities.
- Fund-raising and volunteering activities correlated positively with parents attending social activities more often and also, perhaps

surprisingly, with the increased likelihood that parents talked with their children about academic-related issues.

- Homework support activities correlated positively with greater parent–pupil joint work on homework and coursework projects, and with more frequent discussions between parents and their children about school.

Overall, the evidence suggested that parental involvement was most likely to occur when the activity directly affected their children (postsecondary education and employment activities) or when it gave parents a sense of empowerment (fund-raising and volunteering activities).

Negative responses resulted when schools contacted parents because of the behavior and attendance of students. The study suggested that if schools communicated with parents about teenagers' attendance or behavior problems without describing ways that parents could help teenagers with specific kinds of support, parents did not know how to respond to the school contact. Many times teachers and administrators think it is enough to notify parents about student behavior and the parents will know how to respond. Often this isn't the case. Giving support and advice may be an effective way to help schools reverse the negative relationship with parents that develops around behavior and attendance issues.

In completing this research, Simon (2004) began to ask the following questions about implications for practitioners and parents:

- What is the balance of communication with parents? Does your school mainly write to parents about behavior issues?
- Does your school assume parents know how to be involved in their child's education, or does your school reach out to parents regularly?
- Who are the hard-to-reach families at your school, and how might they be welcomed as partners?
- Would it be helpful to discuss other ways in which your school could include parents and encourage them to support their child's education?
- As a parent, could you become more involved in school activities?
- How can leaders help schools to develop effective ways of communicating with parents?
- Are there examples of effective strategies used to involve parents in combating behavior and attendance problems that you could use to advise parents in this position?

Teachers often make assumptions about how parents go about parenting with regard to negative school-related issues. Many parents don't have the experience with schools to relate to the teacher's or school's concerns. It makes sense to have some responses to parents who may not know how

to handle the situation. Consider having some examples of the things other successful parents have done in managing whatever issues parents are dealing with.

Precautions and Possible Pitfalls

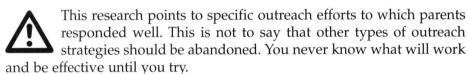 This research points to specific outreach efforts to which parents responded well. This is not to say that other types of outreach strategies should be abandoned. You never know what will work and be effective until you try.

When advising parents or making suggestions, realize that not all parents will be receptive. Young teachers with obviously little or no parental experience may not come across as credible. Also, watch out for the trap of seemingly quick and easy communication through notes to parents. A common way for elementary school teachers to communicate misbehavior with parents is to send a note home. As the study confirms, a note home, with no suggestions on how the behavior might be remedied, is not an effective way to engage parents. Experience has shown us that picking up the phone and having a conversation about student behavior is well worth the time it takes.

Finally, although your attempts to communicate aren't intended as such, some parents might see them as meddling.

Sources

National Education Longitudinal Study of 1988. (2002). *Base-year to fourth follow-up data files.* Washington, DC: U.S. Department of Education, National Center for Education Statistics.

Simon, B. S. (2004). High school outreach and family involvement. *Social Science of Education, 7,* 185–209.

 Strategy 30: Give your parents and the community opportunities to participate in developing learning partnerships.

What the Research Says

 Sanders and Lewis (2005) felt that despite interest in the role of community involvement in school improvement, there have been few studies that have examined the motivations for and the results of community partnerships in schools. The authors explored these notions in case studies of three high schools that featured successful

community partnerships. They found that high school leaders' motivation for community partnerships fell into three sometimes interrelated categories: (1) improving student academic and personal success, (2) enhancing school quality, and (3) supporting community development. The three high schools in the study developed a wide range of community partnership activities that reflected these different motivations for the development of partnerships.

Classroom Applications

Research has shown consistently that with an increase in parent involvement comes an increase in student achievement (Ramirez, 2001). Look at parents as key to building bridges toward developing more interest in the role of community involvement in schools. Historically, schools have not been asked to be more accountable for the learning gains of an increasingly diverse student demographic. And in most states, due to strained budgets, the need to generate resources has never been greater. Many schools now have a renewed interest in looking to the parents and the community to support school improvement efforts and student learning.

Currently, the greatest energy and success for increased community involvement have been in the elementary grades. Elementary schools have long made use of parents with expertise in a particular field or a business owner in the area who is also a parent. These partnerships are very productive in that they can channel additional resources to the schools while also providing students in the neighborhood with role models for future career or college success. High schools generally lag far behind. Educators interested in developing or expanding their community partnerships can learn from this study.

Foley (2001) found that the most common type of community partnership activity in high schools were school–community collaborations in student internships and school-to-work programs. About 50% of principals interviewed reported that their high school had such activities. And while some schools were able to develop, direct, and maintain these resources, a study focused on community partnerships in more than 400 schools found that many have not. And more than half of these schools reported not doing so because of difficulties in identifying potential partners, time constraints, or lack of school leadership. Foley found that secondary schools were more likely to present these problems.

Unfortunately, there is a gap in educators' understanding of how to integrate community connections into a comprehensive high school. The consensus synthesized from the three sample high schools offered the following advice: prioritize the process, permit time, and promote community ownership. The following was adapted from the research of Sanders and Lewis (2005).

- These schools recommended prioritizing the process to create a firm foundation of understanding for a "clearly defined mission." Form a partnership committee and start small with a needs assessment and a strong motivated leader who can work outside the classroom boundaries and deal with various community members. Create a strategic plan with clear action steps. You need a clear vision and a willingness to start small and not shortchange the development process. The school principal should be involved and make this a priority.
- The schools in the Sanders and Lewis (2005) study also warned of the importance of permitting the necessary time for partnership program development. You need to take time, and you need to be dedicated and keep it up past the first few months of trying. Time is needed to identify school and community needs, to recruit community partners/mentors, to attend planning meetings, and to reflect on past information to better design and create new opportunities. Much of what needs to be done is done in addition to teachers' regular responsibilities. The principal needs to support this effort, as time to create the community paradigm is essential.
- Finally and most important, community members need to feel ownership of any partnership. Community partners need a clear niche they can call their own. They need to know they are valued. Promote ownership by listening and accommodating the ideas and concerns that your community partners present. It should also be noted that individual community members might need to be trained to work with students. Structuring the students' learning experiences is tough for teachers. Most community members don't have the insight educators have in structuring learning activities and managing students.

Precautions and Possible Pitfalls

There are schools that don't seek help and support from community members and businesses. There are also schools that ask for help and input, but don't really listen to their parents or community members. Be careful not to promise or offer opportunities you can't follow up on, and if you are a teacher, make sure your administration and board are behind what you want to do.

There are teachers who feel that parents are something they have to "deal with" rather than "work with." They can become a negative force and can make it hard to keep a positive perspective. There are also barriers to parental involvement that come from the stereotypical views teachers hold about parents. Barriers come from views some teachers hold about

parents of lower socioeconomic means, single-parent families, certain minority families, or at-risk families.

Sources

Foley, R. (2001). Professional development needs of secondary school principals of collaborative-based service delivery models. *The High School Journal, 85*(1), 10–23.

Ramirez, A. Y. (2001). Parent involvement is like apple pie: A look at parental involvement in two states. *The High School Journal, 85*(1), 1–9.

Sanders, M. G., & Lewis, K. C. (2005). Building bridges toward excellence: Community involvement in high schools. *The High School Journal, 88*(3), 1–9.

Strategy 31: Few schools have a clear or explicit rationale for parental involvement or participation, so when updating your classroom's or school's home, community, and school policy, it is helpful to discuss with all stakeholders the hoped-for benefits of parental involvement.

What the Research Says

The primary schools in this study (Edwards & Warin, 1999) invested considerable time and effort in securing parental involvement in their children's learning. The authors set out to discover exactly what reasons schools offered for the time they had invested in parental involvement. What did the schools think were the role and value of parental involvement? Edwards and Warin's (1999) research was part of an evaluation of a four-year study in the U.K. that aimed to improve literacy and numeric performance through parental involvement in 70 schools (primaries with six secondary and some special schools). The study looked primarily at questionnaire results of a postal survey of 60 schools participating in the project. The researchers also drew on information from previous surveys and from case studies of participating schools compiled using interviews, field notes, and documentary analyses between 1992 and 1997. The questionnaires asked teachers what their rationales were for parental involvement. The answers were sorted into a number of categories based on the meaning of the responses.

- Supporting pupil learning at home
- Communicating to parents about school activity

- Parents know their children better than we do
- Showing children that home and school are linked
- Developing self-esteem
- Parents become better educated
- Parents can work as volunteers in school
- Linking the school and community
- Providing a support network for parents
- Parents become aware of the demands on the teacher

From their analysis of the evidence, the authors reported that:

- The schools' reasons for parental involvement were not well elaborated.
- The degree of parental involvement was not clear, and schools did not measure participation carefully. The authors suggested that this might have been due to poor record keeping in some schools.
- Teachers expressed a number of reasons for involving parents, but the most dominant of these was for parents to act as agents of the school in teaching their children elements of the school curriculum.
- Primary schools were overwhelmingly concerned with "getting parents in" but did not measure the effectiveness of participation in terms of pupil achievement.
- The self-esteem mentioned by teachers in responses to questionnaires tended not to take into account the crucial role of parents and home in developing their children's self concept—particularly in relation to their cultural and community context.
- In planning tasks for parents, schools concentrated too much on very skilled tasks which really needed specialist teaching knowledge.

Classroom Applications

The researchers conclude that the main focus in the schools' reasons for parental involvement was on breaking down barriers between home and school to improve the one-way flow of information and materials that carried school values into pupils' homes. They also reported that some schools felt that improving the connections between home and school helped with discipline. They believed that parental involvement showed the children that school and parents were on the same side, so they did not try to play school against home. The primary motivation to include parents focused on transmitting school values to parents. The goals of these relationships were not based primarily on instruction.

However, in primary schools, they concluded that teachers were looking toward parents to help them deliver aspects of the overloaded primary

curriculum. Hence, if parents could act as home tutors, then teachers' efforts in encouraging parents to get involved would have been worthwhile. At the very least, barriers between home and school could be whittled away so that parents would come to value the efforts of the school, ensure their children's attendance, and show that they supported the school so that pressure on hard-pressed teachers could be eased.

While sympathetic to hardworking teachers, the researchers go on to argue that schools could be placing children from disadvantaged homes in a double bind. Children whose parents operated in ways approved by the school were likely to be those least in need of additional help and most likely to benefit from the strategies advocated by the school.

Overall, the researchers concluded that perceptions of parental involvement by teachers and schools represented less of a partnership than a "colonization of home by school" (Edwards & Warin, 1999, p. 328). They argued that a new view of parental involvement is needed that might require teachers to have a better understanding of the social conditions of identity construction, a fuller understanding of the demands of literacy and mathematical pedagogy, and more time to prioritize curriculum demands. Specifically, they recommended that before teachers engage in negotiations with parents about what they might mutually expect, teachers should meet a number of conditions in their initial training, professional development, and working contexts:

- Updating their explicit understandings of the complexities of teaching literacy and mathematics so their expectations of parents build on what they can really offer as parents.
- Improving their understanding of the limits of self-esteem, in both the home and school environment, and the importance of social conditions in the development of children's sense of who they are. They can then work more effectively to help parents help their children by starting from where the parents are.
- Reducing the curriculum delivery demands on primary teachers so they can adapt curriculum priorities flexible enough to meet the needs of their parents and local communities. While acknowledging that this represents "yet another wish-list" item, Edwards and Warin (1999, p. 338) argue that any response to the question, "Why bother with parental involvement?" has at least partly to be a pedagogic one, based on analysis of how children learn and how instruction is delivered. Their report shows that the schools involved in the study were still a long way from approaching parental involvement in this manner.

When Edwards and Warin's (1999) concerns are reduced to a simple form, it is clear they are saying that recruiting parents for instructional

purposes takes planning, carefully considering all stakeholders. The following comments are adapted from Edwards and Warin (1999).

- When updating your school's home–school policy, it is very helpful to spend time discussing the hoped-for benefits of parental involvement with all stakeholders.
- Parents are often asked to do tasks for which they were ill-equipped. How can you, as a teacher, support parents to help their children's learning? How can you find out what the parents bring to the table and build on what they know and can do? Is the school willing to support you with planning time?
- Parents who need the most support to help their children are least likely to become involved in home–school initiatives. How can you recruit the hard-to-reach parents? This idea and exact nature of the approach should be discussed on a schoolwide level.
- Few schools evaluate the success of their strategies for parental involvement, either by keeping records of the extent of parental involvement or by trying to find out whether such efforts contribute to increased learning. How do you attempt to evaluate the effectiveness of home–school contacts? How can data be gathered to validate any outcomes?

Precautions and Possible Pitfalls

Many teachers have experienced the dilemma of having willing parent volunteers and no idea of what to do with them. This is awkward and puts the teacher in a sad situation. You want the help but don't know how to utilize it when it comes. And you often feel it is politically incorrect to turn down parents. This is when schools need to manage parental help and volunteers in committees or departments to be clear on the academic and instructional purposes for the parents in the classroom.

Teachers should not be in a position to feel helpless in trying to develop a role for helpful parents. Schools should develop clear goals and training strategies for parents and not just turn them over to teachers, creating more "prep" work for them. Parent–school relationships need formal attention from all stakeholders. This avoids increasing the workload for teachers and misunderstanding parents.

Source

Edwards, A., & Warin, J. (1999). Parental involvement in raising the achievement of primary school pupils: Why bother? *Oxford Review of Education, 25*(3), 325–341.

Strategy 32: Middle school teachers need to recognize and work with communication preferences of parents to foster more effective communication and avoid miscommunication.

What the Research Says

Halsey (2005) explored teachers', parents', and students' perceptions of involvement in the education of young people. The results of the case study suggest that teachers and parents perceive communicative efforts differently. Schools and teachers tend to employ institutional (open house, newsletters) communicative methods, and yet parents often prefer more personal, individual approaches to involvement. Because of this disconnect, both parents and teachers within this study became discouraged by the mismatch of communication preferences.

Results and conclusions came out of data collected using a series of interviews, observations, and document collection in a small, rural Texas junior high school.

Classroom Applications

Findings brought out by the Halsey (2005) study include the following:

1. There is a lack of a clear definition and guidelines regarding the parents' roles in both academic and extracurricular activities. Parent involvement centered on extracurricular activities (e.g., attending field trips, concerts, or athletic events). Parents, teachers, and students recalled much of the parent involvement in these activities but little in the academic classroom. While the school had an "open door" parent policy about interacting with the school concerning academics, few parents actually met with teachers or volunteered for other types of involvement.
2. Few teachers questioned whether parents were adequately informed about opportunities for parent involvement. Most felt the open door policy was enough. Teachers concluded and believed that parents were unwilling to become involved.
3. Parents reported that there was not the perception of an open invitation for classroom involvement. A few parents reported that the classrooms were deliberately kept off limits.
4. Students reported that the perception of parents in the classroom was unnatural and not expected in junior high.

5. The majority of teachers at the school relied primarily on institutional contacts such as open house and weekly newsletters to communicate with parents. Newsletters contained announcements of events and activities. Parents reported expecting more information about their attendance and participation in the events. The parent requests were not detailed enough for them. Institutional contacts were less likely to contribute to parent involvement than personal contacts between teachers and parents. Parents reported that they prefer personal contacts more than teachers do. Teachers reported feeling somewhat threatened because of the chance for possible questions about student progress or performance without the opportunity to prepare (pp. 65–68).

A final obstacle for parent involvement is overcoming the misconceptions that parents, teachers, and students hold. Teachers and parents both harbor misperceptions about each other's support and true desire for parent involvement. Because parents did not always respond to institutional communication, teachers felt the parents to be disinterested, and parents often believed that teachers wanted limited parent involvement because of a lack of personal communication. To compound the problem, both parents and teachers believed that students were not supportive of parent involvement. All these misconceptions may be present in many schools and are difficult to overcome. It may not just be a lack of desire on the part of the main actors but a difficulty overcoming misconceptions.

Many parents and teachers lacked understanding about the role of parent involvement at school. All participants often seem to be uncertain about the specific kinds of involvement that are appropriate for middle school or junior high.

The suggestions from the Halsey (2005) study seem obvious. They focus on improving institutional communication about parent involvement by promoting individual and more casual contact. Also, there are individual teachers at most sites that are known for their parent involvement practices and can promote and provide information about effective methods. If you want to become more involved with parents, tap these teachers as resources. Also, if you are a secondary teacher, look to elementary schools for ideas; successful communication with parents is more common there. Elementary schools generally have more extensive and larger parent involvement programs. Working across grade levels can serve as a bridge from elementary to middle or junior high school within a community.

Within your current methods, try to limit ambiguous expectations surrounding institutional communication. Share your school's or your beliefs and expectations about parent or community involvement with others.

Appropriateness of any parent involvement can be addressed and specific guidelines can be defined and implemented by consensus.

Precautions and Possible Pitfalls

Developing a relationship between the classroom, families, and community means that more opportunities are needed for teachers and parents to get to know each other. Unfortunately, many of these opportunities require teachers to meet with parents during their personal time and afterschool hours. There are no easy recommendations for this problem. Teachers and the principal working together will need to make some personal decisions about their home and work boundaries. If the school principal has a vision of how parent communication can benefit student achievement, and this is clearly articulated to the staff and buy-in is gained, the staff, possibly through the site council, will find a way to make more personal communication happen.

Source

Halsey, P. A. (2005). Parent involvement in junior high school: A failure to communicate. *American Secondary Education, 34*(1), 57–69.

Strategy 33: Examine one model, an online environment used as a vehicle for parent–teacher communication using technology.

What the Research Says

Merkley, Schmidt, Dirksen, and Fulher (2006) described how parent–teacher communication might be enhanced using a Web-based system that manages student reading artifacts along with teacher insight and explanation. They examined how one reading tutor used technology to communicate with parents about their child's literacy growth while the child was enrolled in a university-based tutoring program called the Reading Improvement Clinic. The premise for their work was that establishing mechanisms for meaningful parent–teacher communication is often underemphasized during education classes. Also, it's common that parents find their children less than communicative about what happened during their day, adding to the need to find better levels of communication.

In this study at a Midwestern public university, university students enrolled in Supervised Tutoring in Reading classes were paired with community children in the Reading Improvement Clinic. Each university student engaged in 25 hours of tutoring an assigned child with literacy needs. Students' grade levels ranged from Grades 1 to 8. Researchers expected half of the family applicants would have Internet access at home. Other tutors used the traditional hard copy approach.

Sharing information with families permeated the tutoring experience and expectations. There were required family communication components as well as objectives and minimal requirements for each contact. They were

- A parent communication by phone
- An introduction letter
- Three informal e-mail notes
- A reading assessment letter
- A summary letter and tutoring electronic portfolio and a parent–teacher conference

Each one of these components included specific guidelines as to how each was to be done. In the end, participant tutors emphasized that advantages far outweighed any disadvantages. The parents had instant and ongoing understanding. To follow up on the results of this research, the study group planned to follow this study with an analysis of parent responses to the program.

Classroom Applications

There are many ways to look at the research of Merkley and colleagues (2006). The types of communication highlighted in the research appear to exhibit the natural progression of home–school communication in the beginning of the twenty-first century. To address barriers of time and schedules, e-mail and Web-based communications have emerged as viable options to increase parent–teacher interaction and provide school-based information in a timely and consistent manner. In fact, in many communities, communication via e-mail has become commonplace.

Classically, parents find it difficult to get information from their uncommunicative children about what happened during school. Typically, many parent phone calls to teachers deal with this type of miscommunication. Instead of just listening to their children, parents are seeking other methods like school Web sites and portals to obtain that information. According to the 2004 Nielsen/NetRatings survey, 74.9% of U.S. households with a phone line have access to the Internet. Parents with access are

beginning to rely more on these online sites for daily updates about their child's grades, attendance, and homework. These online communication mechanisms are more convenient for parents, as they do not have to interrupt their workday to phone a teacher or attend a conference.

Precautions and Possible Pitfalls

 The Merkley and associates (2006) research prescribed a minimum number of contacts for each tutor in their program. Each type of contact was different and focused on different things. Should all schools mandate a minimum amount of parental contact? The big problem is time and numbers, especially for secondary teachers. A secondary school teacher might not be able to maintain the mandated contact load described in the research.

Rather than mandate a specific level of interaction, it is suggested that the technology find its own level of use with the willingness of the parents, teachers, and schools to use the new lines of communication available to them. If a teacher is motivated to expand the role of technology, they are welcome to do it.

Sources

Merkley, D., Schmidt, D., Dirksen, C., & Fulher, C. (2006). Enhancing parent–teacher communication using technology: A reading improvement clinic example. *Contemporary Issues in Technology and Teacher Education, 6*(1), 11–42.

Nielsen/NetRatings Survey. (2004). *US broadband penetration jumps to 45.2%.* Retrieved July 30, 2007, from http://www.websiteoptimization.com/bw/0403/

 Strategy 34: Help parents understand media coverage of educational issues. Informed parents should not let national media reports change their views of their own children's abilities or local schools.

What the Research Says

 Parents may develop misconceptions about their children's abilities as a result of reports in the media. One study by Jacobs and Eccles (1985) examined the impact on parents of a media report on gifted junior high school students. Extensive media coverage

focused on a report of a major gender difference in students' mathematical aptitudes. The study compared parents' views about their children's mathematical aptitudes before and after exposure to the media report. The results showed that the media coverage changed parents' attitudes about their children's mathematical abilities. Fathers of sons and mothers of daughters developed stronger gender-based stereotyped beliefs after the media coverage. This can perpetuate unrealistic or limiting expectations for students.

The Phi Delta Kappa/Gallup Poll (Rose & Gallup, 2006) found the public school rating of local schools to be near the top of the poll's 38-year history. They also found that the closer people got to schools in the community, the higher grades they gave them. "A" or "B" grades were given by 49% of those surveyed for the schools in their communities. Seventy percent believed that school conditions reflected the conditions in the general society. There was near consensus for the belief that the problems the public schools face result from societal issues and not from the quality of schooling. Only 22% attributed the problems facing public education to the performance of the schools rather than to societal problems.

Classroom Applications

The 38th Annual Phi Delta Kappa/Gallup Poll (Rose & Gallup, 2006) offered educators some insight and also helped define public relations goals for schools. The big goal for educators is to keep parents involved and knowledgeable. Teachers can offer periodic workshops for parents, keeping them informed of what is being taught, how it is being presented, and what can be expected of their children, in both performance and results. This sort of workshop experience will also give teachers an opportunity to communicate with parents regularly and to inform them of their individual child's progress and ability to be successful in whatever discipline is being taught. Parents will then be more prepared to interpret reports from the media and other sources. These same parents would also be less likely to succumb to overgeneralizations and stereotypes that could undermine their child's performance.

The messages students take home also filter through their parents. For example, many students find one discipline or another to be particularly frustrating. Many parents react by saying that they didn't do well in that subject themselves, so they tend to accept this from their children. Sometimes it appears to be a sort of badge of honor to admit weakness in science or mathematics (unlike almost any other subject!). Just consider the messages that your students might take from you and your classes and realize that they talk to their parents.

Precautions and Possible Pitfalls

Extreme patience must be used when working with parents. Recognize that many of them may have been away from a school setting and the concomitant behavior of students for many years. Media reports may or may not reflect local situations and will need to be placed in a local context for parents.

A teacher should be cautious when reporting frequently on a student's progress and their perception of the student's abilities and potential. Leave room/time for improvement and never close the door on an individual student, no matter how frustrating the child's progress may be. It is especially important to remember that some parents have a tendency to overreact to the teacher's comments, and that may have deleterious effects.

Sources

Jacobs, J. E., & Eccles, J. S. (1985). Gender differences in ability: The impact of media reports on parents. *Educational Researcher, 14*(3), 20–25.

Rose, L. C., & Gallup, A. M. (2006, September). The 38th Annual Phi Delta Kappa/Gallup Poll of public's attitudes toward public education. *Phi Delta Kappan, 88*(1), 41–53.

Strategy 35: Explore the concept of "ambiguous loss" as a useful concept to understand the idea of parental deployment and students in military families.

What the Research Says

Huebner, Mancini, Wilcox, Grass, and Grass (2007) found that parental deployment had substantial effects on the family systems, most notability ambiguity and uncertainty. Youth in military families are especially affected by parental deployment because their coping mechanisms are not completely developed. In this research, focus groups were used to inquire about uncertainty, loss, resilience, and adjustment among youth ages 12–18 who had a parent deployed, most often to a war zone. They found the concept "ambiguous loss" best described the phenomena these young people experience. This research went on to explore these concepts, changes in mental health, and relationship concepts.

Classroom Applications

With the rise in military deployments, many teachers are educating emotionally and academically distracted children. Many teachers are unfamiliar with the challenges families face during deployments. In 2005, about 39% (over 469,999) of the children of deployed parents were age 1 or younger, 33% (over 400,000) were between the ages of 6 and 11, and 25% (over 300,000) were youth between the ages of 12 and 18.

According to the Huebner research (Huebner et al., 2007), how parents prepared their children had a significant effect on how well children were able to cope with separation. These young people were prepared by discussions about where their parents were going, the new responsibilities they would need to assume while they were away, and even more importantly, how much both parents loved them. Conversely, youth whose parents simply left home with very little or virtually no discussion seemed to be coping less effectively.

- Behavioral changes included being distracted from schoolwork while others said they worked harder to improve grades so as not to disappoint the deployed parent.
- Hiding emotions was another characteristic cited by many. They claimed they often hid their feelings to protect other family members.
- Others avoided having to deal with worry by staying busy, exercising, and sleeping.
- Some teens reported that despite efforts to hold their emotions, they often "lashed out" at others for things that usually wouldn't upset them.
- Many teens described the parent that remained as "stressed out" due to the increased responsibility and having concerns over money or worrying about the deployed spouse.
- Changes in discipline were another factor mentioned. Some of remaining parents became stricter while some became more flexible.
- Siblings often described relationships with each other as stronger, bringing them closer together.
- Changes in family routine also changed as meals became less formal and casual, and it was common for older siblings to be relied on more for babysitting and, in essence, co-parenting.
- When asked about the support they received from others, some said they were happy with and receptive to the support from family, friends, and more formal supports, while others sometimes label the attention as "phony." Some complained that the support was only temporary and died down as time went on.
- Teens talked about their struggle in finding a balance between wanting to talk about what was happening and wanting to be distracted from it.

- Most reported that the Internet and cell phones allowed sometimes daily communication that was helpful because children were assured that everything was OK and the parent was not hurt. In contrast, some complained that the communication caused them to think about the deployment more.
- Finally, some experienced problems when the parent returned, as roles changed again. Teens especially complained about their parent treating them as if they were the same age as when they left and not getting credit for the responsibilities they assumed.

As you can see, there are a large number of responses from the children of deployed parents. Empathy is the key quality in working with families and being ready to recognize behaviors that reflect some of the symptoms described here. It's very hard to stereotype any standard responses. Some children may be receptive to your efforts, and others many not want the attention at all. The key is to reach out to try to do what you can to accommodate not only the students but to reach out to the remaining parent as well.

Using a few keywords in a search engine brings up many Web sites with various forms of information and suggestions in working with military families. Each geographic area in the United States has a different resource set to work with. Again the key to providing the most appropriate help is to know your parents and students well. You can begin with Allen and Staley's (2007) article at http://www.journal.naeyc.org/btj/200701/default.asp. Their article offers suggestions for teachers.

Precautions and Possible Pitfalls

Again, each student is an individual, as are the families they come from. There are no one-size-fits-all responses, and each family will have their own needs and comfort levels for your involvement. Don't forget to share what you know about the students and the families with colleagues as the affected students move through the school.

For schools with large numbers of military families, a schoolwide response or program may be the answer to providing help.

Sources

Allen, M., & Staley, L. (2007, January). Helping children cope when a loved one is on military deployment. *Beyond the Journal, Young Children on the Web.* Retrieved August 3, 2007, from http://www.journal.naeyc.org/btj/200701/pdf/BTJAllen.pdf

Huebner, A. J., Mancini, R. M., Wilcox, M., Grass, S. R., & Grass, G. A. (2007). Parental deployment and youth in military families: Exploring uncertainty and ambiguous loss. *Family Relations, 56*(2), 112–122.

Strategy 36: Help parents make informed decisions regarding afterschool programs and out-of-school time.

What the Research Says

The U.S. Department of Education's (2003) article, "When Schools Stay Open Late: The National Evaluation of the 21st-Century Learning Centers Program" offered vast insight into the genre of afterschool programs. Afterschool programs have grown rapidly in recent years, spurred by rising employment rates of mothers, pressure to increase academic achievement, and concerns about risks to children who are unsupervised during afterschool hours. The percentage of public schools offering extended day programs (which include beforeschool and afterschool programs) more than tripled from 1987 to 1999, from about 13% to 47%.

In its first year of data collection, the team gathered data from roughly 1,000 elementary school students in 18 schools in 7 school districts and from 4,300 middle school students in 61 schools in 32 school districts. The elementary study was based on random assignment, in which outcomes of students assigned to the program were compared with outcomes of students not assigned to the program. The middle school evaluation was based on a matched-comparison design, in which outcomes of students who participated in programs were compared with outcomes of similar students who did not. Findings from these data were presented in the study's first report, which was released in February 2003.

For the second year of data collection, researchers gathered additional data in two ways. First, they added more elementary school programs and students. Second, they followed middle school students for a second year, which enabled the evaluation to explore whether there were outcome differences after two years. The results are summarized in this new report, which contains findings from this second year of data collection. A third report will analyze impacts for elementary students after two years.

A Selection of Key Findings From the Second Year

The findings from the second year of the study are generally consistent with those from the first year. Specifically, the study found

- *Few impacts on academic achievement.* Programs did not affect reading test scores or grades for elementary students. Grades for middle school students in programs were higher in social studies relative to the comparison group but not in English, mathematics,

and science. Programs did not increase whether elementary or middle school students completed their homework. Middle school students in programs missed fewer days of school and were more likely to aspire to attend college.

- *Elementary students felt safer.* Elementary students in afterschool programs reported feeling safer during afterschool hours. Middle school students did not report feeling safer.
- *Mixed evidence on negative behavior for middle school students.* Some estimates pointed to higher levels of negative behaviors for middle school students, while others indicated no differences between treatment and comparison groups.
- *Some impacts on parent outcomes.* Parents of participating elementary school students were more likely to report that they attended school events. Other measures of parent involvement did not increase. There was some evidence that programs increased whether mothers of elementary students worked or looked for work. Involvement of middle school parents did not differ between the treatment and comparison groups. No employment difference was observed for mothers of middle school students.
- *Few impacts on developmental outcomes.* Elementary students were more likely to report helping other students after school. They were no more likely to report being able to work with others on a team, believe the best of other people, or set goals and work to achieve them. Middle school students showed no differences in these outcomes.
- *Low middle school attendance in second year.* Two attendance patterns emerged in the study's second year. First, many students who had access to programs in the second year (53%) did not attend. Second, among those who did attend, average attendance was low (30 days) and similar to attendance during the first year (33 days).
- *Moderate elementary school attendance.* The first report noted that elementary school students attended programs an average of 58 days in the school year.

Classroom Applications

In many communities, the time of glorified babysitting is over. Parents are searching for meaningful choices for their children, and teachers stand to benefit from their choices. More and more, afterschool programs are being constructed as informal learning environments, using those few hours each day to create meaningful and rich spaces in which to engage and teach children.

The explosion of afterschool programs represents nothing less than the reinvention of the school day in many communities. Few current

issues in child and youth development receive as much attention today as organized out-of-school time. One key factor to its significance is its sheer quantity—children spend about 80% of their waking hours outside of school. The rationale behind this support is clear: Many studies suggest that organized afterschool activities promote positive outcomes for children and youth.

There is also growing evidence that good afterschool programming makes a difference in kids' lives. Studies in child development and education suggest that attendance at afterschool programs is associated with better grades, peer relations, emotional adjustment, and conflict resolution skills. Children who attend programs also spend more time on learning opportunities and academic and enrichment activities than their peers. Combine this evidence with the statistics we know all too well—that unsupervised time after school is associated with involvement in violence, substance abuse, and other risk-taking behaviors—and the necessity for high-quality afterschool programs becomes even clearer.

Bridging school and afterschool does not mean that all programs must become school-based or that they should become school-like. What is important is that programs aim to create continuity across learning opportunities, achieve integration of different learning goals, and deepen children's exploration and skill acquisition, all the while respecting the fact that there exist many types of learning that should be protected across a diversity of learning environments. Increasingly, programs divide the time into nonacademic learning and recreational activities, such as sports or arts and crafts; academic activities such as structured curricula or enrichment in language arts, science, and math; and homework support.

New research on afterschool care offers fresh insights for parents on how to choose an afterschool program and what to expect when they do. While the programs, which serve nearly one in five children of employed mothers, help keep kids safe, they don't always deliver the homework help parents expect or even help improve kids' behavior. Instead, parents have to shop carefully for programs that meet their goals.

The following information was developed by the Northwest Regional Educational Laboratory in 2001:

> It can be difficult for schools to build an afterschool program that satisfies the complex needs of today's families. It can be equally difficult for parents to know how to select an afterschool program for their child. The following checklist has been developed from indicators of quality often used by researchers who study and evaluate afterschool programs. The list addresses six components of quality programs: safety, health and nutrition, organization, program staff, space, and activities and time. While it would be difficult for an afterschool program to meet all the listed criteria (each age group has specific requirements), it is important that these factors are at least considered as program goals are developed.

The indicators on the following list can be used by any interested parties and parents/caregivers to help gauge the quality and effectiveness of their afterschool efforts.

Safety

- Is the program licensed or accredited? School-run programs may not be required to have a license but should meet or exceed state licensing requirements.
- Are there careful check-in and check-out procedures so children are always accounted for?
- Is there a telephone nearby in case of emergencies?
- Are play/recreation areas safe? Is there adequate adult supervision? Is the play equipment well maintained and age appropriate?
- Are hazardous materials locked away? Cleaning supplies should be locked in a cupboard or closet.
- Is the facility smoke-free?
- Is the staff trained in first-aid and CPR?
- Are the students and staff taught what to do in case of an emergency?

Health and Nutrition

- Is water available at all times for drinking, cooking, and clean-up? Is there a place for the kids to wash their hands before eating and after doing science and art projects?
- Are snacks and meals nutritious?
- How often are snacks and meals available?
- Are a variety of physical activities that are fun, age-appropriate, and inclusive of all students included in the daily routine?

Organization

- What are the goals of the program?
- Is the program based on child development research?
- Is the program tailored to specific community and neighborhood needs?
- Is the program well coordinated with what is happening at school? Is there communication between teachers and afterschool staff? Is there time for homework to be completed?
- Does the program collaborate with local community organizations?
- Does the program encourage parental involvement? How many parent volunteers are there? Is there a parent volunteer requirement?

- Does the program engage in planned and continuous evaluation? Are there ways for the students and their parents to make suggestions about the program?

Program Staff

- Is the staff skilled and qualified? What kind of training have they received?
- Talk with the staff. How do they feel about children?
- Do students feel the staff members are patient and fair?
- Does the staff make a point to talk with parents regularly?
- What kind of background and credentials does the staff/director have? Has the director studied education, child development, or another related field?
- Are there opportunities for staff members to participate in training and staff development?
- Is the staff sensitive to diversity?
- How does the staff handle conflict between students? Do they give the kids a chance to work out problems themselves?
- If a child needs discipline, how does the staff handle it? If a child is upset, are staff members calm, comforting, and sensitive?
- When a child succeeds, do they offer praise and encouragement?
- Are children encouraged, but not pressured, to try new activities?
- Do staff members enjoy working with each other and treat each other respectfully?
- Are the staff members good role models and examples for students?
- Are there enough staff members to supervise well and give enough attention to each child? (The National Association of Elementary School Principals recommends no more than 12 children per staff member.)

Space

- Is the environment inviting, warm, colorful, and cozy?
- Is there enough space for students to move around without disturbing other projects and activities?
- Is space accessible to participants with physical limitations?
- Are there a variety of spaces (quiet spaces for study or rest, small-group areas, and large play areas)?
- Are the bathrooms clean and conveniently located?
- Is the temperature comfortable?

- Is there a clean, safe (protected from traffic and unwanted visitors) outdoor space?
- Is there enough well-kept play equipment for everyone?
- Are there adequate materials and supplies for activities?

Activities and Time

- Are a variety of activities offered (physical, cognitive, group, and individual)?
- Does the program emphasize social relationships by encouraging a family-like atmosphere?
- Are activities challenging for different age groups?
- Are activities flexible, fun, culturally relevant and linked to students' interests?
- Are new skills introduced as appropriate?
- Do the students have opportunities to make choices about how they spend their time?
- Are the hours of operation convenient?
- Does the program operate when school is closed?
- Is the tuition affordable? Is there a sliding scale based on family income?

Precautions and Possible Pitfalls

 Communication between afterschool staff and school staff is essential yet difficult. Many things can occur during the afternoon, which could potentially continue the next school day, or vice versa. The principal, afterschool lead, and school's teachers should work together on a communication system whereby information on discipline incidents or emotional issues can effectively be shared. Parents will not, and should not, view the school and site-based afterschool care as two separate institutions.

Source

Northwest Regional Educational Laboratory. (2001). *After-school programs: Good for kids, good for communities.* Retrieved August 7, 2007, from http://www.nwrel.org/request/jan99/article7.html

U.S. Department of Education, Office of the Under Secretary. (2003). *When schools stay open late: The national evaluation of the 21st-century learning centers program.* Washington, D.C.: Author.

8

Working With Families and Especially Challenging Students

There is nothing more unequal than the equal treatment of unequal people.

—Thomas Jefferson

They may forget what you said but they will never forget how you made them feel.

—Anonymous

 Strategy 37: Know how researchers define at-risk, high-risk, and disadvantaged parents, students, and neighborhoods, and begin to look at those factors through the students' and parents' eyes.

What the Research Says

 Educational jargon isn't always precise or universally understood and accepted. Alexander and Entwisle (1996) tried to define what the characteristics of the terms *at-risk*, *high-risk*, and *disadvantaged* really are.

117

Classroom Applications

Communities act, behave, and function as the social, political, and cultural webbing for parents, families, and especially children that live in them. The community context links families and children to a set of expectations, routines, and local cultural traditions. These societal/community scenarios are embedded in the fabric of the physical geography and culture of the neighborhood. Hopefully, children's social and personal actions and reactions flow from the safety and opportunities communities provide as well as from parenting styles. Again educators hope student success, high-value norms, and respect for property also flow from healthy neighborhoods.

How do you classify a community as healthy or high-risk? In high-risk neighborhoods, groups of interlocking and corrosive conditions are visible, identifiable, and persistent and undermine safety and opportunity. A real or perceived constant threat or risk of violence, dense or dilapidated housing and transience, subpar health care and employment opportunities, and lack of public transportation all contribute to breaking apart the nurturing and safe social fabric of a community.

The notion of a high-risk community is defined by a set of social and economic conditions that place individuals at risk for failure or for encountering serious problems related to employment, education, self-sufficiency, or a healthy lifestyle. These at-risk conditions include and reflect both the physical environment or community characteristics, such as crime and limited employment options, and individual qualities, such as persistent poverty or low educational achievement. The potential student issues or failures encountered by schools in these neighborhoods are linked by those labeled "at risk."

The interaction between individual characteristics and any particular environment may lead to a greater risk of negative outcomes. Individual and environmental characteristics are widely examined in exploration of social stratification, educational challenges and inequality, and school and social policies. Alexander and Entwisle (1996) suggested that individuals "disadvantaged" by low socioeconomic status are more susceptible to adverse community environmental conditions, such as weak schools and unsafe housing situations. In conditions of socially depleted neighborhoods, parents are often challenged in their efforts to transmit positive morality norms and values because of a lack of positive community structure and societal controls.

So how does the social fabric of a community influence a student's well-being, hopes, and personal goals when they are so heavily impacted by the individual and community characteristics used to described high-risk situations? How are the parents' patterns of involvement in home- and school-based learning activities affected by these neighborhoods? These community-level conditions begin to compose the challenging con-

ditions that parents must confront in managing their children's educational experience both at home and at school, which usually reflects the community also. Few disagree with the notion that these out-of-school components are deeply connected and intertwined yet external to a student's experiences in the more formal school setting.

Certain qualities or elements present in individuals of communities, known as "protective factors," and function to assist people in high-risk communities overcome adverse or less-than-ideal conditions. Individual protective factors include the ability to form positive and protective relationships with others, the ability to identify problems and apply the appropriate resources in solving them, the ability to act independently and gain control over the environment, and the ability to set goals, to focus and persist on achieving them, and to maintain a positive attitude.

The schools and neighborhoods that offer programs that develop resiliency in individuals include the following elements: a sense of authentic caring and a developed familiarity for parents and students, high expectations with the guidance and resources to achieve goals with these expectations, and many opportunities to include meaningful parent participation and personal responsibility.

How do schools promote long-term social ties between students, families, and educators? Against the background of a dysfunctional social context, do school communities bind families in webs of support that mitigate problems and empower the parents' abilities to promote positive school outcomes for their children? The key for schools and teachers is to realize that they can be an organizational hub in establishing ties between members of these communities who share similar attitudes, norms, and values important in establishing a strong sense of shared expectations, obligations, and trust. Catholic and other similar schools and sometimes magnet schools are very good at binding communities of learners and their families. Individual families and students are united by common experiences, beliefs, and goals, and private schools unite people in a strong net of mutual interest and support. The specific institution functions as the glue connecting individuals and families.

Hurtig (2004) came up with an interesting strategy to involve parents in a writing and publishing project serving adults in a high-risk community. Again the goals were to develop a sense of community unity. The research project was a participatory, ethnographic, and ethnolinguistic study of the cultural, social, and educational impact and significance of the Parents Write Their Worlds Project, a parent writing and publishing project serving adults in poor and immigrant communities in the Chicago area. Parents Write Their Worlds (PWTW) was created by Hal Adams, founding director of the Community Writing Project (CWP) at the College of Education, University of Illinois at Chicago, and Janise Hurtig, and the project has received funding from local foundations, individual public schools, and the University of Illinois at Chicago.

Hurtig's (2004) article states, "PWTW invites parents into their children's school to participate in personal narrative writing workshops taught by CWP staff, where they meet weekly to write and share stories that draw on their life experience and knowledge. The parent writers then work together in small groups to edit selected stories that are published in the magazine *Real Conditions* and circulated to the school, community, and beyond. Parent writers are also invited to read their stories at school and community events" (p. 1).

Precautions and Possible Pitfalls

 There are very few pitfalls here, and the strategy emphasizes what important roles teachers, parents, students, and schools can play in anchoring a community in a positive way.

Sources

Alexander, K. L., & Entwisle, D. R. (1996). Schools and children at risk. In A. Booth & J. F. Dunn (Eds.), *Family–school links: How do they affect educational outcomes?* (pp. 67–89). Mahwah, NJ: Erlbaum.

Hurtig, J. (2004). *Parents write their worlds: A parent's involvement bridging urban schools and families.* Chicago: Center for Research on Women and Gender, University of Illinois at Chicago.

Strategy 38: Be aware that parents and teachers often differ in their views of adolescent stress, conflict, moodiness, and risk-taking behavior.

What the Research Says

 The purpose of this study (Hines & Paulson, 2006) was to determine whether parents and teachers differed in their views of adolescent stress and to examine whether these perceptions influenced parenting and teaching behaviors. The phrase "storm and stress" was coined by G. Stanley Hall (1904) characterizing the adolescent period as a troubled and unique period in a life cycle. This period is further described as one in which adolescents are incapable of rational thought and whose behaviors are in constant conflict with family and societal norms. The three distinct behaviors that characterize the period are (1) parent/teacher–adolescent conflict, (2) emotional moodiness, and (3) expression of risk-taking behavior. The research (Hines & Paulson, 2006)

cites these as perpetuated stereotypes of adolescents. The researchers feel that more current research does not support these characteristics and that it doesn't support the notion that these behaviors are universal and inevitable. Research has suggested that less than 10% of families with adolescents experience serious relationship difficulties, and 15% to 30% of adolescents experience serious developmental difficulties.

The leading question for this research (Hines & Paulson, 2006) targets how adolescents are perceived by the adults with whom they have the greatest interaction, namely, parents and teachers. Secondly, the researchers wanted to know if parents and teachers differ in their perceptions of adolescent behaviors. Finally, they wanted to know what effects these beliefs might have on parent and teacher interactions and their parenting and teaching styles. It was expected that teachers would hold a more stereotypical view due to their exposure to a more diverse population of adolescents. Do parents and teachers alter their interactive styles to deter the anticipated negative effects of the adolescent period?

In Hines and Paulson (2006), 70 middle and high school teachers and 94 parents participated. Instruments to measure perceptions of adolescent "storm and stress" behaviors were used to gather data. Generally, it was suggested that parents and teachers continue to identify storm and stress notions of adolescence. This confirms the endorsement of negative beliefs and the view that adolescence is a troubling and difficult stage of life. Overall, teachers were found to endorse higher levels of perceptions relative to parent–adolescent conflict, moodiness, and risky behavior than did parents. Researchers felt that the teacher's responses to certain behaviors may encourage the demonstration of other problematic behaviors.

Classroom Applications

Much of the research on adolescence has been based on adolescents whose behaviors were likely to gain attention, thereby confirming a homogeneous view of a population of adolescents engaged in stormy and stressful behaviors. Current research no longer supports this notion. Instead, low to moderate levels of conflict behavior, moodiness, and risk-taking have been found to be more typical of this age group (Arnett, 1999). Authoritative parenting and teaching practices, developed with a moderate level of control (demandingness) coupled with high levels of warmth (responsiveness) are known to contribute to healthy adolescent development (Marchant, Paulson, & Rothlisberg, 2000).

The adolescents' search for autonomy may compete with conventional parent and teacher goals of household and classroom management, expectations, standards, and discipline. Their exploration and search for gratification is often the target of parent and teacher efforts to delay satisfaction in order to conform to family, social, and classroom rules. According to

research consensus, most of these disagreements involve minor issues and are not long lasting and pervasive. Similarly, research on emotions and moodiness also reflect a more moderate response to the adolescent years. The emotionality of the period may reflect normal responses to the combination of physical, cognitive, and social changes. There is a transformation of the parent–child relationship. For example, an adolescent's desire to spend more time with his or her peers may be an attempt to deal with the emotional ups and downs of the period.

With respect to risk-taking behavior, evidence does suggest the notion that adolescents are overrepresented in a number of categories of risky behavior but not to the degree of stereotypical rebellion and risk taking held by many. Risky behaviors are those that involve sensation seeking and impulsivity, such as missing school, alcohol and drug use, and sexual behavior. While a majority of adolescents might admit to breaking the rules or committing a deviant act, the majority do not participate in serious delinquent behavior.

It would follow that teachers and parents who hold a more stereotypical view of the adolescent period might present more controlling and less responsive behaviors due to their beliefs. Therefore, schools and households that are characterized by an emphasis on control and discipline demonstrate less responsiveness in adolescent, teacher, and parent interactions. Parenting and teaching styles may reflect stereotypical views of this period and not the reality. These perceptions can produce responses that may encourage the demonstration of other problematic behaviors.

Teachers and parents may tend to develop more authoritarian practices in order to control threatening situations related to order and management based on extreme beliefs. The message that this research is giving teachers and parents is that the threat of parent/teacher–adolescent conflict, emotional moodiness, and expressions of risk-taking behavior can be based on very limited information. This could result in parents and teachers reacting in fear based on limited experience or inaccurate media reports.

Parent and teacher responses to their negative stereotypical beliefs produce changes in parenting and teaching styles that affect relationships and subsequent behaviors.

The take-home message is that authoritative parenting and teaching practices, developed with a moderate level of control (demandingness) and coupled with high levels of warmth (responsiveness) are known to contribute to healthy adolescent development. Management style should reflect the reality of teenage or adolescent behavior, not the stereotype. Perceptions can taint the learning environment with misinformation about the overall nature of groups of students. Many times a teacher's expectations are based on these perceptions, and if they are not accurate, the expectations may not be reasonable. Teachers fear class management problems and disruptions but should not overreact to stereotypical beliefs about adolescents' behavior.

Precautions and Possible Pitfalls

 A teacher's worst fear is the fear of losing class control. Some teachers are so afraid of this that they subconsciously expect it to happen. For many reasons they bring some of the stereotypical ideas described in the research into the classroom. Students can pick up on this fear, and that's when trouble starts. Conversely, students can also sense a confident and self-assured teacher and classroom environment. Careful instructional preparation and experience take care of some of this fear.

Parent contacts don't always provide solutions to what's happening in the classroom. Parents are also subject to the fear of losing control of their child. Teachers need to understand that some parents feel helpless in dealing with their children. When you run into such a situation, it's not the time to compare frustrations. It's the teacher's job to take care of the children in their classroom and offer hope, suggestions, and potential solutions to the problems students bring to class.

Sources

Arnett, J. J. (1999). Reckless behavior in adolescence: A developmental perspective. *Developmental Review, 12,* 339–373.

Hall, G. S. (1904). *Adolescence: Its psychology and its relations to physiology, anthropology, sociology, sex, crime, religion, and education.* New York: Appleton.

Hines, A. R., & Paulson, S. E. (2006). Parents' and teachers' perceptions of adolescent storm and stress: Relations with parenting and teaching styles. *Adolescence, 14*(164), 597–614.

Holmbeck, G. N. (1996). A model of family relational transformations during the transition to adolescence: Parent–adolescent conflict and adaptation. In J. A. Graber, J. Brooks-Gunn, & A. C. Peterson (Eds.), *Transitions through adolescence: Interpersonal domains and context* (pp. 167–199). Mahwah, NJ: Lawrence Erlbaum.

Marchant, G., Paulson, S., & Rothlisberg, B. (2000). Relations of early adolescents' perception of family and school context with academic achievement. *Psychology in the Schools, 38,* 505–519.

 Strategy 39: Be aware that "at-risk" may mean that a student is living with a mentally ill parent.

What the Research Says

Reupert and Mayberry (2007) estimated that more than 20% of children live in families where one parent has or had a mental illness. Their study began with the premise that given the roles

of schools in the students' academic and psychosocial development, it is important to identify effective strategies that teachers and other school staff can use to support children. In the Reupert and Maybery (2007) study, six teachers (two elementary and four secondary), two counselors, and one high school principal were interviewed to identify issues and strategies in supporting, from within the school environment, children whose parents had a mental illness.

The Bibou-Nakou (2004) study was based on a pilot European project called the Daphne Project, a collaboration between Greece and England regarding parental mental illness and students' welfare and needs. This research focused on the responses of a group of primary school teachers regarding the identification issues and assessment needs of children living with a mentally ill parent.

Classroom Applications

All the cited research supported the idea that mental illness in parents presents a risk for children in the family. They have an increased suicide rate and are affected by their parents' mental illness in other diverse ways (Drake, Racusin, & Murphy, 1990). Also according to the cited research, these children also have a higher risk for developing mental illnesses than other children. The risk is particularly high when the parent's illness is manic-depression, schizophrenia, alcoholism or drug abuse, and major depression. Risk can be inherited from parents or the general home environment. Mental illness can limit the parent's ability to provide the love and guidance necessary for healthy development. An inconsistent, unpredictable family environment can detract from a child's focus at school. Sadly, many parents fail to identify their illness as a problem for their children or deny that they have a mental health problem; therefore, schools and teachers can't always be proactive in addressing the students' needs. Many times, information is passed through schools informally through counselors, special education teachers, or other school personnel with knowledge of a specific family. Early intervention can prevent many types of problems typical of students from this group. All school staff members should be aware of these students' vulnerabilities. Unfortunately, many times community professionals or social services pay the most attention to the mentally ill parent and ignore the children in the family. So what should the typical classroom teacher do when confronted with these situations?

First, teachers need to network with colleagues when they sense a problem. Many times, teachers become knowledgeable informally. Ask any colleagues who you feel might have insight into the problem to find and gather information that will help you. Help may come from others who have prior success in working with the student.

The biggest dilemma is whether to acknowledge that you know about the student's situation. Some students would rather you not know about their parents. There is no one right answer. Teachers will need to be very sensitive and, again, gather as much prior knowledge as possible before deciding what type of relationship to foster with the student. Some protective and positive things teachers can do are the following:

- Foster a strong, healthy student–adult relationship with the student.
- Make an extra effort to foster interest in and success in school.
- Help develop outside interests for the student. Extracurricular activities help.
- Make a specific effort to scaffold homework assignments because students might not be getting the support they need from their parents.
- Help develop the students' inner strength and personal and instructional coping skills.
- Consult with the school psychologist for help.

In addition, educate yourself and be prepared to offer resources to the students. The two best Web sites to help you do this are the Children of Parents with Mental Illness (COPMI) site at http://www.copmi.net.au/jsp/resources/resource_view_parents.jsp and the Medical Library Association Encyclopedic Guide to Searching and Finding Health Information at http://www.personal.umich.edu/~pfa/mlaguide/urlsubj/mh4.html.

Precautions and Possible Pitfalls

It would be a mistake for teachers to tread too heavily in the student's life or the parents' lives if they are not welcome. Many times, families are and want to remain guarded regarding their personal lives. Of course, it is a teacher's responsibility to report any suspected abuse, but a teacher will need to decide the extent of their intervention carefully. It may just mean giving a little special attention to the student without acknowledging any awareness of the family situation, or your intervention might extend further. However, if you feel that a parent's mental health could potentially put the child at risk, do not hesitate to file a report with Child Protective Services. Again, there are no specific rules or guidelines. However, it is best to work within the school community or in a team before proceeding with any decisions regarding strategies. There are some real pitfalls here to avoid, and working in teams can help you avoid the risks.

Sources

Bibou-Nakou, I. (2004). Helping teachers to help children living with a mentally ill parent. *School Psychology International, 25*(1), 42–58.

Drake, R. E., Racusin, R. J., & Murphy, T. A. (1990). Suicide among adolescents with mentally ill parents. *Hospital Community Psychiatry, 41*, 921–922.

Reupert, A., & Maybery, D. (2007). Strategies and issues in supporting children whose parents have a mental illness with the school system. *School Psychology International, 28*(2), 195–205.

Strategy 40: By targeting the father's involvement with their children, schools can add another protective factor in counteracting the conditions that might lead to low school achievement levels.

What the Research Says

Flouri & Buchanan (2004) investigated individual long-term contributions that mothers and fathers made in support of their children's day-to-day education. Specifically, the team looked at the role of early fatherhood involvement in the child's later educational attainment and achievement independent of the role of early mother's involvement. Secondly, they looked at whether the impact of the father's engagement depends on the range of the mother's involvement.

The initial sample size of 7,259 was reduced to 3,303. Data was collected on the mother's and father's involvement with the child at age 7 and the achievement of the child after leaving school at age 20. Flouri and Buchanan (2004) found that the involvement of mothers and fathers independently predicted the educational attainment expected at age 20.

The Nord, Brimhall, and West (1997) study, *Fathers' Involvement in Their Children's Schools*, concluded with the following major considerations. Although some of the specifics of the analyses are lost when generalizations are made, taken all together the results suggest the following broad conclusions.

1. The involvement of fathers, as well as mothers, in their children's schools is important for children's achievement and behavior. Children do better in school when their fathers are involved in their schools, regardless of whether their fathers live with them.

2. Fathers in two-parent families have relatively low levels of involvement in their children's schools. Many fathers in two-parent families are not very involved in their children's schools.

3. Single mothers and fathers are involved in their children's schools. Single mothers and single fathers exhibit nearly as high levels of involvement in their children's schools as mothers in two-parent families.

4. Children benefit when their nonresident fathers participate in their schools, not when their fathers just maintain contact with them. The active participation of nonresident fathers in their children's schools is strongly related to children's behavior as measured by whether the children had ever been suspended or expelled and whether they had ever repeated a grade. However, children who see their nonresident fathers, but whose fathers do not participate in any of their school activities, do no better on any of the outcomes than children who have not had contact with their fathers in more than a year or who have never had contact with their fathers.

5. School climate is related to parental involvement. Mothers and fathers are more likely to be highly involved in their children's schools if the schools welcome parental involvement and make it easy for parents to be involved.

Classroom Applications

There are compelling reasons to promote the involvement of fathers in their children's lives: the value of their positive influence, their effectiveness in increasing children's academic achievement, and the importance of their financial support (Nord et al., 1997).

Teenagers and young adult males may need extra help to assume their full fatherhood roles, but most, if aided, will work hard to be successful parents. Public interest in fostering fathers' involvement is increasing because of the recognized benefits of fathers' contributions to their families. In fact, the National Education Goals contain a family involvement mandate.

Many schools have comprehensive programs for pregnant and parenting females, in which they encourage mothers to identify and involve fathers in their children's lives and to recruit them for father programs. They may invite fathers to some programs for mothers.

Schools and teachers may often need to consider the demographics of their school and community. Effective programs must take into consideration the ethnic differences and use culturally sensitive outreach strategies and curriculum. Often there is cultural inertia at work with some males.

Young fathers may need help to understand that the structure of the families of their birth, heavily influenced by historical ethnic traditions and experience, may not be workable in the United States today. For example, Latinos, who are most responsive to warm, personal, informal contact—in their native language, if appropriate—need to consider whether an adequate family income can result from traditional gender role divisions. African Americans may feel hopeless and powerless, based on past treatment of blacks in the United States, and may mistrust both personal counseling and agents of authority (Kiselica, 1995).

The benefits to children, families, and society of the commitment of fathers are undisputed. Therefore, it is worth the time and effort of schools and community organizations to implement programs for young fathers that will enable them to develop into responsible adults, meet their obligations, and create a generation of well-nurtured and effectively educated children.

The following father involvement programs are examples of how communities across the country are meeting the need to support fathers' involvement in children's learning. These examples, adapted from the U.S. Department of Education (2000), illustrate the kinds of fathers' involvement programs that are working in schools, childcare centers, and communities.

- The Buhrer Elementary School (PreK–5), Cleveland, Ohio, provides family math courses for mothers and fathers, and all home–school communications are in at least two languages. The school has organized block parent meetings that are held at locations other than school so that those parents who cannot come to the school for meetings can address issues nearer to home with school staff who attend. Results: 18–20 parents attend a typical block meeting with an annually increasing number of block parents attending school functions.
- At Cane Run Elementary School (K–5), Louisville, Kentucky, families participate in the Even Start Program, with parents studying for the General Education Diploma while children are in school or the on-site nursery. The school's Family Resource Center links fathers and mothers to many community services and runs afterschool tutoring and recreational programs for children. Results: PTA membership and the number of mothers and fathers visiting the school building daily have both multiplied by a factor of ten. During the last two years, discipline referrals have declined 30% each year while attendance has maintained a steady 94%.
- R.E.A.D. to Kids—Reconnecting Education and Dads, Kansas City, Missouri, is a project of the Urban Fathering Project. This activity helps dads develop a reading program for their children. Results: More than 450 dads in 12 schools participated in the program in its first year.

- Kindering Center (PreK and elementary), Bellevue, Washington, has established a weekly support group for fathers of children with special needs, run by the National Fathering Network. It now has affiliates in 35 states. Results: Enrollment has grown from 25 to 100 participating fathers, all of whom are better able to manage the stresses of having a child with special needs.
- Avance Child and Family Development Program (PreK), San Antonio, Texas, offers a 33-week fatherhood curriculum, covering topics such as child growth and development, handling stress, learning to live without violence, and childhood illnesses. The program also offers a General Education Diploma and English as a Second Language classes. Results: The program teaches parenting and personal skills to more than 60 men per year, encourages fathers' involvement with their children, and strengthens their relationships with their children's mothers.
- The Mary Hooker Elementary School Family Resource Center in Hartford, Connecticut, primarily serves Puerto Rican low-income families who are either bilingual in Spanish and English or speak Spanish as their primary language. Program activities with fathers, conducted in both English and Spanish, are often held in the evenings or on Saturdays. Activities include parenting classes, picnics, field trips, and early education classes. Babysitting is provided as needed. Results: Many of the 250 parents who attended the program's parental involvement meeting also attended the meeting's fatherhood workshop.
- The Pinellas County (Florida) Head Start's Accepting the Leadership Challenge, a male involvement initiative, began by taking 30 men away for the weekend and leading them through a bonding exercise, which helped them to form a group. The program offers fathers training in parenting, nutrition, literacy, and computers; educational travel; and opportunities for successful family time. Results: As of its ninth year, the number of male involvement groups has expanded.
- At the Fairfax–San Anselmo Children's Center (PreK and afterschool), Fairfax, California, on one Saturday per month, as part of the Men's Breakfast Program, fathers first have breakfast with their children, have a fathers-only discussion led by the center director, and then rejoin their children to do yard work and other fixing up of the center. Results: Before the program, very few fathers participated in parent–teacher meetings or other aspects of center life; now, virtually all fathers participate.
- The Florence S. Brown PreK Program, Rochester, New York, holds one lunchtime meeting per month and one evening meeting per month. Both of these meetings bring fathers to the center to spend time in the classroom with their children and to do handiwork and

yard work (for example, fixing broken toys or repairing the playground). Results: Fathers took a lead role in a successful lobbying effort to prevent cutbacks in state funding for the entire PreK program.

- At the Sunbelt Human Advancement Resources, Inc., Head Start (SHARE) in Greenville, South Carolina, male volunteers visit men at the Perry Correctional Center to provide inmate fathers with information on Head Start and its services to children and families, as well as mentoring and life-skills training. Results: Visits to the correctional center provide male involvement volunteers with ideas for their mentoring program with youth within group homes to prevent these young boys from becoming a part of the justice system.

- Parents as Teachers (PreK), St. Louis, Missouri, is a statewide program, widely recognized as a national model, that advocates parents are children's first teachers. The Ferguson–Florissant High School has adapted this program for teen parents and parents-to-be, offering both "Dads Only" and "Moms Only" classes. The school also runs a preschool-based "Messy Activities" night to encourage fathers to play with their children. Results: There has been increasing involvement by fathers in families who participate in the program.

- At Hueco Elementary School (PreK–6), El Paso, Texas, all parents participate in the "Super Readers" program, which provides incentives for parents to read with their children. About 20–30 parents attend monthly Parent Communication Council meetings, and teachers receive release time to conduct home visits. Results: Parents involved in at least one activity at school increased from 30% to 80% per year. Parent participation has increased to include school decision making, classroom instruction, furthering their own educational goals, and helping children more at home.

- At Roosevelt High School (9–12), Dallas, Texas, teams of faculty, parents, and other community leaders go from door to door during their "Walk for Success." These teams talk with parents about their needs, interests, and school improvement. Parents of sophomores attend classes about state tests, and a parent liaison makes 30–60 calls to parents per day to reinforce communication between home and school. Results: Attendance at PTA meetings increased by a factor of 20. Student achievement on state tests rose from the 40th percentile to the 81st percentile in reading and from the 16th to the 70th percentile in math.

- The Illinois Fatherhood Initiative (IFI) is the country's first statewide nonprofit volunteer fatherhood organization. Founded in 1997, IFI connects children and fathers by promoting responsible fathering and helping to equip men to become better fathers and father figures. Results: Through its volunteer board of directors

and board of advisors, IFI creates strategic partnerships with private and nonprofit organizations. Its activities include the Illinois Father-of-the-Year Essay Contest (more than 140,000 school-age children have submitted essays during the past three years) on the theme, "What My Father Means to Me"; a Me and My Dad essay booklet that includes essays, artwork, and a six-part curriculum focused on child–father issues; a Faces of Fatherhood Calendar; an Illinois Fathers' Resource Guide; a quarterly newsletter; and a Boot Camp for New Dads, a hospital-based program that brings together first-time dads with soon to be first-time dads to help them make the transition to fathering.

Precautions and Possible Pitfalls

Many strategies just don't have any real pitfalls. Yes, it might take some extra effort and thought to help fathers get involved, but it is very worth it according to the research.

Sources

Flouri, E., & Buchanan, A. (2004). Early father's and mother's involvement and child's later educational outcome. *British Journal of Educational Psychology*, 74(2), 141–153.

Kiselica, M. S. (1995). *Multicultural counseling with teenage fathers: A practical guide*. Thousand Oaks, CA: Sage.

Nord, C. W., Brimhall, D. A., & West, J. (1997, October). *Fathers' involvement in their children's schools*. Washington, DC: U.S. Department of Education, National Center for Education Statistics. (ERIC Document Reproduction Service No. ED409125)

U.S. Department of Education. (2000, June). *A call to commitment: Fathers' involvement in children's learning*. Retrieved August 6, 2007, from http://www.ed.gov/pubs/parents/calltocommit/intro.html

Strategy 41: Understand the beliefs that low-income parents have about their role in their children's academic learning.

What the Research Says

Drummond and Stipek (2004) interviewed 234 low-income African-American, Caucasian, and Latino parents, rating the importance in helping their second- and third-grade children

in reading, math, and homework and of knowing what their children are learning. Also, parents reported whether they had taught their child in math and reading and read with their child in the previous week. In addition, they responded to open-ended questions about the type of help they deemed appropriate. On questionnaires teachers rated each student's reading and math skills and noted whether they had given a child's parent suggestions for helping with either subject. Findings showed that parents rated the importance of helping their child with academic work very high. Parents of second graders tended to rate the importance of helping higher than did parents of third graders. Drummond and Stipek stated that, as in past research, ratings varied systematically as a function of parents' perceptions of children's academic performance and as a function of whether teachers had offered suggestions; however, parents perceived helping with reading as more important than helping with math. Results suggested that teachers who desire more parent involvement might need to use different strategies for the two subjects. In addition to specific approaches for helping with math, reading, and homework, parents noted other activities they believed would help their children succeed.

Classroom Applications

Veteran teachers are generally well aware of the benefits of family involvement in children's education. Today, as in the past, parental support is thought to be a critical component of education, and teachers assume, whether accurately or not, that families support their efforts and expectations for children's learning. Yet in today's society the issues surrounding parental school involvement and support are complicated by a large range of family arrangements and a wide sociocultural difference among classroom teachers, children, and families. Specifically, urban families are often marginalized from everyday school life by poverty, racism, language, and cultural differences, and the parents often perceive that public education is designed for children from middle-class, White families at the expense of others.

Upper- and middle-class and upper- and middle-income parents, for example, feel that they should collaborate with school efforts. But low-income families often perceive themselves as being outside the school system and feel it is the school's responsibility to do the teaching.

Second, parental feelings of efficacy contribute to their involvement in their children's school. Parents who believe they can make a difference in their children's education are more likely to visit and participate in school activities than those who feel ineffective. Third, some schools are more welcoming than others, and the extent to which schools make parents feel comfortable and valued contributes to the adults' participation in their children's education. Teachers and schools serving low-income, ethnically

diverse neighborhoods must make greater efforts to welcome families, because those are the parents who often feel excluded because of differences in their ethnicity, income, and culture.

There are a range of reasons why low-income parents, from diverse cultures especially, resist involvement in school activities, but certainly cultural and communication differences between teacher and families lie at the heart of the problem. There is often a mismatch between the discourse style of the school and teacher. When a teacher's conversation styles match that of the community, children are more able and eager to participate in classroom activities. Teachers who are familiar with children's conversational styles, including their uses of silence, are more successful in their instruction than teachers who are not. Urban teachers or teachers in schools with large numbers of low-income students often lack knowledge and respect of the ethnicities and cultures of the children they teach and often have a limited knowledge of what parents do to help their children at home. Even the most well-meaning teachers do not always recognize the impact of family, values, beliefs, and expectation about schooling; consequently, some parent involvement projects do more harm than good because they do not build on the families' cultural capital and cultural prior knowledge.

This can be accomplished when teachers actively develop an understanding of children's cultural backgrounds and when teachers make sustained and creative efforts to collaborate with families. It is suspected that many parents as well as teachers assume an "us–them" attitude about each other. Whether fair or not, there is stereotyping going both ways.

Drummond and Stipek (2004) found that more than half the parents in their study felt that they should go to school and ask their child's teacher what they are learning. Low-income parents do view schools as a source of information. Schools and teachers need to remain committed to communicating with parents about their child's learning. Here are a few suggestions.

- Teachers should ask parents what they doing at home to help their children academically and reinforce the parents' interest in helping. It also should be noted that, in general, reports of giving help were higher for literacy curriculum than math. Realize that parents may need more help in some content areas than in others. Teachers often complain that parents do not help children with their schoolwork. Parents counter the notion and explain they did not know what homework teachers assigned their children. Parents need to know from the teacher what the homework is and how to help their children.

- Low-income, urban parents are more likely to participate in school activities when they feel their children are respected and their communities and heritages are valued. When parents perceive that

teachers do not like their children, they often will not participate or contribute in school activities.

- Schools are responsible for establishing open communication with parents. Yet we learned that teachers, even the exemplary ones, expected parents to communicate with the schools in middle-class ways, such as telephoning them, visiting, and writing notes. Many low-income, diverse parents feel vulnerable with school authority, and they don't comfortably communicate with teachers in ways to which White, middle-class families are accustomed. Many parents do not have cars and can't easily visit the school. Some speak little English hesitantly, and some feel anxious about their own lack of education.

- Low-income schools need alternative ways of connecting and communicating with parents who live in high-poverty areas. For example, the conventional "Parents Night" might be held at a community room in the neighborhood where families live. Schools with children who are acquiring English should plan for interpreters when parents attend conferences and other school events. While some of the parents are bilingual, their anxiety about visiting school still blocks their ability to understand what teachers say to them.

- Teachers must learn how to conduct effective parent conferences and break out of the "us–them" mentality. Teachers should learn conversational strategies that focus on children's positive qualities, as well as identify ways they might grow and be helped at home.

Precautions and Possible Pitfalls

Working with parents, especially low-income and within diverse demographics, should always be viewed as work in progress. There are no one-size-fits-all solutions to interacting with parents. Rarely do teachers work in a homogeneous school or classroom in urban and suburban settings anymore. Once you shoulder the responsibility and gain some experience in dealing with parents and home–school relationships, it becomes just another part of your skill set.

Beware of the research that finds parents aren't likely to participate with the school if they perceive the teacher doesn't like the child. With few exceptions, teachers like (love!) all children, yet if they use a communication style that differs from the parents, there is the possibility that the parents will misinterpret and feel their child is not liked. This situation can be helped by an awareness of the problem, and sometimes just taking the time to really talk to the parent about their child will show the parent how much you care.

Also, be as vigilant as you can about arranging for interpreters at parent conferences or other meetings. In many schools, there are only a few adults who are bilingual, and the principal and teachers are smart to work together to set up a schedule to take advantage of the interpreter. In a parent conference, never rely on a bilingual student to translate to the parent. While this might work in a situation that is informal or when communication is needed instantly (emergencies), for a formal educational conference, you should never put the student in the role of the information bearer.

Although the time it takes to establish relationships and effective communication is great, the rewards for helping families among this group of parents can be greater!

Sources

Diaz-Rico, L. T., & Weed, K. Z. (2006). *The crosscultural language and academic development handbook: A complete K–12 reference guide* (3rd ed.). Boston: Allyn & Bacon.

Drummond, K. V., & Stipek, D. (2004). Low-income parents' beliefs about their role in children's academic learning. *The Elementary Journal, 104*(3), 197–215.

9

Working With Families From Nondominant Cultures

Remember, remember always that all of us, and you and I especially, are descended from immigrants and revolutionists.

—Franklin D. Roosevelt

People can only live fully by helping others to live. When you give life to friends you truly live. Cultures can only realize their further richness by honoring other traditions. And only by respecting natural life can humanity continue to exist.

—Daisaku Ikeda

> **Strategy 42: Examine the role of parents in high-achieving schools serving low-income, at-risk populations.**

What the Research Says

 Ingram, Wolfe, and Lieberman (2007) investigated the critical elements of parent involvement as related to children's improved academic achievement. Survey data was collected from 220 parents whose children attend three Chicago public elementary

schools. The schools serve largely minority, low-income student popula-tions and score in the top third of the Illinois State Achievement Tests. Results suggest that schools struggling with unsatisfactory student achievement may benefit from focusing parent involvement efforts on building parenting capacity and encouraging learning-at-home activities.

Classroom Applications

Parents who participated in the Ingram and colleagues study (2007) made several recommendations with implications for teachers. The parents suggested that teachers provide families with information on homework policies and how to help their children with their school-work and that the teachers encourage parents to become aware of the informal learning opportunities outside of school such as libraries, zoos, museums, and so forth. Teachers can also reinforce the importance of these activities by recognizing the efforts of the students and families in the classroom environment in a positive way. They further suggested that teachers provide guidance and support for caregivers to supervise and assist the children at home with homework assignments and other learn-ing opportunities. They also suggest that teachers help parents locate com-munity resources necessary to help them accomplish their parenting as well as other family goals.

Parent from this study also gave feedback suggesting that schools can influence parent involvement in their children's education by providing training for both parents and teachers. Parenting education courses and other training opportunities can make a big difference, helping parents maximize their impact on academic achievement.

Schools can also help by providing training for teachers and staff to increase their competence in working with parents and other caregivers, especially those families who might not feel comfortable with the school environment. While it is not reasonable to meet all the needs of the fami-lies that schools serve, schools and teachers can take the lead in rallying community resources to assist families in obtaining health, nutrition, employment, and adult educational services. In addition, schools can act as facilitators in connecting informal learning opportunities to families and students.

Precautions and Possible Pitfalls

With so many opportunities to develop programs for parents and other caregivers, schools and teachers should realize that some things will work and others will need to be modified, dropped, or given more time to succeed. Clearly this research (Ingram et al., 2007) linked parental involvement with educational success for students. In

many communities, resources are limited. This study suggested that focusing resources into encouraging effective parenting and learning at home will yield significant results.

Source

Ingram, M., Wolfe, R. B., & Lieberman, J. M. (2007). The role of parents in high-achieving schools serving low-income, at-risk populations. *Education and Urban Society, 39*(4), 479–497.

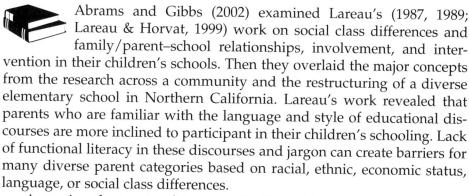

Strategy 43: Include parents from marginalized groups by making them feel welcome with a plan to communicate with them about their student(s).

What the Research Says

 Abrams and Gibbs (2002) examined Lareau's (1987, 1989; Lareau & Horvat, 1999) work on social class differences and family/parent–school relationships, involvement, and intervention in their children's schools. Then they overlaid the major concepts from the research across a community and the restructuring of a diverse elementary school in Northern California. Lareau's work revealed that parents who are familiar with the language and style of educational discourses are more inclined to participant in their children's schooling. Lack of functional literacy in these discourses and jargon can create barriers for many diverse parent categories based on racial, ethnic, economic status, language, or social class differences.

Accepting the tenets of Lareau's findings, Abrams and Gibbs (2002) followed the efforts of the New Washington School, a K–5 public elementary school located in urban Northern California, to restructure parent–school relationships with more carefully devised inclusive parental involvement strategies. Their study focused on a parent demographic with a median income of $21,554; 26% were two-parent households, and 50% of the single-family households with children younger than 18 fell below the federal poverty line. The student body included 35% Latino, 35% African-American, 20% White, and 10% Asian students. The questions Abrams and Gibbs tried to answer were

- Can a change in school policies alter traditional patterns of parent–school relationships?
- What are the mechanisms that facilitate these changes in the patterns, and where do these patterns of exclusion exist?
- Where are they broken down?

They found that the potential for social change was often obstructed by the mechanisms of social and cultural reproduction infused in individual power relationships and agendas between social class and ethnic and cultural groups. Conflicts and tensions became the outcome of diverse perspectives, meeting styles, and discourse in unfamiliar school jargon. Different agendas from different stakeholders seriously inhibited compromise.

Classroom Applications

It's clear from this study that bringing traditionally marginalized individuals and groups together comes with issues for consideration. Many individuals were not familiar with the protocols of school discourse and the subtle and not-so-subtle micropolitics of special interest perspectives in the school and classroom setting. In this case, while avenues for participation were constructed, the school did not set up clear directives about parental roles, and the school felt that more solid intervention and training might have helped avoid some of the conflict and tension over power distribution.

Bringing parents together in restructuring situations highlighted the contested nature of schools and their programs in a diverse, pluralistic society. In many cases, larger social and community relationships were acted out in the forum of the perceived role of public education within the contested needs of societies. Schools needed strategies to mediate power relationships in environments of competing needs and concerns about children's education.

Many parents see the school and the classroom from the singular perspective of their student's unique needs and personal goals. If the school is involved in a program of parental inclusion, teachers may be dealing with parents who have no experience in school discourse or school jargon. Teachers are called upon to not only respond to parent concerns and needs but also to educate parents in the workings of the classroom and the school. Marginalized parents are not accustomed to taking leadership roles and, many times, any roles within traditional parent involvement paradigms. In addition, parents may not have had a positive experience with school as students themselves or may have culturally different values and expectations of schools than that of the majority.

It is often difficult for teachers to see schools and classrooms from alternative societal and cultural perspectives. However, in an urban setting, developing these strategies for positive participation is a must for creating a working environment of mutual respect with diverse parents.

Communication is often the key to building successful parent–teacher relationships. While written notes may be a common starting point, if parents are not functionally literate in English, oral communication through telephone calls or conferences may be more effective. Many teachers find

that student-led conferences early in the year can facilitate the beginning of a positive relationship between parents, students, and teachers.

Above all, patience and respect are key in allowing these relationships to grow and mature. Help them develop and adjust parents' roles as they become more comfortable in the educational setting.

Precautions and Possible Pitfalls

Parents come to the playing field of educational interaction from their relative social locations outside of school, and these positions often define their styles of interactions with the school and each other. By helping to make marginalized groups and individuals feel included and welcomed, teachers may alienate and create some resentment among parents from more traditionally privileged social and cultural groups. They might not always agree with the new parental leadership programs and policy changes, or they may see them as a threat to their power base. Real change is a challenge, and threatening traditional power relationships at school comes with consequences. Think about strategies to help prepare all stakeholders for the coming changes ahead of time.

Sources

Abrams, A. S., & Gibbs, J. T. (2002). Disrupting the logic of home–school relationships: Parent involvement strategies and practices of inclusion and exclusion. *Urban Education, 37*(3), 384–407.

Lareau, A. (1987). Social class differences in family–school relationships. *Sociology of Education, 60,* 73–85.

Lareau, A. (1989). *Home advantage: Social class and parental intervention in elementary education.* New York: Falmer.

Lareau, A., & Horvat, E. M. (1999). Moments of social inclusion and exclusion: Race, class and cultural capital in family–school relationships. *Sociology of Education, 72,* 37–53.

Strategy 44: Involve nondominant and culturally diverse parents as resources in the classroom.

What the Research Says

Studies of Latino immigrants show that parents are highly interested in their children's education (Goldenberg & Gallimore, 1995). These parents, although they may be unfamiliar

with the American education system, display a strong desire to see their children succeed and want to support them. Research with minority parents and parents from lower socioeconomic backgrounds indicates that these parents want to be involved in supporting local schools (Metropolitan Life, 1987). Studies involving African-American parents report the same high interest, but note that many of these parents lack the confidence that is necessary to support involvement (Chavkin & Williams, 1993).

Classroom Applications

Some teachers may feel uncomfortable using parents of nondominant and culturally diverse students and their families as resources in the classroom. This reluctance often stems from concern about language difficulties and cultural differences. And yet, because of our changing population, all teachers should expect a diverse population of students. The challenges facing teachers in these diverse settings require social literacy that goes beyond the aspects of culture often approached in teacher education classes. Teachers need to give thought to the proper handling of major holidays, religious customs, dress, and food. Many teachers express a need for a more comprehensive kind of insight into the social ideals, values, and behavioral standards of the cultures of their students. Individual cultures have different approaches to child rearing and schooling, and having a working understanding of these approaches helps teachers include parents more effectively.

For example, many teachers focus on critical thinking and Socratic questioning techniques. These emphasize a student's active class verbal participation. If a student is from a cultural background that stresses quiet respect in school, he or she may need to be taught how to become a more active participant in classroom discourse. Teachers can help this process by communicating with parents about a more active style of participation. Teachers can also provide participation opportunities, such as journal writing or small-group discussions, to help build communication skills.

Teachers may want to preplan small-group activities to include students from different cultural backgrounds. These students can then work to build language skills as well as content comprehension.

Many teachers find that allowing students to work in small-group activities to preview their homework assignments helps improve homework completion. Students can discuss possible strategies for problems to ensure that all students have a basic understanding of the assignment. This also helps students whose parents may not be able to read the assignment in English, as well as those whose parents may not have the time or skills to assist at home.

Parent volunteers, once trained, can be used in varieties of ways. Guest speakers on various topics (related to culture or not) can enhance

instruction and provide variety. Some teachers find that having parents assist in managing small-group or learning center activities can also facilitate learning.

There are a variety of cultures represented in most heterogeneous classrooms, and teachers need to make the effort to learn about them. Parents make an excellent source of information along with the students themselves.

Precautions and Possible Pitfalls

 Parents of immigrants and culturally diverse students can be an untapped resource in today's classrooms. Care should be taken to keep parents informed through communication, written or verbal, in the parents' native language, when possible, if their English is not proficient. The teacher must also be aware that just because he or she sends home information in the parents' native language, the parent may still not be able to read or write in that language. It is not uncommon to find parents who have no formal education before immigrating to the United States. The more information teachers have about students, their families, and their cultural identity, the more teachers can best work with parents in supporting students' learning.

Sources

Chavkin, N. F., & Williams, D. L. (1993). Minority parents and the elementary school: Attitudes and practices. In N. F. Chavkin (Ed.), *Families and schools in a pluralistic society* (pp. 73–83). New York: State University of New York Press.

Goldenberg, C., & Gallimore, R. (1995). Immigrant Latino parents' values and beliefs about their children's education: Continuities and discontinuities across cultures and generations. In P. Pintrich & M. Maehr (Eds.), *Advances in motivation and achievement: Culture, ethnicity, and motivation* (Vol. 9, pp. 183–228). Greenwich, CT: JAI.

Harris, L., Kagay, M., & Ross, J. (1987). *The Metropolitan Life survey of the American teacher, 1987: Strengthening links between home and school.* New York: Louis Harris and Associates.

Metropolitan Life. (1987). *Study of minority parent involvement in schools.* New York: Author.

Trumbull, E., Greenfield, P. M., Rothstein-Fisch, C., & Quiroz, B. (2001). *Bridging cultures in our schools: New approaches that work.* Mahwah, NJ: Lawrence Erlbaum. Retrieved September 15, 2008, from http://books.google.com/books?id=NKmoE0PoYysC&pg=PA139&lpg=PA139&dq=Trumbull,+E.,+Greenfield,+P.+M.,+Rothstein-Fisch,+C.,+%26+Quiroz,+B&source=web&ots=Vw90ME0 09v&sig=Kj5eiYyRJPDISqFUHE7VUsjRr3U&hl=en&sa=X&oi=book_ result&resnum=1&ct=result

Strategy 45: Help educate parents from nondominant cultures in the differences in high school course placement as they relate to college and university entrance requirements.

What the Research Says

 Torrez (2004) believed that Latino parents generally trust secondary school systems that often misclassify or misdirect their students within curricular decision making. Parents of Latino high school seniors at three Southern California high schools were surveyed with the aim of identifying the information available to them to help their children take adequate steps toward preparing them for entrance into a four-year college or university. All the parents who responded to the survey were either Mexican immigrants or Mexican American. Ninety-two Latino parents responded.

There was a definite achievement gap, in terms of Latino college and university attendance rates at all three high schools. Non-Hispanic White senior students, while in the minority, met eligibility requirements for the California State University (CSU) system 50% of the time. In contrast, only one-third of the Latinos met the CSU eligibility standards. Torrez (2004) found that most parents did not know the college preparatory courses their children needed in Grades 9–12 that met the admission requirements of the CSU system. Thirty percent did not know that the SAT was an important factor in admission to colleges and universities. Only 41% of Latino parents indicated any knowledge of the SAT, and only 10% knew the significance of the numerical value of the score. Only 8% had any knowledge of California's A through F requirements that indicate which classes are considered college prep classes.

About 75% of the parents surveyed considered a four-year college/ university education to be important to their child, yet only 10% reported having a student who was in the process of actively enrolling in a four-year college or university. None of the parents of seniors reported that they expected their child to enter a University of California school (typically filled by the top 10% of high school students). Many reported that their child planned to enroll in community college.

Finally, many parents were under the impression that their students were being prepared for college when they were enrolled in classes that did not meet the prerequisites for a four-year college or university experience. Most troubling was the fact that 92% of the parents had never discussed these issues with a counselor, although 42% reported contact with school faculty and/or counselors on other matters.

Torrez (2004) felt that parents could not describe in detail the quality of education their child received and also that they were not knowledgeable

about course curriculum and other factors for enrolling in college or university systems the following year.

The conclusions of Perna-Walter and Titus (2005) also followed a similar line. They stated that the likelihood of a high school student enrolling in a two-year or four-year college after graduating from high school appears to directly relate to the volume of resources available to them through social networks at their school. Students who attended high schools in which a large share of parents contacted the school about academic matters are more likely to enroll in a four-year college. Thus the characteristics of a high school's parent contact patterns influenced the distribution of postsecondary opportunities for Latino students.

Classroom Applications

In many schools, there is often a widespread belief that parents in certain cultural groups don't care about their children's education. However, in contrast to this notion, the Torrez study (2004) found that Latino parents do communicate high expectations to their children and trust that schools are preparing their students for post-high school educational experiences. The involvement of language minority parents in their child's education is crucial to their academic achievement, and intervention to facilitate involvement should begin in elementary school.

From their comments, Latino parents would welcome multiple modes of effort, communication, and education. Many students were placed in curriculum tracks not likely to lead students to a college or university, and there was little communication between the school and the parents regarding these critical issues. Torrez (2004) believed that this distinct lack of communication is the underlying cause of the low college or university attendance rates among Latino students.

Many culturally diverse parents do not understand the importance of becoming an advocate in guiding their children through the paradigm of high school curriculum necessary for college or university entrance. You could form a hypothesis that the students who were successful at meeting the eligibility requirements had parents who knew the system and that those who didn't meet eligibility requirements had parents who did not know what types of interventions were necessary. This was not part of either cited study, yet the goal for educators is to train families to advocate for their children, especially in high school.

The results of these studies tell us that Latino parents and others from nondominant cultures would benefit from communication interventions to help them become better advocates for their children. This could take the form of workshops to help them gather information about curricular requirements, SAT preparation, and the availability of financial aid. These efforts should begin in the middle schools and continue through high school and would help parents better advocate and exploit the opportunities

available to them and their students. The goal for schools is to not only provide and increase the necessary resources but also help and encourage parents to become proactive, involved parents in decision making regarding post-high school education.

Precautions and Possible Pitfalls

Many Latino parents in the Torrez study (2004) expressed dismay when they found that their children could be placed in curriculum tracks that made entrance to college less likely. It wouldn't be a bad idea to start educating parents about these requirements when their children are in elementary school. There is much research (see Strategy 55) that indicates parental expectations are the most effective form of parent involvement, so the sooner the parents are familiar with the requirements, the earlier they can transfer the expectations to their children. All educators, teachers, counselors, and administrators involved with Latino students and parents must take responsibility for helping remedy the post-K–12 achievement gap. College preparation programs that involve parents is a must.

Finally, while the research involved Hispanic/Latino families, it is not unrealistic to believe that other cultural groups not familiar with the school protocols could also be at a disadvantage.

Sources

Perna-Walter, L., & Titus, M. A. (2005). The relationship between parental involvement as social capital and college enrollment. *The Journal of Higher Education, 76*(5), 485–518.

Torrez, N. (2004). Developing parent information frameworks that support college preparation for Latino students. *The High School Journal, 87*(3), 54–62.

Strategy 46: Become knowledgeable about how the parental demographic (socioeconomic status and ethnicity) background influences parental academic involvement.

What the Research Says

Hill and colleagues (Hill et al., 2004) found that previous research has shown that parental involvement in schooling affects achievement that in turn influences career and educational aspirations of their children. They investigated the influence demographic background (socioeconomic status and ethnicity) had on

parental involvement in children's schooling and how this influenced achievement, aspirations, and behavior.

The research consisted of a multisite longitudinal study of 463 families in Tennessee and Indiana. The study involved students from seventh grade (Year 7, 12 years old) through to eleventh grade (Year 11, 16 years old).

Not surprisingly, the researchers found that parental socioeconomic status and ethnicity both directly and indirectly influenced parental involvement in schooling and children's progress. Here are the details:

Higher Parental Education

- Adolescents from families with higher levels of parental education experienced fewer behavioral problems (social, attention, and aggression), which have been linked to lower achievement and aspiration (but not work or career aspirations).

Lower Parental Education

- Parental academic involvement from parents with lower educational levels resulted in increased adolescent educational and career aspirations (the desire to be upwardly mobile) but did not improve behavior or achievement.

Ethnicity Within This Category

- A direct relationship was identified between parental academic involvement and achievement for African Americans but not for European Americans.

Higher Parental Socioeconomic Status

- Young people are indirectly influenced by parental academic achievement and occupation, which may result in them modeling the positive achievements of their parents.

Lower Parental Socioeconomic Status

- Again, young people may model their parents' lower socioeconomic status in both education and occupation.
- Parents with lower socioeconomic status may not become involved in their children's schooling in ways that enhance or change school behavior or performance, but their involvement may communicate their expectations for their adolescents' future success and upward mobility.
- Parents with lower educational levels may not be comfortable or capable of assisting their children with schoolwork, which results in a lack of guidance, support, and involvement from parents into their children's schooling.

Ethnicity Within the Category

- Perceived or actual discrimination has resulted in African-American parents distrusting schools and monitoring rather than collaborating with them.
- For European-American families, there may be many factors that influence achievement, and parental academic involvement may be less influential as a unique factor.

Finally, again with little surprise, parental involvement in schooling often declines during adolescence, as involvement can lead to conflict with the adolescent's need for autonomy, independence, and detachment from family.

Classroom Applications

The findings of Hill and others (Hill et al., 2004) will be useful to both educators and parents as they call attention to the subtle differences in parental academic involvement based on factors described in the research, in schooling, and in how these influence achievement, aspirations, and behavior.

Parental academic involvement was defined in the study as parents' involvement with schools and with their children to benefit their educational outcomes. Examples of this given by the researchers included volunteering, attending PTA meetings, parent–teacher contact and communication, and involvement in academic-related activities at home. They suggested that parental academic involvement works to establish relationships with teachers, school administrators, and other parents and fosters information about school policies and behavioral expectations. What are the implications of the study for practitioners? In completing this exploration, Hill et al. (2005) began to ask the following questions about implications for practitioners:

- How can practitioners foster a positive relationship between parental academic involvement and their children's achievement?
- Would you find it helpful to discuss with colleagues strategies for channeling both parental and student aspiration into achievement?

School leaders may wish to consider the following implications:

- This study identified important yet complex relationships that exist between parents and young people's schooling. Could you do more to help your colleagues understand and nurture the parent–student relationship in your institution?
- The research highlighted a lack of support for parents that resulted in a failure of students to reach their potential. Could you do more

to provide support, education, and guidance for parents in your institution?

● How could you exploit parental academic involvement transition, both academically and vocationally?

Parental inertia regarding their students' expectations and their own participation is often hard to overcome and must be done one student at a time. For example, in some cultures, long-term expectations for female students are very different than for males. If a teacher wants to influence these types of expectations, he or she needs to become a powerful, supportive mentor and role model for that specific student. Schoolwide programs can only do so much, and then it takes a personal, one-on-one, trusting relationship to reset subtle, deep-seated expectations.

Precautions and Possible Pitfalls

 It would be a serious mistake to use these findings to stereotype or profile your students and their parents. The findings only offer teachers the opportunity to begin to develop strategies to address specific concerns related to parental involvement. Some parents will fit the profiles described in the referenced study, but others will surprise you. Be careful not to put yourself between parental expectations and your own personal beliefs about what you think should be in your students' future.

Source

Hill, N. E., Castellino, D. R., Lansford, J. E., Nowlin, P., Dodge, K. A., Bates, J. E., et al. (2004). Parent academic involvement as related to school behavior, achievement, and aspirations: Demographic variations across adolescence. *Child Development, 75*(5), 1491–1509.

> *Strategy 47: Consider how students from nondominant backgrounds are impacted by a teacher's homework practices.*

What the Research Says

Brock, Lapp, Flood, Fisher, and Han (2007) stated that in the past decade, the number of English language learners in the United States has more than doubled. Also, students from nondominant backgrounds comprise the majority of students in the

nation's largest school systems. Finally, they estimated that English language learners will make up 40% of the school-age population by the 2030s.

The research was prompted by the resurgence of public opinion about the value and importance of homework coupled with the rising numbers of children from nondominant backgrounds. This phenomenon has raised questions about how students from nondominant backgrounds in American schools, especially in the urban areas, are impacted by teachers' homework practices.

This study was designed to explore

- Why teachers in one large urban community assigned homework and what their homework practices were.
- What kinds of homework they assigned and how they described their students' homework practices.
- What the teachers' beliefs were about the impact of homework on their students' success at school.

Brock et al. (2007) collected surveys from 133 elementary school teachers who were working on master's degrees in literacy and interviewed 27 other teachers about their homework practices. The study revealed that

- Results were encouraging because although teachers engaged in "typical" homework practices (i.e., the kinds of homework they assigned and their reasons for assigning it), they did make provisions to help their students to be successful with homework.
- They were also encouraged to learn that almost all the teachers they interviewed made provisions to ensure that their students had the support they needed to successfully complete their homework.
- These teachers knew that the parents of English language learners may not be able to support their students' homework in English. Teachers made provisions for determining other methods for students to receive help (before-school and afterschool homework clubs, being available for them, etc.).

Interestingly, teachers in this study also did not question the broader issues relating to the nature and usefulness of homework in general and assigned homework to meet parent expectations and the district's requirements that are different from purely instructional purposes.

Unfortunately, there were no precise guidelines coming out of this resource, and teachers and schools will need to ask themselves the hard homework questions and develop local policy that suits their individual setting, students, and parents.

Classroom Applications

Teachers assign homework for many reasons. Most teachers see homework as paradigm for students to practice skills, especially in math, reading, and spelling. This can be seen as a review of what they have been working on during class. This means a review of prior concepts and a reinforcement of what the students are doing in school. This idea also applies to learning to play a musical instrument, to folk arts, and to a few other areas within the school experience.

They also assign homework to give students opportunities to develop self-discipline and responsibility. Some teachers also assign homework because parents want and expect homework and worry if it's not being assigned, and in some districts, there is a mandate or guidelines for homework. While there are no precise and perfect guidelines for the role and structure of homework for every situation, there are topics for discussion that need to take place.

Many students and their families from nondominant cultures may not have the materials and linguistic resources to successfully engage in the historic canons of homework practices. So what questions should teachers ask themselves while structuring homework activities, and what assumptions should they make?

First, do all the students have the resources to complete their assignments? In this study (Brock et al., 2007), two-thirds of the teachers wouldn't assign homework requiring the Internet. The respondents in the study stated that they or their schools provided all the materials necessary for the student to complete their homework. Pencils, paper, crayons, worksheets, and/or books for reading were considered the basics. Only 2 out of 27 stated they also needed glue, scissors, or other craft items.

Second, should all students receive the same assignments? Again, in this study, 22 out of 27 used scaffold techniques like assigning a reduced workload for struggling students or varying the nature and reading level of books assigned. Varying the homework for a class is harder, but if it is within grade-level expectations, a reduced load might be necessary.

Third, what role does the homework grade play in overall assessment? Some teachers and schools had a separate homework grade, or an effort grade, and homework didn't count toward a class grade.

How often should you assign homework? Sending the same homework load on a regular basis also helps develop patterns of participation that become more ingrained in the family's lifestyle.

A few other questions to consider are

- Should students be able to do homework at school, and what messages does that send to students? How does this decision affect students of various abilities and skill levels? Is it fair?

- Is it fair to assign work that requires adult help at home? This is a tough question and is dependent on the demographics of the class and community.
- How do you make sure all students have the outside help or resources they need to complete their homework and not frustrate the student's effort?

In the referenced study (Brock et al., 2007), teachers of students from nondominant cultures reported that 60% to 75% of their students completed their homework when the assignments were modified in some of the ways described above.

While there are few studies that look at the effects of homework on achievement and learning, it's clear that homework is not going away and is an expected part of a child's school experience. With empathy and careful planning, the pitfalls of a lack of equal opportunity can be avoided, and students from nondominant cultures can be bolstered by academic success within the homework paradigm.

Precautions and Possible Pitfalls

Homework is a touchy subject in many schools and communities. The competition for the student's time outside of your classroom is tremendous today. Families can view homework as an intrusion into family time or activities. Make sure you have a clear homework philosophy and can intelligently articulate it to colleagues, administrators, and most importantly parents—especially parents who are not familiar with the American school system and the tradition of homework.

Source

Brock, C. H., Lapp, D., Flood, J., Fisher, D., & Han, K. T. (2007). Does homework matter? An investigation of teacher perceptions about homework practices for children from nondominant backgrounds. *Urban Education, 42*(4), 349–372.

10

Families, Schools, and the Social Aspects of the Classroom

You have not converted a man because you have silenced him.
—John Morley

Most of our obstacles would melt away if, instead of cowering before them, we should make up our minds to walk boldly through them.
—Abraham Maslow

> ✓ **Strategy 48: Enlist the help of parents toward the acquisition and teaching of instructional-related social skills as they may be different from the social skills parents value at home.**

What the Research Says

 The present study (Beebe-Frankenberger, Lane, Bocian, Gresham, & MacMillan, 2005) extended the work on teacher expectations by comparing the types of social skills expected for success from both the parent and teacher perspective.

For elementary and secondary school teachers, the researchers' findings suggest a core of four classroom behavior expectations based on the social behavior theme of cooperation. The four cooperative skills identified as universal at all ages in classrooms are as follows:

- Produces correct schoolwork
- Ignores peer distractions while doing classwork
- Easily makes transitions from one activity to another
- Finishes class assignments within time limits

In contrast, parents rated self-control, responsibility, and assertion as the most critical social skills at home rather than cooperation. The study clearly defines the differences and possible disconnects between home and school behavior expectations for students and suggests some type of mitigation by teachers to enlist the help of parents in expanding their son's or daughter's social expectations.

Classroom Applications

The facilitation of school success and prevention of school failure necessitates the support of all students to adjust to behavior expectations during the early school experience. This is done by explicitly including cooperation skills necessary for classroom organization and mastering instructional pathways. Making these social adjustments early will reduce problem behavior, which in turn will create a more effective learning environment and reduce class distractions.

Early collaboration with parents can help put teachers and parents on the same page regarding the different types of social skills associated with functional competence in the home and at school. It stands to reason that if the behaviors expected at home match those at school, then a student will have fewer adjustments to make when entering the classroom. Conversely, if the behaviors are functional and acceptable at home and not at school, then the child will have greater social adjustment challenges. The lack of continuity for behavioral expectations held by teachers and parents or caregivers may pose difficulties for some students as they try to manage the teacher's instructional pathways.

This is not to say that parents should or must hold identical expectations but that the school and classroom behavioral expectations need to be defined and clarified for all stakeholders.

Relatively few parents are involved frequently in the classroom or at school, yet most parents want to know how to help their own son or daughter at home. Thus, communicating the specific social skills teachers want to foster and gaining the assistance of parents toward teaching these skills early should be a common and very desirable goal. So in addition to teaching parents how to monitor homework, help them understand your

classroom behavior expectations for their child. Both parents and teachers value appropriate social skills, and teachers can develop a common ground between them.

Develop individual or schoolwide strategies to articulate cooperative classroom behavioral goals for your students. Help the parents and guardians understand the teacher expectations for the transition from school to home and help them prepare. Target the four school readiness skills of following directions, working independently, working in groups, and communicating. Ask parents to challenge their children by providing them with opportunities to practice these skills and abilities. Also ask them to reward their children with praise, attention, and small rewards. As a variation, ask the parents to "play school" with them and allow the child to reverse roles and play teacher so he or she can practice both following and enforcing the classroom rules and desired behavior. Students shouldn't be caught between home and school expectations when you involve parents in achieving your goals. When mothers and fathers favor self-directed child behavior over adult-directed behavior, it becomes a clear predictor of later social adaptation to school and relationships with other students and teachers. Children exhibit better behavior in learning environments.

Think about composing a list of "rules for school." The school environment is full of rules and expectations. Schools expect children to know these protocols and follow them. You can help parents reinforce these protocols by asking parents to discuss them at home.

Finally, remind parents to help their children cope with frustration. Schools and classrooms can be stressful and frustrating. The ability to maintain self-control, remain calm, and work persistently on instructional activities helps in maintaining positive interactions with teachers. Parents have the ability to help their students develop a range of coping strategies for these qualities. Remind parents of these strategies when the child is becoming frustrated, and remind them that children also learn by imitating their parents' behavior.

Precautions and Possible Pitfalls

 Teachers need to be sensitive to cultural and behavioral differences between home and school. Many cultures have different customs and expectations for social interaction. Many cultures have different social expectations for boys and girls.

Source

Beebe-Frankenberger, M., Lane, L. L., Bocian, K. M., Gresham, F. M., MacMillan, D. L. (2005). Students with or at risk for problem behavior: Betwixt and between teacher and parent expectations. *Preventing School Failure, 49*(2), 10–17.

Strategy 49: Understand the role parents play in bullying behavior at school.

What the Research Says

All of the cited researchers examined the influence that mothers, fathers, friends/peers, and teachers had on mitigating bullying behaviors. Olweus (1993) found that parents are often unaware of the bullying problem and talk about it with their children only to a limited extent.

Batsche and Knoff (1994) and Olweus (1993) found that students who engage in bullying behaviors appeared to have a desire to feel in control and powerful. Bullies appear to derive satisfaction from the harassment and the infliction of injury and suffering on others. They also seem to have little empathy for their victims and often defend their actions by saying that their targets of the bullying provoked them.

Rigby (2005) found that parental anti-bullying influences beyond primary school as conveyed through expectations had little influence on how children, especially boys, treat their peers. Studies indicate that bullies usually come from families where physical punishment is used, where the children are taught to strike back physically as a way to handle problems, and where parental involvement and warmth are often lacking. Students who regularly display bullying behaviors are generally defiant or oppositional toward adults, antisocial, and apt to break school rules. In contrast to prevailing myths, bullies appear to have little anxiety and to possess strong self-esteem. There is little evidence to support the contention that they victimize others because they feel bad about themselves.

Batsche and Knoff (1994) and Olweus (1993) "characterized" students who are victims of bullying behavior as typically anxious, insecure, cautious, and suffer from low self-esteem, rarely defending themselves or retaliating when confronted by students who bully them. They may lack social skills and friends, and they are often socially isolated. Victims tend to be close to their parents and may have parents who can be described as overprotective. The major defining physical characteristic of victims is that they tend to be physically weaker than their peers; other physical characteristics such as weight, dress, or wearing eyeglasses do not appear to be significant factors that can be correlated with victimization.

Both Rigby (2005) and Gini (2004) concluded that the best way to deal with bullying is through some form of peer intervention. Parental and teacher influence was of a secondary nature.

Classroom Applications

We know from this research that direct communicating of the expectations of teachers regarding bullying behaviors is likely to have little effect on how students interact. Rigby's (2005) research showed that

teachers are seen, by a large proportion of students, as an irrelevant force in the ways students interact with one another. Bullying is a problem that occurs in the social and academic environment as a whole. The bullies' aggression occurs in social contexts in which teachers and parents are generally unaware of the extent of the problem and other children are either reluctant to get involved or simply do not know how to help. Given that bullying in schools happens mostly in the presence of other students and often stops when objections are raised, there is growing evidence that some form of peer mediation is the best way to approach the problem. Counter-bullying programs can include forms of peer counseling or peer pressure facilitated by school personnel. Teachers and other school staff can organize these arrangements but take a very passive role in their implementation.

Strong correlation appears to exist between bullying other students during the school years and experiencing legal or criminal troubles as adults. In one study, 60% of those characterized as bullies in Grades 6–9 had at least one criminal conviction by age 24 (Olweus, 1993). Anecdotal reflection supports the notion that chronic bullies seem to maintain their behaviors into adulthood, negatively influencing their ability to develop and maintain positive relationships.

The school environment is compromised in a very negative way by bullying. Victims often fear school and consider school to be an unsafe and unhappy place. As many as 7% of America's eighth graders stay home at least once a month because of bullies (Batsche & Knoff, 1994; Olweus, 1993).

The act of being bullied tends to increase some students' isolation because their peers do not want to lose status by associating with them or because they do not want to increase the risks of being bullied themselves. Being bullied leads to depression and low self-esteem, problems that can carry into adulthood.

Finally, it's clear from the research that parental roles as potential solutions to the problems aren't promising and that teachers should look to peer mediation techniques to affect the problem. Solutions to bullying behaviors seem to lie with the schools and not the parents.

Banks (1997) made the following suggestions:

- An initial questionnaire can be distributed to students and adults. The questionnaire helps both adults and students become aware of the extent of the problem, helps to justify intervention efforts, and serves as a benchmark to measure the impact of improvements in school climate once other intervention components are in place.
- A parental awareness campaign can be conducted during parent–teacher conference days, through parent newsletters, and at PTA meetings. The goal is to increase parental awareness of the problem, point out the importance of parental involvement for program success, and encourage parental support of program goals. Questionnaire results are then publicized.

- Teachers can work with students at the class level to develop class rules against bullying. Many programs engage students in a series of formal role-playing exercises and related assignments that can teach those students directly involved in bullying alternative methods of interaction. These programs can also show other students how they can assist victims and how everyone can work together to create a school climate where bullying is not tolerated.
- Other components of anti-bullying programs include individualized interventions with the bullies and victims, the implementation of cooperative learning activities to reduce social isolation, and increasing adult supervision at key times (e.g., recess or lunch). Schools that have implemented Olweus's (1993) program have reported a 50% reduction in bullying.

Precautions and Possible Pitfalls

There is a clear lack of attention in the research to the characteristics of the victims and bystanders in the bullying equation.

Oliver, Hoover, and Hazler (1994) surveyed students in the Midwest and found that a clear majority felt that victims were at least partially responsible for bringing the bullying on themselves. Students surveyed tended to agree that bullying toughened a weak person, and some felt that bullying "taught" victims appropriate behavior.

Charach, Pepler, and Ziegler (1995) found that students considered victims to be "weak," "nerds," and "afraid to fight back." However, 43% of the students in this study said that they try to help the victim, 33% said that they should help but do not, and only 24% said that bullying was none of their business.

There were no clear remedies directly offered for the victims or bystanders regarding their roles in bullying behavior. However, by facilitating student discussions and drawing attention to the role bystanders' interventions can play, students can directly influence potential intervention behavior.

Sources

Banks, R. (1997). *Bullying in schools.* ERIC Digest. Champaign, IL: ERIC Clearinghouse on Elementary and Early Childhood Education. Retrieved July 19, 2007, from http://www.ericdigests.org/1997-4/bullying.htm.

Batsche, G. M., & Knoff, H. M. (1994). Bullies and their victims: Understanding a pervasive problem in the schools. *School Psychology Review, 23*(2), 165–174.

Charach, A., Pepler, D., & Ziegler, S. (1995). Bullying at school—A Canadian perspective: A survey of problems and suggestions for intervention. *Education Canada, 35*(1), 12–18.

Gini, G. (2004). Bullying in Italian schools. *School Psychology International, 25*(1), 106–116.

Oliver, R., Hoover, J. H., & Hazler, R. (1994). The perceived roles of bullying in small-town Midwestern schools. *Journal of Counseling and Development, 72*(4), 416–419.

Olweus, D. (1993). *Bullying at school: What we know and what we can do.* Cambridge, MA: Blackwell.

Rigby, K. (2005). Why do some children bully at school? *School Psychology International, 26*(2), 147–161.

Strategy 50: Become aware of how parents react to their children being excluded from mainstream school due to behavior problems.

What the Research Says

McDonald and Thomas (2003) examined the human cost of exclusion and found that it wasn't confined to the student. Parents of excluded students felt they were judged as unworthy parents and were reduced to observers in the discourse about their children's future educational decisions. Viewing themselves as partners in the educational enterprise of their students, they often described themselves as powerless in the exclusion (suspension or expulsion) processes. McDonald and Thomas described how a group of parents experienced the exclusion process, and their stories are not often heard. They also described how parents experienced their son or daughter's mainstream schooling prior to the exclusion process.

This study was a qualitative case study based on interviews and took place in Australia. The authors deliberately sought out a range of people involved in the process. The study group included a total of 26 people: ten students (seven male and three female), eight parents, three staff members (two teachers and one learning support assistant), an educational psychologist, three different types of social workers, and a youth offending team member. The parents' exclusion stories were gathered in two parts. The first was an explanation of the reason for their son or daughter's exclusion, and the second focused on what they experienced and how they felt during the process.

The interview process evolved over the course of the study. The parents' anger from the experience and their sense of powerlessness when confronted by the process of exclusion were voiced clearly in the interviews. The experiences of the parents produced a clear picture of parents traumatized by their children's exclusion.

Classroom Applications

Many parents in the McDonald and Thomas (2003) study voiced their concerns over the way they were handled after their students left the classroom. In addition, almost all felt that their son or daughter's exclusion from the classroom was based on a culmination of petty misbehaviors that built up over time before the problems got to the administration.

All the parents attributed at least some of their child's misbehavior and exclusion from mainstream school to the teachers. They felt that the attitude adopted by the teachers had a major influence on their children's behavior. It was mentioned that their older children's experience at the school influenced the teachers' behavior toward the younger sibling. Another parent explained that the teachers contributed to the problem by the way they taught their class and handled discipline: the lessons were not engaging enough, and their son was bored. Parents also stated that it was the teachers' job to control the students.

Another parent placed the blame for her child's behavior on other students due to bullying. Even though the parents attributed different reasons to their child's exclusion, the majority of parents agreed that they were angry and frustrated over the exclusion process and their student's loss of instructional days and lack of interest in discussing their current and future educational options. Some felt that the school's response and the return to the classroom were slowed due to the timetable of organizing meetings and arranging help. Many meetings were included with people the parents had not met before. The parents felt intimidated and saw the meetings as negative experiences. The students also found the meetings difficult with the parents feeling so angry and uncomfortable. One mother believed that in the meeting with school staff about her son's behavior she was "made to feel like an unfit parent" and felt belittled. All agreed that these meetings were very tough for parents. The authoritarian nature of mainstream schools seemed restrictive and prohibitive. Few of the children involved enjoyed harmonious relationships with teachers and found the curriculum difficult.

All these factors contribute to an invisible and "obvious" hierarchy of worth based on behavior and academic ability and added to the worthlessness these students might feel, and the parents sensed this attitude.

Educators like to see their classrooms as places where opportunities abound and futures are made. The other side of this is that schools also tell parents and students what is not possible for them. The educational paradigm tells families what their students are not going to be able to do in their futures. If the system doesn't seem to be working for some students, there is a ripple effect that reaches the parents. Possibly just as damaging is that the parents feel the sense of being judged and criticized for their

child's action. It is difficult to believe that in their time of turmoil regarding their student's behavior, the process makes the parent vulnerable to getting the message that they are unfit parents or solely to blame for their child's behavior at school. At the time schools really need the parents' help, parents can feel a sense of powerlessness, alienation, and further isolation from the school.

The perspective of the parents' experience of exclusion is a story not often heard by teachers because the teachers are thinking of their own situations and trying to protect the classroom environment for the other students. Empathy is an obvious word to use here. The goal is to make the exclusion practices of the school inclusive and see parents as part of the solution. That means to positively involve parents in the processes of exclusion from the beginning of the problem. Next, all stakeholders need to focus on prioritizing and securing future educational services and, lastly, continue to create, develop, and help realize a dream or vision for what is possible to keep hope alive. This all begins with how teachers incorporate involving the parents in a solution-focused manner well before the administration formally begins the processes of exclusion. Again, as each school and situation is different regarding exclusion, the key is to have empathy for the parents or caregivers and to realize that ideally, they are your partners in the educational enterprise of their child. If they feel powerless or unworthy as parents, you're not likely to find a solution including them. Keep them on your side.

Precautions and Possible Pitfalls

If you've been around education for a while, you know that it would be foolish to see all parents as victims of their child's behavior and powerless. Stereotyping parents can get you in trouble. The goal is to empower parents to help their students adopt academic and social behaviors that serve everyone involved well. Again, if you are around long enough, you will encounter parents who want your help and parents who will blame everyone else in the child's life and be in total denial.

A trap that principals can fall into is getting caught between teachers and parents. The principal is obligated to support and maintain a safe school environment. Sometimes the principal will empathize with the parent, because he or she can see the view from outside the classroom, and it can be that there are many petty events that lead up to a "final straw" that causes the teacher to demand an exclusion. A schoolwide discipline program created by teachers, principals, and parents can help avoid this problem. Consistency of consequences and attitudes about discipline problems from teacher to teacher can make it a lot easier to talk with parents and

involve them in the process of a suspension in a positive way. Also, a proactive principal can intervene when he or she begins to see those petty infractions.

The key for teachers and administrators is to do what you can to understand the parents' perspective and be ready with responses—never mind how your relationship with the parents goes. This is best done in teams where everyone can contribute to and support the process of finding solutions and no one is dealing with the situation in isolation. This protects you and also provides the best possible environment for helping both the students and the parents.

Source

McDonald, T., & Thomas, G. (2003). Parents' reflections on the children being excluded. *Emotional Behavioral Difficulties, 8*(2), 108–119.

11

The Role of the School Administrator

Increasing Student Achievement Through Parent Involvement

We need leadership that is tough enough to demand a great deal from everyone, and leadership that is tender enough to encourage the heart.

—Thomas Sergiovanni

A shared vision is not an idea . . . it is, rather, a force in people's hearts . . . at its simplest level, a shared vision is the answer to the question "What do we want to create?"

—Peter Senge

 Strategy 51: Be aware of the potential disconnect between parent and teacher perceptions of family involvement, and set up systems to ameliorate the difference in views.

What the Research Says

In his research study on parent and teacher perceptions of family involvement, Lawson (2003) noted that there are often "unarticulated assumptions and implicit theories of action that undergird what parent involvement means and represents to its primary actors: parents and teachers" (p. 82). The qualitative study, which was conducted at a high-poverty elementary school in a Midwestern city, utilized focus groups and interviews of teachers, involved parents, and uninvolved parents to determine the differences in attitudes and understanding of what parent involvement is and/or should be. Lawson found that although both groups shared the goal of the greater good for children, there were fundamental differences, with teachers having a more school-centric viewpoint and parents having a community-centric perspective. The following summary of the study gives a picture of the problems at the school and a basis to begin a conversation about these problems at your own school.

Many barriers to effective parent involvement existed for the two groups. The study found that parents were burdened with community concerns. First, the changes in the community surrounding the school over the previous two decades had left parents with worries. The neighborhood barbecues and children playing after school had changed with the advent of drugs and gangs in the area. Whether "involved" or "uninvolved," parents were keenly aware of their responsibility to put food on the table and ensure that their children have a quality education. The parents also felt that because of the changes in the community, there had been changes at school. Surveillance cameras, closed campuses, and stringent discipline policies all gave the parents the feeling that their children were being treated differently and oftentimes harshly. While the interviews exposed this belief, the researcher also discovered that there coexisted the acknowledgment that the children were often misbehaving, but parents believed the reasons for the misbehavior were rooted in misunderstandings, and many times the parents were blamed for student comportment, which led to anger on the part of the parents.

A second barrier that Lawson (2003) identified was the perception of the parents that poor parent–teacher communication began at the school. Often communication was initiated when there was a problem, and then there was no perceived venue for parents to express their viewpoints. Parents in the study thought that teachers acted like they knew it all, due to their education, and the parents were given no credit for their experiences and knowledge. Furthermore, parents felt that teachers made assumptions about children, based on what they knew of the parents. This caused anger in the parents and deteriorated trust. Trust was further broken down by negative school experiences, spreading quickly through the community.

Involved and uninvolved parents both had the same reactions to the communication issues.

Children learning to associate parental involvement as a negative experience posed the third challenge to the family involvement program at this school. Parents indicated that the school systems and policies contributed to the problem. For example, it was noted that home–school communication was routinely sent home via backpack flyers, and because students were unsure about having parents active in their school lives, oftentimes, the flyers were not distributed. Parents didn't learn about school activities, and teachers would question why the parents didn't show up to an event. This method of communication served to further the separation of the two groups and make the chances of working together less likely.

Parents responded to the role of the school and parent involvement with the school in a community-centric way. Circumstances surrounding the working relationships of the two groups were always seen in the context of how the school fit into the community. When asked how the parents thought the school could get more parent support and involvement, the response was to give the school a community-centered atmosphere, even to the extent of the school offering GED courses to parents. Parents acknowledged that this was beyond what teachers and the school had been trained or might be expected to do, while still maintaining that it would be nice to have a true center to the community serving parents and students.

Teachers' perceptions of parent involvement were school-centric and also included many barriers to effectiveness. Teachers' ideas of parent involvement included two domains: school based and home based. School-based involvement consisted of volunteering, helping with field trips, noon supervision, and assisting the teacher with any classroom needs. Home-based involvement was the supposition that parents needed to reinforce school values and the school's mission at home. The first barrier noted by Lawson (2003) was that while acknowledging that parents couldn't always be expected to engage in the school-based practices, there was the belief that lack of home-based involvement was a detriment to both student and teacher. Teachers felt that when home-based strategies weren't in place, behavioral issues arose and interrupted the learning process.

Teachers' suppositions about parent education level and the intergenerational lack of support for schools also formed a barrier to mutual views on the effectiveness of parent involvement. Teachers thought that parents needed to be educated on the benefits of school involvement and involvement in their children's lives in general. This belief was linked to the idea that some employed parents were more deserving of compassion, while unemployed parents were not. Status and background also played a part in the teachers' views of the parents. It was believed that less educated

parents were more intimidated by teacher education levels and dress, while more educated parents were less intimidated. Additionally, teachers thought they were bribing parents and that parents should not require an incentive to come to an event. Teachers believed that feeding parents at an event is a form of bribery that would not be necessary if the parents really understood the need for them to be involved in their child's education.

The research also showed a disconnect between perceived teacher responsibilities and parent responsibilities. Teachers were quoted as saying, "This is the job I was trained to do. All I want to do is teach; we're not social workers." This sentiment was repeated by the majority of interviewed teachers, along with the opinion that giving families additional support somehow lets them "off the hook," because they are not living up to their responsibilities.

The final barrier identified by Lawson (2003) was a lack of ownership in the program, which was an area of overlap in the parents' point of view. Although the school had a parent advisory committee and a parent involvement coordinator, many teachers felt that they were excluded from the planning process and were therefore less likely to become involved or support the program. Poor communication as to the vision and implementation of the parent involvement program and other programs at the site led to teacher isolation and withdrawal.

To summarize, this study (Lawson, 2003) concluded that the primary goal of parent involvement differed between the two parent groups and the teachers. The "involved" parents' primary goals were to support children with social, behavioral, and academic assistance, to make sure students were treated fairly, and to support teachers. The "uninvolved" parents were motivated to become involved in school to protect children from being treated poorly, labeled, or neglected by teachers and the school. The teachers' primary goals were to have parents support teachers' needs and school goals and help reinforce at home and at school what is taught or modeled in the classroom.

Leadership Applications

In order for an underperforming school to make strides in student achievement, the principal must take responsibility for the expectations, culture, and climate of the school. The described study (Lawson, 2003) and other research point to the potential at a school for conflict between parent and teacher perceptions of parent involvement. The following applications are recommended based on the above findings:

- *Provide a way for parents and teachers to create a unified vision of family engagement practices.* As noted in the research, parents and teachers assigned different values and meanings to parent involvement, and there was no system for the sharing of beliefs or airing of

assumptions. A prototype for this sort of collaboration can be found in the Parents and Teachers Talking Together (PT3) program developed by the Prichard Committee for Academic Excellence in Kentucky (Henderson, Mapp, Johnson, & Davies, 2007). This model brings 15 parents and 15 teachers together in brainstorming and communication sessions where each group has a chance to listen to the goals and dreams of the other. Whether an administrator uses the Pritchard model or develops one of his or her own, it is important for both groups to have a feeling of influence and understanding, so there is more buy-in to the parent engagement program.

- *Provide professional development for teachers on generational poverty, with strategies to better understand the culture and ways to communicate with the families.* Teachers working in a school with high poverty rarely live in the area. The values and upbringing of the staff can be a huge mismatch for the experiences and culture of the families they serve. Indeed, Lawson's (2003) research report clearly establishes a lack of understanding or empathy for the surrounding community. Professional development assisting teachers with the communication styles, values, and hidden skills of families in poverty can give teachers the skills and empathy needed to create the types of relationships with the community that will allow for greater parent involvement, resulting in increased student achievement. Books like *A Framework for Understanding Poverty*, by Ruby K. Payne, can provide a starting point for staff development that would enable teachers to understand the point of view of parents in low-income communities.

- *Set up communication systems that will allow teachers and parents to be aware of the purpose, policies, and procedures surrounding family engagement at your school.* Any school administrator will tell you that communication is a major barrier to a school improvement initiative at a site. Every minute of a teacher's day is occupied with urgent activity. From preparing and administering daily lessons that require differentiation for all students in all subjects to dealing with discipline issues in the classroom and on the playground, teachers don't have much time to check e-mail and discuss the best way for the school to increase family engagement. When the twice-monthly staff meetings roll around, there are so many issues that an administrator would like to communicate to the staff that the "information dump" is overwhelming, and principals are hard-pressed to find the opportunity for input and buy-in to a school improvement initiative like parent involvement. Similarly, parents are also busy victims of time and responsibility and aren't able to be involved in visioning sessions or even to read the latest flyer sent home.

Precautions and Possible Pitfalls

When a principal attempts to create a shared vision, unless both groups have a willingness or understanding of how important the work is, the act of creating a vision could create more conflict. Deliberate education of both parents and teachers as to the purpose and parameters of the work is advised, with a facilitator who has an outside point of view so there is no perception of a hidden agenda.

If the administrator initiates staff development to give teachers a broader perspective and empathy toward the community's situation and cultures, or tries a model of parent and teacher communication like the Pritchard model, it is important to have quality follow-up. One-time staff development sessions are not effective in changing teacher and/or community behaviors and attitudes. The principal also needs to make sure proper resources are allocated to any staff development effort if it is going to be effective.

Do not launch into a staff development or communication plan surrounding parent–teacher issues unless you have buy-in from staff. Use data from school climate surveys to demonstrate the problem, and present research on the effectiveness of parent involvement and evidence of the achievement gap at your school to develop the base of commitment from teachers. Teachers may become defensive if it seems you are taking sides with parents. Work through the problem with the objective of creating a school culture where teachers and parents share the same vision of student achievement and have the skills and understanding to work together to achieve the goal.

Sources

Lawson, M. (2003, January). Parent and teacher perceptions of parent involvement. *Urban Education, 38*(1), 77–133.

Henderson, A., Mapp, K., Johnson, V., & Davies, D. (2007). *Beyond the bake sale.* New York: The New Press.

> *Strategy 52: Make "compliance" your friend. Use NCLB as an avenue to promote parent and community relations through attention to discourse surrounding home–school communications and policies, and use school councils effectively to advance the culture of collaboration with parents and community at your site.*

What the Research Says

The No Child Left Behind Act of 2001 (NCLB) has had a sweeping impact on public education. Since its inception there has been a focus on research-based teaching strategies, the closing of the achievement gap between ethnic and socioeconomic groups, and parent involvement. Section 1114 of NCLB states that there shall be a written parent education policy at the district and site level, that parents should be involved in the creation and review of the policy, that there will be an annual parent meeting to involve parents in the improvement of the school's Title I plan, and that each school will have a school–parent compact. Although the research is voluminous as to the positive effects of parent involvement, as noted earlier in this book, research also uncovers the danger of disengaging families through loaded discourse and lack of facilitative leadership at the site and district levels when implementing compliance items. This is something that principals need to be aware of and work to improve.

Merriam-Webster's Dictionary (1988, p. 392) defines *discourse* as "formal and orderly and usually extended expression of thought on a subject." As mentioned in Chapter 8 of this book, there can be a disconnect between the language used at school by the faculty and that used by the parents. Indeed, the "extended expression" surrounding parent involvement is rife with words and phrasing that go beyond a simple lack of connection with the school, seemingly placing parents in a "double bind" (Nakagawa, 2000). As described in her research review, "Unthreading the Ties That Bind: Questioning the Discourse of Parent Involvement," Kathryn Nakagawa describes the double bind of parents as protectors or problems. Noting that much of the language used in policy on parent involvement formalizes parents as problems, Nakagawa cited examples like this from the Hawaiian legislature: "The legislature finds that lack of parental responsibility lies at the root of many of our societal problems today. . ." (A Bill for an Act Relating to Parental Responsibility for Education, 1999). The bill goes on to state that only through parent involvement can educational problems be resolved, putting the parents in the situation of being the problem and the solution.

An NCLB compliance item thoroughly explored by Nakagawa (2000) is the family–school compact required by the school-level parent involvement policy. All schools receiving Title I money must have a parent involvement policy, containing the compact. When researching the discourse surrounding these compacts, Nakagawa found that often, the requirements contained in the compact were more measurable for parents than teachers; the structure was a "form" contract versus "bargained" contract, which implies more power to the school; and rarely was there a description of teaching quality or rigorous curriculum. Always, the document is presented to the family by the school, indicating that parents are the target of improvement and that schools are in charge.

Given the research on language surrounding parent involvement compliance items, Nakagawa (2000) cautioned school leaders and policy makers. She is not the only researcher to note the problem. Epstein and Hollifield (1996) cautioned that the compact required by the Improving America's Schools Act, the forerunner of NCLB, would need to be created cautiously with the intent to go beyond compliance and "help schools develop strong programs of partnership" (Epstein & Hollifield, 1996, p. 272).

School site governance councils are also required by many states and can serve to fulfill the many requirements of the federal government's parent involvement policy in NCLB. These councils have been in existence for decades, starting in the 1980s as a result of the "A Nation at Risk" report, stating a growing crisis in public education. Site councils were initiated in order to improve school decision-making processes, thereby increasing student achievement (Shatkin & Gershberg, 2007, p. 584). Effective school site councils exist where there is a high level of parental and community involvement and input into decision making and where there is an accomplished school principal with strong leadership and collaboration skills (Shatkin & Gershberg, 2007, p. 603).

A study of views of school site council effectiveness by Pharis, Bass, and Pate (2005) surveyed 80 elementary school councils with a 55.7% response rate. Data on issues actually addressed by school site councils was obtained through agendas and minutes. The survey addressed perceptions of effectiveness, delving into the factors that school site council members believed contributed to school council effectiveness. The results showed that parent and community involvement and school–community communication were perceived to be the most successful area of work in which the councils engaged (Pharis et al., 2005, p. 36). Respondents further identified open communications and availability of information as factors enabling school council effectiveness. In order to have this openness, a dialogue should exist where the principal doesn't take command but facilitates, listens, and acts on suggestions. The principal can make the difference for the success or failure of a school council (Collins, 1996).

Leadership Applications

Many school administrators view compliance very simply: One must be careful to comply with laws that govern state and federal funding. Many times these items serve as an additional headache to principals; they're just another thing the central office tells them they have to do. The truth of the matter is that most of these items—like site-level parent involvement policies, school–parent compacts, and governance councils—are rooted in research and are in place to ensure students equitable rights to an education. Since these policies must be followed, the wise principal works to make them useful and friendly, going beyond "compliance."

As pointed out by Nakagawa (2000), the language used by those in leadership positions can have a negative impact on parents. School principals should be aware of this when complying with the many mandates for parent involvement set forth in NCLB. When creating parent–school compacts, principals and district-level leaders should *examine the language and responsibilities in the compact*. Are there more parent responsibilities? Are these responsibilities measurable while the teacher responsibilities are vague? Does the language of the parent pledge appear to put the parent in a "double bind"? Using a qualitative method of measuring loaded language modeled after the example in Nakagawa's study (2000, pp. 460–462), take a look at the following compact sample taken from the California Department of Education Web site (http://www.cde.ca.gov/ls/pf/pf/sampleelemcom.asp):

Staff Pledge

I agree to carry out the following responsibilities to the best of my ability:

Provide high-quality curriculum and instruction.

Endeavor to motivate my students to learn.

Have high expectations and help every child to develop a love of learning.

Communicate regularly with families about student progress.

Provide a warm, safe, and caring learning environment.

Provide meaningful, daily homework assignments to reinforce and extend learning (30 minutes for Grades 1–3 and 60 minutes for Grades 4–6).

Participate in professional development opportunities that improve teaching and learning and support the formation of partnerships with families and the community.

Actively participate in collaborative decision making and consistently work with families and my school colleagues to make schools accessible and welcoming places for families that help each student achieve the school's high academic standards.

Respect the school, students, staff, and families.

Parent/Family Pledge

I agree to carry out the following responsibilities to the best of my ability:

Provide a quiet time and place for homework and monitor TV viewing.

Read to my child or encourage my child to read every day (20 minutes for Grades K–3 and 30 minutes for Grades 4–6).

Communicate with the teacher or the school when I have a concern.

Ensure that my child attends school every day and gets adequate sleep, regular medical attention, and proper nutrition.

Regularly monitor my child's progress in school.

Participate at school in activities such as school decision making, volunteering, and/or attending parent–teacher conferences.

Communicate the importance of education and learning to my child.

Respect the school, staff, students, and families.

Note that three of the nine teacher items are quantifiable, while five of the eight parent items can be measured. Also look for wording that can be seen as mildly insulting. Note the fourth responsibility of the family pledge, "Ensure that my child attends school every day and gets adequate sleep, regular medical attention, and proper nutrition." The tone of that would imply that these things aren't being done, and the undercurrent is that parents are the problems.

The principal should take an active role in the creation of his or her school's compact. Language and subtle messages can be far more positive than negative. Also, format can be determined by the principal. Does the compact contain any open-ended statements, so the parent receiving the document can have input, thus feeling some sort of shared power with the school? How the compact is used is also a question of leadership. Should it be passed out at parent conferences, signed, and never used again? Or can the principal start assemblies with key phrases from the compact? Can the principal put explanations of it in the school newsletter, with examples connected to student achievement? The more positive communication a principal can have with the school community, the greater the connection and likelihood that improved student achievement can result.

The principal should be a facilitative leader of the school site council. NCLB is very clear about how important parent involvement is, with as many as 29 compliance items in Section 1114. Many of the items can be accomplished through the collaborative work of the school site council. School site councils can be managed in many ways, but in order to go beyond compliance, the principal must be a facilitative leader who listens, keeps an open mind, conducts transparent meetings, and invites the parents to share in the decision-making process. Principals shouldn't plan agendas on their own, but jointly with the school site council members or the chairperson. Agendas should reflect topics of interest and importance to school site council members.

In the study by Pharis et al. (2005), topics ranged from use of school funds, communication strategies, and extracurricular activities to the highly important school improvement plan required by NCLB. When parents are working side by side with the principal on compliance items, there is a greater likelihood that the mandates will be realized and helpful to school improvement efforts.

Precautions and Possible Pitfalls

 As noted above, there are an abundance of compliance items contained in NCLB. Principals would be wise to educate parents on the value of NCLB and not dwell on its difficulties. NCLB is a bipartisan creation and may not be repealed or changed drastically in the near future. Indeed, many of the mandates mentioned in this section have existed for years prior to NCLB, seen first in Elementary and Secondary Education Act (ESEA, 1965) and then in Improving America's Schools Act (IASA, 1994). Parent involvement is a cornerstone of the legislation, which should be seen in a positive light. It is the principal's responsibility to make sure the school is in compliance, and parents should be an integral part of the improvement process.

Sources

A Bill for an Act Relating to Parental Responsibility for Education. (1999). Hawaii House Bill No. 846.

Collins, A. (1996). School councils and principal: Issues and challenges. *The Canadian School Executive, 16*(4), 3–6.

Epstein, J. L., & Hollifield, J. H. (1996). Title I and school–family–community partnerships. *Journal of Education for Students Placed at Risk, 1,* 263–278.

Merriam-Webster. (1988). *Webster's new world dictionary: Third college edition.* New York: Simon and Schuster.

Nakagawa, K. (2000, September). Unthreading the ties that bind: Questioning the discourse of parent involvement. *Educational Policy, 14*(4), 443–472.

Pharis, T., Bass, R., & Pate, J. (2005, Winter). School council member perceptions and actual practice of school councils in rural schools. *The Rural Educator, 26*(2), 33–38.

Shatkin, G., & Gershberg, A. (2007, November). Empowering parents and building communities: The role of school-based councils in educational governance and accountability. *Urban Education, 42*(6), 582–615.

Talley, K., & Keedy, J. (2006, August). Assessing school council contribution to the enabling conditions for instructional capacity building: An urban district in Kentucky. *Education and Urban Society, 38*(4), 419–454.

Strategy 53: When working with parents and the community, be an authentic leader.

What the Research Says

As has been well established in this book and the literature surrounding parent involvement, communication and parent outreach is a key issue. It has also been recognized that the principal of a school is one of the most important links to overall student achievement and the goal of parent involvement. A school principal is constantly searching for the best ways to communicate and work with parents and community in an effort to lead and support student achievement. In their literature review called "Leader Authenticity in Intercultural School Contexts," Walker and Shuangye (2007) asserted that principals need to be authentic leaders in order to engage all school and community stakeholders.

Walker and Shuangye (2007) defined intercultural school contexts as "the cultural values which underpin the actions and behaviours of the different groups which comprise the school and its wider community" (p. 190). In 2003, 37% of students in U.S. schools were minority students, and in the western states, 54% of all students were minorities (U.S. Department of Education, 2005, p. 33). This makes the likelihood of a principal having school communities with different cultural values extremely high, thereby making communication of school practices and the solicitation of parent involvement very complex.

To deal with these complex issues, Walker and Shuangye (2007) proposed "authentic leadership" as the solution. By "carefully accounting for the cultures which comprise the school and how these impact relationships" (p. 190), a principal can lead authentically. This means that the school leader must be constantly learning and responding to new situations, rather than acting on the basis of what has been effective in the past. Walker and Shuangye (2007, p. 194) drew a comparison from the work of Weick (1996) to firefighting, or the "trust and mistrust" experience. A firefighter must approach each emergency situation knowing that he or

she must rely on past experience, yet acknowledge that experience is "relevant and limited." In other words, a school principal can and should reflect on past experience, yet always be ready to create new knowledge and practice based on the experiences unfolding before him or her.

Walker and Shuangye further described authentic leaders as principals who will "incorporate understandings of diverse community needs and other contextually relevant perspectives to build their authenticity" (2007, p. 186). This means moving beyond a set of leadership "best practices" and adjusting practices to fit the nature of the intercultural situation of the school. In order to do this, school principals must constantly learn about the cultural aspects of their school population. This commitment to learning is at the core of authentic leadership.

Leadership Applications

The word *authentic* inspires trust. Authentic leadership can only increase a principal's capability to lead and connect with the community. In order to do this, the principal must engage in constant learning. Knowing the cultures within your school and your community becomes the first step to this authenticity. A school might contain several different types of English learners (Jaramillo & Olsen, 1999) whose parents come with several different sets of cultural beliefs that might, on the surface, seem the same or similar and yet they can be quite different. For example, an educated parent of an English language learner and an immigrant parent with no education might seem, on the surface, to share the same culture when, in reality, their points of view can be vastly different. The principal in this type of school must not only be aware of the values of the various cultures, but must reflect on how those values differ from his or her own and what effect that difference might have on communication.

One way to ascertain the different cultural elements that compose a school's intercultural makeup is to conduct a "culture audit." The purpose of a culture audit is to "examine how diverse cultural perspectives are reflected in the values and behaviors in the overall school culture" (Sailes, 2008, p. 80). Sailes directs us to the National Center for Cultural Competence (http://www.nccccurricula.info/culturalcompetence.html) that recommends the following audit procedures:

- Assess the current culture
- Analyze the findings
- Select areas for improvement
- Continue to monitor and adjust

Just knowing the different cultures is not enough if that knowledge doesn't inform leadership actions. An authentic leader must be able to

apply the knowledge to situations that occur within the school and community. For example, an audit might reveal that a traditional celebration at school makes some groups feel excluded. The principal's responsibility is to work with those who have a vested interest in maintaining traditions and those who are offended. This can be as simple as including the country of Sudan in the annual Olympic Day, instead of just the European countries the teachers had traditionally selected.

Finally, a principal must embrace the "trust/mistrust" concept. When dealing with interpersonal situations in such areas as homework, safety, student interactions, or requests for school support through volunteering or serving on site councils, the principal can use prior experience to initiate actions but should be highly aware of the new perceptions that can occur due to the ever-changing cultural contexts. Should a situation occur where a community member's reaction to a school procedure is not as expected, it might be explained based on prior experience (parents don't have enough time to serve on school councils), or it could be that the actual procedure is contrary to the cultural concept of the parent or parents receiving the message (the school shouldn't be asking parents to give input into the Title I policy; the school administration and teachers should be the experts). In an instance like this, the school leader must reflect and not jump to conclusions. If the principal determines that the parents' lack of enthusiasm for school site council help is due to lack of time, instead of a cultural misunderstanding, there is a lost opportunity to connect and communicate.

Precautions and Possible Pitfalls

Authenticity is exactly that—an authentic way of dealing with parents and community. It is borne of a desire to work with parents and to increase student achievement. Authentic leadership is not something that has certain steps that an administrator can memorize and check off when responding to situations. As Walker and Shuangye state, "Authentic leadership is not something which comes just through clarifying and adhering to a set of personal beliefs, nor does it have a definitive endpoint. Rather, it is an ongoing interaction between how well one understands oneself with the meanings of a given educational context; and what can best be done to improve student lives and learning within this context" (Walker & Shuangye, 2007, p. 186). The principal is cautioned to let authenticity develop with the community through a commitment to learning about the cultural differences of the community and reflecting on how best to make decisions, policies, and outreach practices based on this knowledge.

Authenticity also applies to the teaching staff. They deserve the same considerations and compassion as the parents. Don't forget to lead from the heart, as recommended by Peter Senge and Thomas Sergiovanni in the opening quotes of this chapter.

Sources

Jaramillo, A., & Olsen, L. (1999). *Turning the tides of exclusion: A guide for educators and advocates for immigrant students.* Oakland, CA: California Tomorrow.

Riehl, C. (2000, Spring). The principal's role in creating inclusive schools for diverse students: A review of normative, empirical, and critical literature on the practice of educational administration. *Review of Educational Research, 70*(1), 55–81.

Sailes, D. (2008, March). School culture audits: Making a difference in school improvement plans. *Improving Schools, 11*(1), 74–82.

U.S. Department of Education, National Center for Education Statistics. (2005). U.S. Department of Education Home Page, Statistics and Research. Retrieved April 27, 2008, from http://www.ed.gov/index.jhtml

Walker, A., & Shuangye, C. (2007). Leader authenticity in intercultural school contexts. *Educational Management Administration Leadership, 35*(2), 185–204.

Weick, K. (1996). Fighting fires in educational administration. *Educational Administration Quarterly, 32*(4), 565–578.

Strategy 54: Be aware that traditional parental involvement practices could actually serve to exclude the very parents you'd like to involve.

What the Research Says

Extensive research supports increased parental involvement as a means to assist with increasing student achievement. It is so commonly accepted that the federal government has made parent involvement a key compliance item in the No Child Left Behind Act of 2001 (NCLB). One of the main goals of NCLB is to close the achievement gap between underachieving ethnic and economic groups of children and the majority White group.

In their study on upper-middle-class parents and the effect of traditional parent involvement practices on typically underrepresented parent groups, McGrath and Kuriloff (1999) explored the idea that increased parental involvement might actually have an opposite unintended effect. They saw two main problems as contributing to this paradox (McGrath & Kuriloff, 1999, p. 604). First, parents differ by social class and possess unequal social capital. This notion is supported in the research of Horvat, Weininger, and Lareau (2003, p. 320) in that "parental networks vary across class categories." The second situation that contributes to this irony is that typically involved parents are concerned with gaining advantage for their own children (McGrath & Kuriloff, 1999, p. 604). McGrath and Kuriloff began with a synthesis of typical parental involvement strategies, then supported their thesis with a qualitative study of a Northeastern school district.

McGrath and Kuriloff (1999) found three major features in the parent involvement literature pertinent to their case. First, parent involvement is a means to improve educational services to families through increased accountability. Second, parent involvement is intended to strengthen the ties to typically underserved populations, and lastly, it is a strategy to increase student achievement (1999, p. 605). The authors felt that all of these features are admirable and well intended; however, parent involvement can also be used to maintain the status quo for the upper-middle-class by preserving socioeconomic advantages. Inner-city parents and parents of color are likely to have less social capital when dealing with principals, teachers, and well-established systems such as parent–teacher organizations. A finding that contributed to this situation is that White upper-class mothers have social relationships and identities connected to the schools, while African-American mothers' lower levels of school involvement can be attributed to their commitment to the social environment outside of school—with their neighborhood and church affiliations (1999, p. 615).

In their study of the Minsi Trail School District, McGrath and Kuriloff (1999) interviewed parents, teachers, administrators, and nonteaching school personnel. They observed a total of 53 school days and also attended numerous district structuring committee meetings as well as parent–teacher organization (PTO) meetings. Their observations and interviews revealed many interesting conflicts, first with unintentionally excluding new parent groups, and second with academic tracking practices.

The practice of the traditional PTO meeting was an example of how underrepresented parent groups can be made to feel unwelcome. McGrath and Kuriloff (1999) detailed one example of how, when the lone African-American mother at the meeting volunteered that she didn't know some of the details of what was happening at the meeting and was new to the school, the response from the president of the organization was, "Yes, we were all here six years ago" (1999, p. 614). This uninviting manner was typical of many interactions cited by McGrath and Kuriloff during the meetings they observed. At a districtwide PTO meeting, the topic of trying to bring in new leadership was seriously addressed, with many presidents admitting to the "cliquishness" of the organizations at their schools. After much discussion it was determined that trying to cultivate new leaders through classes just wouldn't work, and the traditional method of selecting leaders from those already involved was much more practical (1999, p. 612). Another example of the reverse nature of the PTO meeting in drawing in new parents was the common feeling that the new parents, especially African-American parents, questioned the existing practices (1999, p. 614). McGrath and Kuriloff's observations made a clear case that this typical parent involvement structure is not an effective means to increase parent involvement for minority parents.

The academic tracking of students was another major side effect of highly involved parents versus the minority parents. McGrath and Kuriloff

noted that "involved mothers tended to use their access to educators in efforts to gain advantage for their own children, often at the expense of other children" (1999, p. 618). Using their knowledge of school systems and personnel, upper-class parents could assert their influence to gain desired educational outcomes. Involved White mothers would more often request teachers in the lower grades and lobby for ability tracking of students in the upper grades. These moms had more presence and cachet at the school. As one involved mother put it, "I found those envelope stuffing sessions valuable, because you would sit around and talk. And that's when you find out the things your really want to know" (1999, p. 610). The parent quoted had picked teachers, academic tracks, and teams for her children over the years. She had social capital, and she knew how to use it. Upper-class White parents had well-established social networks at the school that the African-American parents did not. There appeared throughout the research to be a real desire of upper-middle-class involved parents to try to separate their children from those children of perceived lower status.

Leadership Applications

 McGrath and Kuriloff had many recommendations for administrators based on their study (1999, pp. 624–626). A summary of their proposals follows:

- Recognize the problem at your school. Be aware of how your PTO meetings are run, and have suggestions and recommendations to make African-American and other ethnic and socioeconomic groups feel welcome.
- Make sure you link the parent involvement practices at your school to student achievement. Is there a "PTO" track at your school? If so, set up practices to eliminate the harm that can be done educationally to minority students by filling the "preferred teacher" classes with parent requests.
- Think of a way for minority voices to be heard. It might involve creating initial organizations of their own as an entry point into the school environment. (In California, a mandated English Learner Advisory Council allows parents of English learners a voice of their own.)
- Create outreach to traditional community organizations where your underrepresented parents *do* have social capital.
- Determine how you will respond to parent requests. When a parent makes a personal request, put it in the context of how it will benefit the learning for all at your site.
- Manage parent involvement. Stress that all constituents have responsibilities to the community at large, and teach parents the benefits of having a school where all students succeed.

Precautions and Possible Pitfalls

This paradox of unintentionally creating a situation where, in an effort to gain more parent involvement through traditional outreach methods such as PTO, you instead create a situation where you actually discriminate against underrepresented parent and student groups is very real. Any elementary school principal who has had to deal with parent requests for the "good teacher" can tell you that you have to handle this with diplomacy and integrity. Principals at some elementary schools no longer take parent requests. They have worked with the community to establish a culture where parents see beyond the needs of their own children. It is true that a PTO track with all high-achieving students can cause an inequitable situation at your school. Another element that can help with reducing or eliminating the PTO track is having your teachers team and share students, creating tutorial and enrichment situations. Parents see the teachers working together, delivering a consistent curriculum, and holding themselves accountable for student learning, and parents are appreciative of what the school is doing for all children.

The cliquishness described by McGrath and Kuriloff (1999) is also dangerous to your school environment. Be aware of your school's situation and act in an authentic leadership style, as recommended in Strategy 53. If parents see you are consistent, sincere about student achievement, and fair in your administrative decisions, you will be able to promote parent involvement in equitable ways.

Sources

Horvat, E. M., Weininger, E. B., & Lareau, A. (2003). From social ties to social capital: Class differences in the relations between schools and parent networks. *American Educational Research Journal, 40*(2), 319–351.

McGrath, D. J., & Kuriloff, P. J. (1999). They're going to tear the doors off this place: Upper middle class parent school involvement and the educational opportunities of other people's children. *Educational Policy, 13*, 603–629.

> ## Strategy 55: Put it all together: Plan and collaboratively lead the parent involvement initiative at your school.

What the Research Says

Throughout this book research has pointed to the importance of parent involvement in improving student achievement. Whether focused on math, literacy, homework, or bridging the gap between home and school, many effective strategies have been offered that will help a school increase student achievement through engaging their parents.

School principals have the special challenge of ensuring it happens. Keep in mind the old coaching adage, "You either get all the credit, or all the blame." As the site leader, it is your responsibility to create and maintain an effective teaching and learning environment, and working with parents cannot be an "add on," but must be an integral part of your school vision.

An effective parent involvement initiative will most likely be part of an overall school improvement plan designed to promote higher student achievement. In their article, "Learning About System Renewal," Fullan and Levin (2008) stated that

> any education reform that is intended to be sustainable and to result in better outcomes for learners must embody something like the following seven areas of attention:
>
> 1. A small number of ambitious yet achievable goals, publicly stated.
> 2. A positive stance with a focus on motivation.
> 3. Multilevel engagement with strong leadership and a "guiding coalition."
> 4. Emphasis on capacity building with a focus on results.
> 5. Keeping a focus on key strategies while also managing other interests and issues.
> 6. Effective use of resources.
> 7. Constant and growing transparency including public and stakeholder communication and feedback. (p. 292)

These seven areas of attention are imminently applicable when trying to increase student achievement through parent involvement. A school principal must engage all stakeholders and "keep a focus on key strategies" of parent involvement, while still managing other facets of the school program. He or she must include "transparent" communication to stakeholder groups in an authentic manner, as discussed in Strategy 53.

Additional research showed that "without effective leadership, even a staff with many dedicated and skilled teachers fails to function as an effective school community" (Knuth & Banks, 2006, p. 16). Building the common vision of excellence is an accepted role of the school principal, and a school plan or vision that includes parent involvement is an aspect of school reform in which educational psychologists and policy makers have placed great importance (Jeynes, 2005, 2007; Sailes, 2008).

In adhering to Fullan and Levin's (2008) first tenet to effect sustainable change, a school leader should select a small number of achievable goals and communicate those goals. When working on parent involvement, it is advisable to create a plan around the most effective parent involvement applications. In his article called "A Meta-Analysis of the Relation of Parental Involvement to Urban Elementary School Student Academic Achievement," Jeynes (2005) asked four research questions:

1. To what degree is parental involvement associated with higher levels of school achievement among urban students?
2. Do school programs of parental involvement positively influence urban students?
3. What aspects of parental involvement help those students most?
4. Does the relationship between parental involvement and academic achievement hold across race and gender groups?

For a school principal who is searching for some of Fullan and Levin's (2008) "achievable goals," the third question is of the most interest. Jeynes (2005) found that parental expectations yielded the highest effect size, 0.58 standard deviations, with parental reading coming in second at 0.42 standard deviations. Jeynes's (2005) research was further supported by the work of Ingram, Wolfe, and Lieberman in their 2007 study, "The Role of Parents in High-Achieving Schools Serving Low-Income, At-Risk Populations." In this second study, low-income parents at the high-achieving schools filled out questionnaires based on Epstein's (1987) framework for parent involvement. They found that of Epstein's six typologies for parent involvement, two of the six—parenting and learning at home—were the most frequently used by parents at these schools, and these schools were closing the achievement gap between low-income, at-risk populations and White students. Learning at home, as defined by Epstein (2004, p. 16), includes "homework, goal setting, and other curriculum related activities and decisions." Parental expectations make a difference. These parents also

engaged in student learning at home, which supports Jeynes's (2005) finding of parental reading being an effective parent involvement activity.

Leadership Applications

Using the above research, a school principal should combine Fullan and Levin's (2008) seven tenets for sustaining change with the most effective parent involvement strategies. He or she should work collaboratively with stakeholder groups to create a vision for improving student achievement utilizing teachers, the school governance council, and parent–teacher organizations. Parent involvement will be a major component of the plan, especially in that it has been shown to increase student achievement across race and gender (Jeynes, 2005). Because the studies indicate that parent expectations and learning at home have the greatest effect on student achievement, resources should be allocated to create parenting classes and further outreach to communicate with parents on the importance of high expectations and learning at home.

The principal should engage stakeholders by forming a "guiding coalition" of advisors. This group will work collaboratively to ensure the vision is communicated using common language and understanding. Teachers, parents, nonteaching school employees, and community members can be a part of this group.

Finally, the principal should be aware of all the "other interests and issues" that need managing. Parental involvement, while very important, will take a back seat to more immediate needs. In their article on leadership, Knuth and Banks (2006) stated that basic character and relationship tasks must be taken care of before the more complex instructional transactions and leadership challenges can occur.

Precautions and Possible Pitfalls

When leading school change, whether in the arena of increased, more effective parent involvement or changing the cultural dynamics of a school, there are many, many potential pitfalls. As any new or veteran administrator will tell you, it only takes one error to undo a lot of hard work. Fullan states, "Change is a journey, not a blueprint" (1997, p. 122). When you encounter a bump in the road on your change journey, be reflective. Ask yourself, what caused the failure? How can it be prevented again?

Personal experience, not research, leads one to believe that communication is the most important aspect of success or failure. As a school principal, the number of stakeholders and the amount of time you have severely hamper your ability to communicate. Try to think: Who needs to

know this? How can I communicate it to them? How will I know if I have successfully communicated? These simple questions will help you to stay focused on your vision of increased student achievement through parent involvement.

Along with the previous 54 strategies in your tool kit, you have plenty of material to use with your entire school community to improve student achievement. The end of the journey is worth a few wrong turns you might take along the way.

Sources

Epstein, J. L. (1987). Parent involvement: What research says to administrators. *Education and Urban Society, 19*(2), 119–136.

Epstein, J. L. (2004, August). Meeting NCLB requirements for family involvement. *Middle Ground, 8*(1), 14–17.

Fullan, M. (1997). Leadership for change. *The Challenge of School Change*, 115–135.

Fullan, M., & Levin, B. (2008). Learning about system renewal. *Educational Management Administration Leadership, 36*(2), 289–303.

Ingram, M., Wolfe, R., & Lieberman, J. (2007, August). The role of parents in high-achieving schools serving low-income, at-risk populations. *Education and Urban Society, 39*(4), 479–497.

Jeynes, W. (2005, May). A meta-analysis of the relation of parental involvement to urban elementary school student academic achievement. *Urban Education, 40*(3), 237–269.

Jeynes, W. (2007, January). The relationship between parental involvement and urban secondary school student academic achievement: A meta-analysis. *Urban Education, 82*(1), 82–110.

Knuth, R., & Banks, P. (2006, March). The essential leadership model. *NASSP Bulletin, 90*(1), 4–18.

Sailes, J. (2008, March). School culture audits: Making a difference in school improvement plans. *Improving Schools, 11*(1), 74–81.

Local Public Libraries:

National University Library's primary purpose is to support students and faculty for the University System. As a private university, our open access policy for community members is a gift to our neighbors and friends, but is not a moral or civic obligation. We value you as a community member and appreciate that you like to use our computers and other services.

We acknowledge that our limited hours for community access on computers may not fit your needs. Please realize that there are two public libraries in the area that may better serve you.

Serra Mesa/Kearny Mesa Library (B)
9005 Aero Dr.
San Diego CA 92123 (858) 573-1396

Balboa Library (C)
4255 Mt. Abernathy Ave.
San Diego CA 92117 (858) 573-1390

Branch Hours
Mon: 9:30 AM - 5:30 PM
Tue: 12:30 PM - 8:00 PM
Wed: 12:30 PM - 8:00 PM
Thu: 9:30 AM - 5:30 PM
Fri: 9:30 AM - 5:30 PM
Sat: 9:30 AM - 2:30 PM
[Serra Mesa: Sun 1-5 PM]

Map to local Libraries…

Index

CORWIN
PRESS

The Corwin Press logo—a raven striding across an open book—represents the union of courage and learning. Corwin Press is committed to improving education for all learners by publishing books and other professional development resources for those serving the field of PreK–12 education. By providing practical, hands-on materials, Corwin Press continues to carry out the promise of its motto: **"Helping Educators Do Their Work Better."**

NATIONAL ASSOCIATION
OF SECONDARY SCHOOL
PRINCIPALS

The National Association of Secondary School Principals—promoting excellence in school leadership since 1916—provides its members the professional resources to serve as visionary leaders. NASSP further promotes student leadership development through its sponsorship of the National Honor Society®, the National Junior Honor Society®, and the National Association of Student Councils®. For more information, visit www.principals.org.